NO PLASTIC SLEEVES

LARRY VOLK

DANIELLE CURRIER

NO PLASTIC SLEEVES

THE COMPLETE PORTFOLIO GUIDE
FOR PHOTOGRAPHERS AND DESIGNERS

AMSTERDAM • BOSTON • HEIDELBERG • LONDON
NEW YORK • OXFORD • PARIS • SAN DIEGO
SAN FRANCISCO • SINGAPORE • SYDNEY • TOKYO

ELSEVIER

Focal Press is an imprint of Elsevier

Focal Press is an imprint of Elsevier

30 Corporate Drive, Suite 400, Burlington, MA 01803, USA

Linacre House, Jordan Hill, Oxford OX2 8DP, UK

Notices

Knowledge and best practice in this field are constantly changing. As new research and experience broaden our understanding, changes in research methods, professional practices, or medical treatment may become necessary.

Practitioners and researchers must always rely on their own experience and knowledge in evaluating and using any information, methods, compounds, or experiments described herein. In using such information or methods they should be mindful of their own safety and the safety of others, including parties for whom they have a professional responsibility.

To the fullest extent of the law, neither the Publisher nor the authors, contributors, or editors, assume any liability for any injury and/or damage to persons or property as a matter of products liability, negligence or otherwise, or from any use or operation of any methods, products, instructions, or ideas contained in the material herein.

Library of Congress Cataloging-in-Publication Data

Currier, Danielle.

No plastic sleeves : the complete portfolio guide for photographers and designers / Danielle Currier, Larry Volk.

 p. cm.

Includes bibliographical references and index.

ISBN 978-0-240-81090-4 (pbk. : alk. paper) 1. Photograph albums. 2. Art portfolios. 3. Photography--Vocational guidance. I. Volk, Larry. II. Title.

 TR501.C87 2010

 745.593--dc22

 2009037799

British Library Cataloguing-in-Publication Data

A catalogue record for this book is available from the British Library.

ISBN: 978-0-240-81090-4

For information on all Focal Press publications visit our website at www.elsevierdirect.com

09 10 11 12 13 5 4 3 2 1

Printed in China

To H. H. with love and appreciation for all of your support.

To the artists in my community, who over many years have shared their ideas, and been supportive friends and inspiring colleagues.

—L. V.

To P. C., my mom, and the other academic in the family—thanks for all the inspiration.

To C. P., my better half—thanks for all the love, support, and belief in me.

—D. C.

CONTENTS

For more information, including additional portfolios, interviews, resources, tutorials and articles please visit the companion website at

WWW.NOPLASTICSLEEVES.COM

ACKNOWLEDGMENTS

Thank you to all the creative professionals and students for your generous contributions.

We know your work will inspire the readers of this book.

A special thank you to our Acquisitions Editor, Cara Anderson, for all her encouragement, patience, and support.

Thank you to the Senior Designer, Joanne Blank, for all her contributions to the design and development of this book.

A special thank you and acknowledgment to Anne Pelikan for her consultation, demonstrations, and input in regard to the book construction photographs and text.

Author's Note

The process that we have described in this book has evolved over many years through our experiences as educators and professionals in the creative industries. This process has ultimately developed into a system that addresses all facets of the portfolio package. Each step has been carefully planned, organized, and simplified in order to maximize the potential of your complete portfolio package. This book will guide you through a process of conceptualizing, designing, and developing all the interconnected pieces you will need. Professional and student work, diagrams, illustrations, and step-by-step visual guides will provide examples of and demonstrate key concepts, principles, and techniques.

FORM FOLLOWS FUNCTION—THAT HAS BEEN MISUNDERSTOOD.

Form and function should be one, joined in a spiritual union.

FRANK LLOYD WRIGHT

Have you ever heard the phrase "form follows function"? American sculptor Horatio Greenough is credited with the phrase, but it was the American architect Louis Sullivan who made it famous. The phrase became the guiding principle of modernist architects and industrial designers during the 20th century. It means that the structure and appearance of a thing should reflect and support what its purpose is. Let's examine the purposes of your portfolio. Your portfolio of work is the evidence of your experience, knowledge, skills, creativity, innovation, and aesthetic and technical capabilities. In essence, it is the culmination of who you are as a creative professional, and can even indicate where your future interests and passions lay. It is a large part of your identity as a creative professional and will be used heavily to market yourself to potential employers and clients. Therefore, your portfolio, both in print and digital form, should reflect and support your specific goals as a unique creative professional.

Types of Portfolios

In the creative industries a *portfolio* usually refers to an edited collection of visual work that is comprised of separate pieces and projects, representing both range and depth within a particular field. Typically, this collection reflects the best a company or individual has to offer.

There is also a portfolio that is referred to as a "body of work." This describes the collection of an artist, often unedited and presented in its entirety. Sometimes a "body of work" refers to a specific series, developed around a central theme or defined within a particular time period. Such a collection is often edited when exhibited or published in book or website form. Many artists create such collections, often serving as a portfolio of sorts, since they are intended for marketing and promotional purposes. In fact, most art and design students create a "body of work" as their senior project, including many interrelated pieces that are developed over several months time.

What are the goals and purposes of your portfolio? While the work in your portfolio is obviously a very essential part of your ability to market yourself and should be considered carefully, you should not stop there. Your comprehensive portfolio package has the potential to be so much more.

- The intention of putting together a portfolio is to present yourself as having a visual character, to differentiate yourself from the average creative professional, and make yourself stand out, supported by your own unique creative vision and the work you have done to prove yourself.

- Your portfolio package should be considered as a whole—from the first glimpse of your book's cover, to the work included inside, to your website and related professional and promotional materials. All of these materials are essential to marketing and establishing yourself as a creative professional.

- Your portfolio is evidence of your experience, knowledge, skills, creativity, innovation, and aesthetic and technical capabilities. These should be reflected by the portfolio's overarching design concept and backed up by the project work you choose to present.

- You should consider your portfolio not simply as a container for your work, but as a creative statement in and of itself that reflects the value you place on your work and craft. In the creative industries, our goal is very often to make work that captivates, engages, and communicates a point of view. What does it say if a creative professional's portfolio does none of these?

- Ultimately, the goal is to get you the job you want or the types of clients for whom you want to work. You can use your portfolio design as an opportunity to express and characterize the kind of work you want to do in the future.

- A comprehensive portfolio is finally about self, with the end goal of promoting and positioning yourself within your industry.

The Comprehensive Package

While your portfolio book is an essential part of your ability to market yourself, it is not the only piece. As part of a comprehensive portfolio package, you will also need to include an online or digital presentation of your work, a resume, a cover letter, and perhaps even a business card and mailers such as postcards or brochures. The resume, cover letter, and digital portfolio or mailers will function as the first contact and impression you make. These items will work to get your "foot in the door," so to speak.

Since your portfolio book will be built and designed by you, it will most likely be limited to one or two copies. It will be the book you mail to a limited number of select potential employers or clients and/or the book you bring with you to an interview. Along with your interviewing skills, your book must totally impress. Together, all these materials will ultimately be used to establish and secure working relationships with potential employers and clients. In order to do so, your portfolio package needs to function as a whole, with unifying visual elements that integrate the separate, but related pieces—all establishing and reinforcing a consistent, positive message about you.

Brands and Concepts

As previously stated, your portfolio book needs to function in some really important ways. For one, it needs to get you noticed, grab someone's attention, and distinguish you from "the crowd." It needs to communicate your unique talents and experiences in a positive and memorable way. To do this, you will need to develop a *brand statement* for yourself, capitalizing on your unique abilities and creative vision. You will then need to develop an *overarching concept that expresses this brand* through specific visual and verbal means. Some of you may even develop a subsequent *brand identity* that will inform the visual and verbal direction of all of your portfolio materials.

Your message will shape and influence how potential employers and clients perceive and remember you. Distinguishing yourself from hundreds of other similar candidates through a distinct brand concept will provide you with a vital competitive edge.

Therefore, it is important that your portfolio book is not simply a container for your work, but a well-thought-out and well-crafted creative statement, in and of itself. Creating your own unique book, related website, and supporting materials will demonstrate your commitment and dedication to your profession. This is especially true in our competitive creative industries where creative professionals distinguish themselves by taking the initiative to make sure that they show their very best right from the start. The first part of this book will guide you through a number of steps in order to achieve this very important first goal.

The Book

Driven by your brand statement and subsequent conceptual ideas, the two main design goals of your portfolio book can be thought of as interrelated structural parts. Namely, there is the exterior, or front and back cover design, and the interior page layout. While the exterior and interior of a book are certainly related and need to function together as a whole, they do serve different purposes, and separately, each addresses an important function of the book. The front and back cover design addresses the first goal by drawing attention to the book itself and by communicating, through visual and verbal elements, the nature of the content in the book—in this case, who you are as a creative professional.

Once you've piqued someone's interest with the cover design, the interior layout of your book communicates the body of the book—its content. In this case, this is a presentation of your work and related experiences. As the very first step in our process, you will need to take some time to evaluate and edit just what to include.

Your portfolio book and related website need to function by clearly and effectively presenting your work. To do so, the image of the work itself must be the focal point within the composition of each page. Information about the work and any other related visual elements should be secondary. In a visual industry, showcasing and showing off your work is ultimately what will get you the job! As part of our process, we will guide you through the organization and layout of elements within the layout of a page (both print and web based), including image relationships and typographic and compositional issues.

Visual elements, as established by your brand, will be prominent in your cover design and continue to a lesser degree into the interior layout of the book. This is done so that the exterior and interior parts don't seem like separate entities, but are visually related, creating a cohesive experience. Such visual elements could simply be the consistency of a typeface and color that carries over from the cover to the interior pages.

Book Construction

The next step in our process is to construct the actual book. We will guide you through a step-by-step process for creating the structure and form of your portfolio book. The form is, of course, driven by the functions of the book that we have already discussed. Thus, we will show you how to construct a book that can be customized so that it is unique to you, and can easily be updated. In addition, the craftsmanship of your portfolio book is very important as part of your professional presentation. Several tricks and tips will help ensure that you create a well-crafted, quality book presentation.

The Online Presence

Critical to the career of any design professional is an online presence. Having established a brand statement and related design concept for your portfolio book, you now need to transform and extend this to your online presence. Consistency of design and visual statement is key. There are numerous decisions to be made about the function and purpose of your web presence, as well as challenges in bringing your visual identity and work into an online form. The "Web Design" section in Step 6 will help you sort through the key issues as well as understand the key design concerns when developing your portfolio for the web.

Marketing

Your portfolio will only serve you if it is seen. You need to develop marketing materials as well as other ancillary materials to support your book and website. As always, continuity with the rest of your portfolio package is a must. There are, however, many routes to take with mailers, electronic mailings, leave-behind fliers, and business cards. In this part of the book, we walk through the considerations and possibilities of marketing, marketing materials, and resumes, as well as contacts and interviews.

Our Process

For those of you who encounter this book having already started this process in some form, the chapters are designed to allow you to enter the process at any point, to review, revise, and redesign if necessary. For those of you who are just starting this process, it is important to follow each step in the order that we have outlined, as each step informs the next. Since the creative industries are constantly evolving, you will most likely need to update your portfolio package several times throughout your professional career. You may even want to modify or change your brand statement at some point. Politicians and pop stars remodel their images all the time in order to stay current with the times and sway popular opinion. As long as the work in your portfolio reflects your assertions about yourself and your work, you can do the same. Once you have completed the process at least once, it will be easy to go back at any time and rework your portfolio.

Note: Appendices at the back of this book provide resources and information on all topics and materials addressed in the text. These can also be found online at http://www.noplasticsleeves.com. Visit the website regularly for updates, new resources, and to submit your own portfolio or promotional work for a chance to be featured.

A DESIGNER KNOWS HE HAS ACHIEVED PERFECTION,
not when there is nothing left to add, but when

there is nothing left to take away.

ANTOINE DE SAINT-EXUPERY

Writer

EVALUATE & EDIT

This book is designed and structured to allow readers to move to any chapter and apply that aspect of the portfolio process to their work. For those who have never made and distributed a portfolio, the concerns addressed in this first chapter are essential to all of the design, editing, and construction decisions that follow. For those who have previously made a portfolio, what we ask you to consider in this first chapter can be used to evaluate your existing portfolio and guide you through changes you may need to make.

For those just starting out the process may be different, and in fact, this may be the hardest point in the process. It is at this point that you have to access not only your interests professionally, but you also have to take a hard look at your body of work and determine (a) if it is up to standard, and (b) whether it is relevant to the goal or target you have determined for yourself.

For individuals with an established career you may want to review and possibly redefine your target audience and work interest. Has this shifted, or changed? Can you articulate more clearly the kind of work and audience for your portfolio?

In this chapter: you will establish and define the goals for your portfolio and ultimately for your career. Once established, this then determines how you *brand* yourself. You need to begin by accessing where you are and where you want to go. What follows are some suggestions for considering your work and some exercises to help you get feedback and put things into perspective.

What Constitutes an Effective Portfolio?

By defining yourself—creating a brand, which then gets expressed through a visual design—you will take your work beyond a sampling of skills and capabilities. In this sense, it should capture not only your abilities, but also your attitudes and personality. By extending your visual identity to all the pieces in your comprehensive portfolio you can establish this message clearly and consistently, ensuring that your portfolio will stand out and be seen. Some of these aspects will vary with the individual and the goal of the portfolio. The portfolio, however, should function in the same manner as any piece of work you produce as a visual creative. It should be concise, effective, communicate an overarching concept, and hold the viewer's attention long enough to convey your message.

Evaluate, Edit, and Define

The most powerful way you can communicate your unique identity— your strengths and abilities—is through examples of your work. This is, of course, the heart of your portfolio. You need to make sure that every piece included in your portfolio is an example of your very best. That means that you should take the time to evaluate each piece and rework projects if necessary.

What constitutes an editing and evaluation process when you are examining your entire body of work? This differs from editing an individual piece of work. It is important at this very early stage to take a larger view that moves beyond considering individual pieces of work (or projects) . You should assess the sum total of the work that comprises your portfolio and assess how it fits into your intentions as a creative and career artist or designer.

Before you begin looking at the work itself there are key questions that need to be asked. To begin with, you need to make an assessment of your work as it stands, as well as consider your intentions for your career. We start by asking some basic questions. We also have some methods to spark your ideas and help you in evaluating and considering your work.

What is your audience? How would you characterize where you want to end up? In order for you to create an effective visual identity you need to first know what you want it to say. Who is the "client" for this portfolio?

For the Photographer

The photography market is a widely varied environment and you need to consider where you want to place yourself. If you are just beginning in your career there are resources available that can guide you in understanding the photographic market (see Appendix A, where we list some). Are you showing your work to editorial clients who might need to see some versatility? Are you targeting art buyers who might be looking for a cogent vision to apply to a specific account or campaign? If you have different bodies of work that represent different potential markets or subjects, you need to start by defining them.

For the Designer

The career goals of a designer can be somewhat different from that of a photographer. Designers are more often applying for a full-time position at an agency or firm. If you are already working in the industry, you may want to think about how your work can reflect your next intended career move. Are you presenting this work to creative directors who need to understand your abilities from the perspective of a particular kind of work (advertising, brand, publishing, web, etc). As a designer, do you need to show concept development because you want to be more than a production designer?

What is your area (or areas) of practice or specialty? How would you define your work? Does it fit into a particular category in terms of professional practice? Is there more than one category?

Visual character or visual style: What characteristics does your work communicate? Describe your work and its approach and style.

What skills and capabilities are featured in your work? Is there an emphasis on particular kinds of work or is your work more of a general representation? Are their examples that are out of character or unrelated to your intended audience and goals? Do you have process-based examples? Should these be included?

What is the standard for the work? Do the examples meet your criteria for concept, execution, coherence, and consistency?

Note: Rework!

You may have work that is worthy of your portfolio, but needs to be adjusted, improved, and refined. It is never too late to do this, especially if you recognize changes that need to be made after having had some time away from a project or assignment. Never let a subpar piece of work slip in. If someone reviewing your work questions a project, then you need to address this, or at the very least confirm with another set of eyes what might need changes.

Perhaps many of your portfolio pieces come from college assignments or client work, which although strong, may not necessarily be the best representatives of the type of work you want to pursue. You may want to consider eliminating work that you feel deviates from your intended goals or audience and create additional portfolio pieces that take you in the direction you want to go.

How to Start: Describe Yourself as a Creative

Start by writing down a list of adjectives and adverbs that describe you and your creative self. Begin by looking inward for these qualities. Describe your personality, your work ethic, your sense of style, your strengths, your attitudes, and the kind of work you enjoy making. Consider how best to position yourself given the kind of work you've done and the kind of work you want to do. What are your unique talents, conceptual abilities, and skills?

Exercise: Reverse View/Reverse Roles

View yourself as a new client who you are trying to access. You are being asked to make a branding and identity piece that features the work that this client produces. What are the questions you would ask if you were hired to design or photograph for yourself?

Help: Get Feedback

You should solicit as much feedback about your work as possible. Seek out the opinions of industry professionals, professors, clients, and peers. In addition, industry associations, such as AIGA (the professional association for design) and American Society of Media Photographers (ASMP), often organize professional portfolio reviews whereby you can receive feedback from a variety of professionals in your field. Ask for someone's honest opinion; constructive criticism is more valuable than simple praise. Ask specifically what could be improved. Remember that nothing is ever perfect and you should strive to learn and grow. As always, you should consider feedback carefully and make up your own mind about whether or not the opinion of someone else is valid and applicable to your project goals.

How much work should a portfolio contain? At this stage of the process, you probably will have a selection of works that you feel will be suited to your portfolio. As you develop your brand and visual identity, this may shift and you may add or eliminate works. Initially, you may want to hold work for consideration until you are clearer about the direction the portfolio is taking.

While the intended audience and goals for the portfolio can determine the scope and content of the projects, there is still a question of quantity. There is not a set standard, however. You want to consider both what is practical and what is most effective in reaching the viewer of your work. For a student just graduating from school, the average is 8–15 well-developed pieces. Photographers should show cogent consistent groups or series of images. Designers, as well as photographers, should show work that presents capabilities, range, and some aspect of your voice and vision. A designer may include process-related materials that reflect concept development, sketches, and comps.

A well-thought out portfolio should tell a story about you. It should be a journey that displays your talent, thinking, and abilities and it should have a beginning, middle, and end. Lead with a particularly strong piece in order to make a solid first impression. But also end with a strong piece, as this may leave a more lasting impression than the first. Imagine someone going through your book. What is the journey upon which you want to take the viewer? Imagine that you are there with them and they are flipping through your book and asking you questions about you and your work. What kinds of questions do you want them to ask? What pieces do you want them to spend more time on? What pieces do you want to emphasize, or are particularly proud of? Designers, as mentioned, can also show projects at multiple stages—concept, sketching, design mock-ups, finished piece.

At this stage, you are trying to get to a set of works that can help you formulate your brand statement. You are assessing your work to see if it is suitable to your goals and to aid you in developing a visual identity that can be characterized by your work and through your work.

Here are three guidelines:

Concise: What are the fewest number of pieces that effectively convey everything you wish to suggest about yourself as a designer/ photographer? Can you create the most concise statement? In fact, this might be a starting point. You need to bear in mind that if you have too many pieces, the impact of individual works can get lost. As the viewer of your portfolio looks through it, an impression can be built cumulatively. Once you establish this, you don't need to go any further.

Convincing: What quantity will demonstrate that you are capable of the scope of work and production required for your intended goal? What will show a viewer definitively that you have the goods and chops to do the job?

Clear: Show too many pieces and the viewer will lose the thread about you. The pieces will get lost in the breadth of the portfolio. You want the viewer to be seeing a statement that builds on itself. If it gets too lengthy, he or she will not be able to tie everything together, nor does it show your ability as a developer of tight concepts.

How to Sort Your Work

To start, take out any pieces that appear to be redundant, or offer essentially the same idea, demonstration, or method. If they simply repeat something that is already well presented, you should consider removing them.

Can the portfolio work without a piece? Having made an edit of your work, consider taking out a piece or two. Can the portfolio function without them? If so, they don't need to be there. Continue this process until you can't remove any more pieces without making the portfolio appear fragmented, or incomplete.

Having done this first step, the next chapter will take you beyond sorting and organizing the work you have to begin the process of "branding yourself." You will further examine what you offer as an individual visual creative and will revisit some of the questions raised in this chapter, but with greater focus on characterizing yourself further. In this way you will distinguish who you are and your qualities as a creative, leading to the development of an identifiable "brand."

SIMPLY DO GOOD WORK.
UNDERSTAND THAT THE ULTIMATE VALUE OF YOUR WORK IS TRUTH, WHICH IMPLIES A SENSIBILITY OF TRANSPARENCY AND CLARITY.

RICHARD GREFÉ
Executive Director, AIGA

Q&A: Interview with Mary Virginia Swanson, Marketing Consultant and Educator (© 2009, Mary Virginia Swanson)

As a consultant to photographers who are trying to extend their work and build their careers, how important is a printed portfolio versus an online portfolio?

While many designers tell me they make the decision to work with a photographer from reviewing their website, their client may well require showing a proper print portfolio prior to any decisions. I believe one must have both available, each different from the other, designed to be effective in their respective viewing context.

What do you recommend that a photographer have as part of a comprehensive package of his or her work?

First and foremost: great work! Second: A clear brand identity that appears consistently through every element in every format. Print: identity components, mailer, portfolio. Online: website, e-mailers, and possibly e-newsletter.

What makes for a good portfolio? Should it have an overall vision, concept, or a visual identity beyond an edit or series of strong images?

It is generally true that within smaller markets one must have a broad technical and creative "toolkit," to secure the diverse range of commissioned work one town or city has to offer. I would demonstrate the ability to tell a story through your images, in multiple presentation formats.

When competing in a larger market, with a broader range of clients and needs, specializing will help to rise above the pack. If you are a specialist—color, lighting, portraiture, conceptual, whatever it is—if you are one, present your strengths. Whatever your strengths, broad capabilities, or distinct style/technique, every single image you show must be memorable.

How much work do you like to see?

Less is more. It is better to show 10 outstanding photos instead of 20 with some that should not have been included. You can always tell when it was a stretch to grow a portfolio up to 20 images, and when I see portfolios with 25, 30, even 35, I'm editing it in my mind as I'm viewing it ... not a great first impression to make.

How important is the brand or overall visual identity of the portfolio package (including book, website, resume, business card, etc.)?

Essential. First, great work, second, great graphic identity. One that reflects the attributes of YOU and your brand. Successful brand graphics are the result of an inquiry — about you, your strengths, the message you want clients to know about you before they commission you. Is the feeling you want to convey young, hip and modern — "of the moment" and fun to work with? Do you want to appear classic, confident - a solid brand, who always delivers? Does a graphic logo add to their understanding, or is your name with type/color treatment a stronger, more memorable element? I always encourage professional help with branding, from someone or a firm that will go down the path of inquiry pre-design, or at the very least, the advice of branding masters.

Do you have any advice for students or recent grads who are just starting out in the industry/their careers?

Put yourself in a professional situation where you will be constantly learning, where you will overhear the language of your industry, and thus gain a more realistic overview of doing business in today's economy. Mentor with someone who will help you understand negotiations from both sides of the table.

Stay current with technology and with trends. Read your industry trade publications, and those of your targeted clients. Attend lectures and trade shows—hear others talk about their creative practices and business practices. The great artist who understands business will have a far better chance of succeeding. Stay creative—take workshops, exhibit your work, attend portfolio reviews. Don't ever stop pushing yourself to create new work, whether the commissions are coming your way or not. It is your personal work that will be the backbone of your creative skills for your clients.

Q&A: Interview with Richard Grefé, Executive Director, AIGA

Richard Grefé is the executive director of AIGA, the oldest and largest professional association for design in the United States. Prior to joining AIGA in 1995, Mr. Grefé crafted books at Stinehour Press, spent several years in intelligence work in Asia, reported from the Bronx County Courthouse for the Associated Press, wrote for *Time* magazine, and managed the association responsible for strategic planning and legislative advocacy for public television. Mr. Grefé earned a B.A. from Dartmouth College and an M.B.A. from Stanford Graduate School of Business.

How important do you feel an online and/or print portfolio is in securing a creative position in the design industry?

There are probably four attributes that every student or young designer need to convey in pursuing a job: breadth of knowledge, because design is now about content and context, as well as form; attitude, in terms of being curious, willing, and committed to creating effective communications for very specific audiences; the ability to give form to ideas; and an ability to divine clear objectives from a client's brief and to serve those objectives. The last two are well represented in a portfolio that includes an articulation of a business problem, a proposed solution, and a discussion of the approach the designer used to address the problem. This can be accomplished in either digital or print form.

How important do you think a brand or overall visual identity is in the success of a portfolio design?

To the extent that a portfolio is a means of demonstrating the talent of an individual in branding herself, a well-conceived approach to a portfolio is smart, so long as it is not too contrived (in which case it can draw attention away from the work).

Where do you think current trends in design are leading?

Design can be a major contributor to creating value in the knowledge economy. However, it will depend on communication design being conceived as communicating with form, content in context over time. This means that designers must be conceptual, strategic, and multidimensional. They must be able to work across media seamlessly in finding ways to succeed in communicating on the part of their clients. And, increasingly, they must find ways to tune their sense of empathy to other cultures, for the design economy will be a global enterprise in which different cultures will be a critical element of understanding audiences.

Do you have any advice for design students or recent grads trying to break into the industry?

Simply do good work. Understand that the ultimate value of your work is truth, which implies a sensibility of transparency and clarity. If jobs are difficult in the private sector, find ways to help in areas of social engagement; it will be rewarding and give you an opportunity to demonstrate what you can do to change the human condition. Be patient, remain passionate, and even difficult times will pass.

Q&A: Interview with Joe Quackenbush, Associate Professor of Design at Massachusetts College of Art and Design

Joe Quackenbush is an associate professor of design at Massachusetts College of Art and Design in Boston. He has an M.F.A. in graphic design from the Rhode Island School of Design and a B.A. in English from Oakland University in Rochester, MI. He is president of Jam Design Inc., an interactive and print design studio based in Boston. Professor Quackenbush has also taught courses at The Rhode Island School of Design, The University of Hartford School of Art, and Clark University. He recently co-organized the 2008 AIGA design education conference entitled "Massaging Media 2: Graphic Design in the Age of Dynamic Media."

Do you teach a portfolio or promotional materials type of course? What's the course name? What level is it geared toward? Is it a required course?

I do not currently teach a portfolio class. However, I work regularly in helping my students to develop and learn how to present a project as a potential portfolio piece, particularly in interactive classes where the final product is really a small part of the overall process that the students need to convey. We do have a required portfolio class (titled simply "Portfolio"), which is the final senior studio course in our program, offered only in the spring.

What do you think makes for an outstanding portfolio?

- A diversity of projects that include drawing, motion and interactive work, and multiple print pieces that include branding, identity, systems, and expressive projects.

- Lots of process work, preferably in a form that shows the progression of a concept from rough initial sketches to final polished form. I feel strongly that there is too much emphasis on final product and not nearly enough emphasis on a student's process.

- Evidence of collaborative work with other graphic designers and students or business executives from diverse fields.

- Evidence of real-world client work, even if it was conducted during a class.

How important do you feel a print and/or online portfolio is in securing a job in the industry?

Based on everything we hear from the industry and what recent alumni relate, an online or digital portfolio, such as a PDF, is absolutely essential. The days of large boxes custom designed to hold eight or nine projects simply is not practical anymore. We hear repeatedly that books are an increasingly requested form of portfolio presentation.

How important is the brand or overall visual identity of the portfolio package (including book, website, resume, business card, etc.)?

Essential. Graphic designers are in the business of presentation and persuasion. A coherent identity among all facets of a portfolio should be baseline expectation.

In general, how many pieces of work do you think a student should include in his or her portfolio?

For a PDF, book, or web portfolio, I recommend students have between 10 and 12 projects.

Do you have any advice for a student currently working on his or her portfolio and/or promotional materials?

- Work with all your instructors, not just your portfolio instructors, to develop your portfolio.

- Try to work with a writer or editor to make sure your resume and any text you may be writing to support your portfolio is crisp, clear, and free of grammatical errors.

- For interactive projects, make sure to explain the entire process of developing the project clearly. Too often students simply show a click-thru prototype and fail to discuss the research and analysis that helped shape the final project.

INDIVIDUALS, COMMUNITIES, AND ORGANIZATIONS EXPRESS
THEIR INDIVIDUALITY THROUGH IDENTITY.[1]

ALINA WHEELER
Author, *Designing Brand Identity*

BRANDING

funny
serious
energetic
intense
focused
creative
organized
easy going
sarcastic
outgoing
innovative
daring
charismatic
smart
playful
confident
eclectic
enthusiastic
imaginative

The primary function of your portfolio is to present a collection of your best work in order to communicate your experiences and capabilities, in hopes of securing a position or client. While this purpose cannot be forgotten, your portfolio can also be taken much further. It can become a quintessential marketing piece in and of itself. In doing so, it has the potential to make a more impactful and memorable impression on its intended audience. Your ability to develop ideas and market yourself is not only relevant to working in the creative industries, but it can provide a much-needed advantage in such a competitive field. This is especially important for students and recent grads who have not yet had as many opportunities to distinguish themselves in their careers.

In this chapter, the process of defining and developing a brand will be outlined as related to the development of your portfolio. This chapter will address the following issues:

How do you move from an assortment of work to a clear and concise brand statement?

How do you utilize a process of self-discovery to create a brand statement that can be used as a touchstone in the creation of your entire portfolio package?

First, consider where you are in this process. If you:

- *Already have a clear concept or idea for the direction of your portfolio:* Use this chapter to reflect and evaluate this idea as it represents and positions you within your field. Developing a brand statement can't hurt—the clearer you are about how to position yourself within the industry, the better you'll be able to do just that. **Keep in mind (especially for those of you who do not have a design background) that you can develop a brand statement without developing a corresponding brand identity.**

- *Already have a brand and corresponding brand identity:* Use this chapter to reevaluate it. It may be time to analyze your current brand's strengths and weaknesses, refreshing or changing it if need be.

- *Don't know what to say and/or how to say it:* Use this chapter to begin a process of self-discovery, defining and shaping your brand position. The work in your portfolio may not be enough to take you where you want to go. While it's difficult to define something, let alone oneself, in the long run it will help you to have a statement that you can use as a touching point in the development of your portfolio design.

A brand is an attitude. It is a symbolic statement comprised of descriptive qualities that aim to express the heart and soul of an individual, company, or product. These qualities are typically defined by a set of *brand attributes*—a list of descriptive words and phrases that have the power to describe style, tone, and personality; establish connections and associations; and shape emotional reactions. Brands attempt to project certain expectations and promises in the hopes of establishing an emotional and intellectual connection with their target audience. Truly successful brands are able to deliver on those promises through the value that the individual or company provides. Such brands express and establish a specific attitude that is identifiable throughout their particular market.

Think about the clothes you wear, the music you like, and the products you buy. Among all of these things you have choices you make based on certain attitudes and qualities that appeal to you. In some ways, these things even go so far as to define aspects of who you are and the broader culture that you belong to. The most successful brands often become timeless icons of culture—think VW, Coca-Cola, MTV and Apple.

A strong brand should:

- *Differentiate:* Stand out from your competition.

- *Be authentic:* Communicate a message that is relevant and meaningful to your intended target audience.

- *Be memorable:* Consistently communicate a clear and concise message.

A brand is the sum of the good, the bad, the ugly, and the off-strategy. If is defined by your best product as well as your worst product. It is defined by award-winning advertising as well as by the god-awful ads that have somehow slipped through the cracks, got approved, and, not surprisingly, sank into oblivion. ... Brands are sponges for content, for images, for fleeting feelings. They become psychological concepts held in the minds of the public, where they may stay forever. As such you can't entirely control a brand. At best; you only guide and influence it.[2]

— Scott Bedbury, Author, *A Brand New World*

This means that everything you use to represent yourself will in some way define you—the work in your portfolio, the design and craft of your portfolio, how you conduct yourself on an interview, your resume, your website, and even how you compose an email.

Research and Analysis

- Find out about your target audience: What are they looking for?

- Find out about your competition: Who are you up against?

- Analyze your current brand's strength and weaknesses (if you already have one).

Check out our website or see Appendix A for a list of industry sources.

YOU NOW HAVE TO DECIDE WHAT 'IMAGE' YOU WANT FOR YOUR BRAND.
Image means personality.[3]

DAVID OGILVY

Author, *Ogilvy on Advertising*

Defining Your Own Brand Attributes

A good place to start thinking about your own brand statement is by reflecting about the work you've done, the person you are, and the creative professional you want to be. In order to do this, there are some key questions that you should ask yourself. Write down the answers that you come up. Trust yourself and listen to your intuition throughout this process. You should also think about getting the opinions of others whom you trust. Ask faculty, clients, fellow designers, photographers, artists, etc., how they would characterize the work you do and the creative person they perceive you to be. Ultimately, you want to focus in on descriptive key words—adjectives and adverbs that can begin to define your brand statement.

Reflect on Your Work

Ask yourself some key questions:

- What kind of work do you like to do?

- What kind of work do you do best?

- Was there a particular project that you really enjoyed working on?

- How would you define your talents and skill set?

- How would you describe the styles, forms, and concepts with which you prefer to work?

- How would others describe your talents and the work you do? (If you don't know, ask.)

- What does your body of work say about you?

- Is there something missing from your body of work that you think you need?

Reflect on Yourself and Interests

Ask yourself some key questions:

- How would you describe yourself as a creative professional?

- How would you describe yourself in general - your personality, work ethic, beliefs, etc.?

- How would others describe you? (If you don't know, ask.)

- Are these qualities communicated through any of the pieces you've worked on?

- What do you have to offer a company or client?

- What types of experiences engage you?

- What do you find most interesting about the world around you?

- What do you find most interesting about photography, art, and/or design?

- Whose work influences, attracts, and inspires you? Why?

Reflect on Your Future

Ask yourself some key questions:

- What kind of work do you want to do?

- What kind of creative do you want to be?

- Are you doing the kinds of things now that you want to be doing in the future?

- If not, how can you position yourself to get to where you want to be?

- What kind of company or client do you want to work for?

- What kind of company would fit your lifestyle? Are there compromises you are willing or not willing to make (travel, moving to a different location, long hours, etc.)?

- Where do you see yourself in one, two, or five years?

- Is there someone in the field who you admire? Would want to emulate? Why? How did they get to where they are?

This is your opportunity to invent yourself for the first time, or reinvent yourself all over again. Think about where you'd like to be two years from now. How about five or ten years? People change jobs and even careers often throughout their lifetime. Now is the time to think about what you want out of your career.

By defining what you show based on what you truly are and what you want to do, you create a self-selection process: you are *not* for everyone. You are *different*. Be courageous enough to show that you see in a way no one else does.[4]

—Doug Menuez, Photographer

There are many different places where one can find sources of inspiration. Keep in mind that you can't create in a vacuum. Find what will help get your creative juices flowing.

Looking Outward

Try looking outside of yourself for things that inspire and appeal to you. Go to museums and galleries; browse the shelves at libraries and bookstores; flip through industry magazines and online portfolios. Look at the work that other people have made and ask yourself whether or not you want to create similar work. If so, try to define what you are looking at or experiencing. Try to figure out what characteristics define a particular piece that you are drawn to. What makes it stand out? What makes it meaningful to you? What does it communicate about the artist who made it? Try to be conscious of the various visual things that you are drawn to: patterns, signs, graphics, images, films, typefaces, or anything else to which you feel a connection. You should take some time to explore the things around you.

Genres and Styles

While there are many places from which to draw inspiration, an easy place to start is with a "history of" anthology or "style" book. These types of books explore numerous genres throughout the history of a particular discipline. You'll find artists who have explored any number of concepts, styles, and techniques. You may find that you are drawn to the postmodern, deconstructed typographic styles of *Ray Gun* and *Fuse* in the 1990s; or the vibrant psychedelic posters of the 1960s; or the sardonic images of a 1930's photomontage. Perhaps you will connect with the clean, clear "objective" design of the Swiss Typographic style or the expressive illustrations of Push Pin Studios. Perhaps you will be drawn to American modernism and the abstract, symbolic graphics of Paul Rand, Lester Beall, and Saul Bass. Maybe still, a painting will inspire you, or a landscape, photograph, texture, or pattern.

Photographers should look to both photo history as well as contemporary approaches found in commercial photographic production. Perhaps your work is more in keeping with the late 20th-century study of typologies coming out of German photography or you like the freewheeling framing of Winogrand. Look to fashion photography, which has always repurposed historical forms such as: reportage, early color, alternative process, Polaroid, snapshot aesthetics, and plastic or alternative cameras.

Explore a variety of mediums and forms in your search for inspiration. If a particular genre or artist inspires you, try to determine what it is about their work that you find so appealing. Think about how this is or is not reflected in your own work and the type of work you want to do. Does a particular design style match up with how you define yourself and your work? Will referencing it help communicate your unique qualities as a creative individual?

Process

Keep a sketchbook of inspiration as you search and explore. This process may take some time. If the end result is to be meaningful, it is important that you define a brand that is reflective of your own unique vision, talents, abilities, and personality. In the end, you should feel confident about your own creative identity.

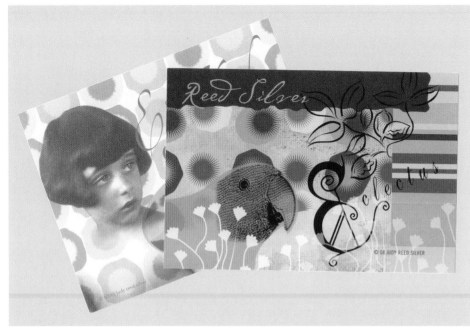

The girl in the image is my mother-in-law from 1930. The bird was my wonderfully goofy pet ecelectus parrot, Saul. The patterns used here are not of a particular era; even though I do get inspiration from vintage colors, patterns, etc., I try to make the patterns/colors fit the subject. I generally like to work with bright colorful patterns in my pieces as a layering effect, incorporated with painted backgrounds.

—Judy Reed Silver

JUDY REED-SILVER, PROMOTIONAL MATERIALS, Calabasas, CA.

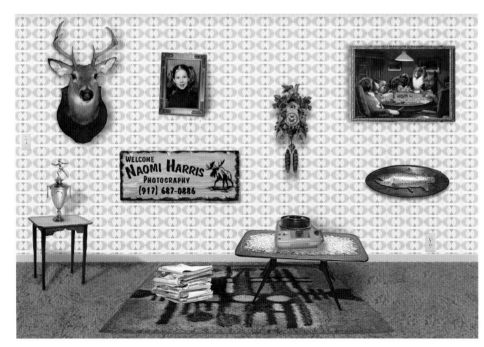

NAOMI HARRIS, PORTFOLIO WEBSITE, New York, NY.
Naomi's website plays with the look of 1970's kitsch.

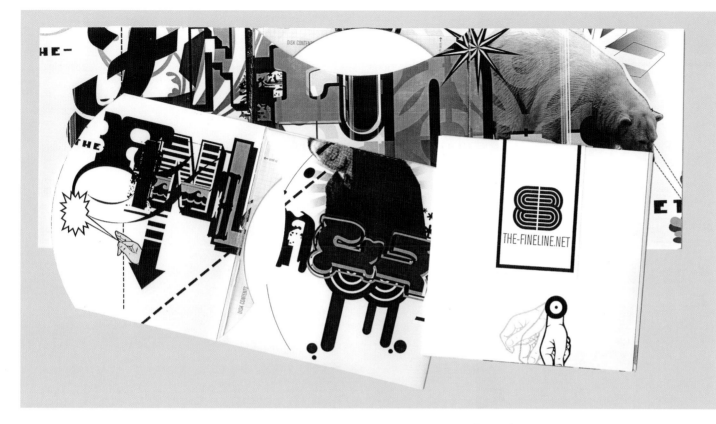

This piece, influenced by postmodern digital and urban graffiti trends, combines graffiti and digital type, comic book symbols, bold shapes, symbols, lines, and eclectic cutout images to communicate a dynamic, raw, and experimental feel. Keeping the design limited to grayscale helps to unify all the elements together into one cohesive piece.

KENNY KIM, STUDENT PORTFOLIO AND PROMOTIONAL MATERIALS, Kansas City Art Institute.

Trends

Consider that certain industries tend to align themselves with certain trends. Think about what is popular in concept and style for the moment. Look to industry leaders, organizations, and publications to find articles and visual examples of what is being called the "latest and greatest." Consider trends not only from the market you are currently in, but also trends evident in the industry that you want to break into. Ask yourself: What concepts, visual forms, or attitudes are being represented? Then consider if you are already aligned with these or even if want to be.

SOLVITA MARRIOTT, STUDENT PORTFOLIO,

Tyler School of Art.

Solvita's portfolio concept emphasizes her creative process and the things that inspire her. Her book design makes reference to a Victorian-style book aesthetic, making associations to the value and respect afforded such of book of that era. Indeed, the craftsmanship of this book is exquisite. A subtle faux foxing technique further affords the piece a more antique look.

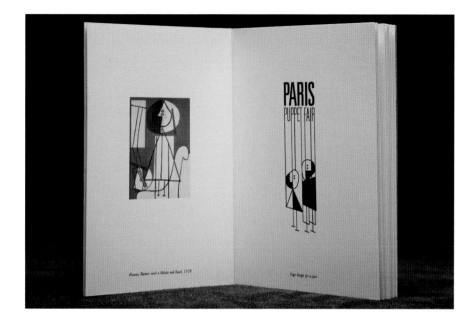

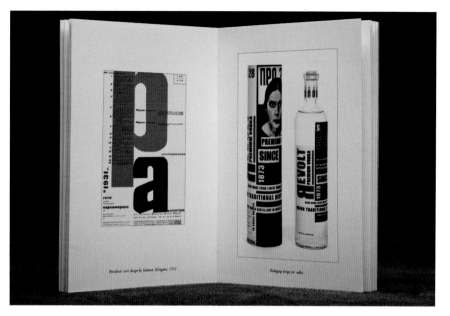

While working on ideas for my portfolio book I was looking for a
common thread that would bring together my different projects.
I noticed that many of my solutions were rooted in history, inspired
by a certain art movement, or referenced an image I had seen
somewhere while researching for my projects. I decided to make this
the theme for my portfolio book. I selected and compared my projects
(that had the most obvious inspiration) to the historical reference or
original image that influenced the end product. I wanted the viewer to
feel the special connection to the history and tradition that inspired
my designs.

— SOLVITA MARRIOTT

Q&A: Interview with Kristen Bernard, Graphic Design Student, Endicott College

Kristen Bernard expects to graduate in May 2010 with a B.F.A. in visual communications (concentration in graphic design), and a minor in communications. Kristen has interned at EBSCO Publishing in Ipswich, MA, and freelances as an associate designer for the firm Visual Communications in Lowell, MA. She is an active member of Endicott College's AIGA student chapter. Check out Kristen's website at *http://www.kristenbernard.com/*

Were you a student when you created this piece? Was it created in response to a course assignment?

At Endicott, we are all expected to complete a portfolio class, where we create a book, website, and other materials. In one assignment, we were directed to "brand" our design style. This was challenging because we had to develop a concept that reflected our individualism, style, and taste for design. To arrive at my concept, I listed some words I thought described who I was and how I designed. I came up with words such as "clean, organized, structured, bold, and balanced." With these words in mind, I began thinking of the " + " sign with its balance and structure to inspire my book.

How did you arrive at the idea or concept behind your piece? What do you think it communicates about you?

With my cover design, I wanted to demonstrate that I could be counted on for solid graphic design skills—focusing on type, layout, and color. I wanted to communicate a formal, clean, and structured look. For this reason, I choose to reference the Swiss International Typographic style for my inspiration.

What was the most challenging part about creating this piece?

The most challenging piece to this assignment was trying to target who I am as a designer. With limited professional experience, I relied on examining my personality to come up with my "brand." However, as my personality grows and evolves, I would expect my design to grow and evolve as well.

Who have you sent it out to? How did you send it? What did you follow up with (call, email, etc.)?

As of now, I have not distributed the book to anybody, but have used the resume and an invoice design regularly since December 2008. Resumes were usually printed on a thicker paper stock or emailed as a PDF, and I plan to follow up with both email and phone call.

Do you have any advice for a student currently work on his or her portfolio and/or other promotional materials?

Any advice I could pass on: Collect any design materials you admire, are inspired from, or are generally attracted to, and tape them into a sketchbook. Subscribe to creative publications and become a member on design-based websites. In addition, you may really love an idea you are working on, but be prepared to throw it away and start from scratch if you find yourself going nowhere. Don't force anything.

KRISTEN BERNARD, STUDENT PORTFOLIO, Endicott College.

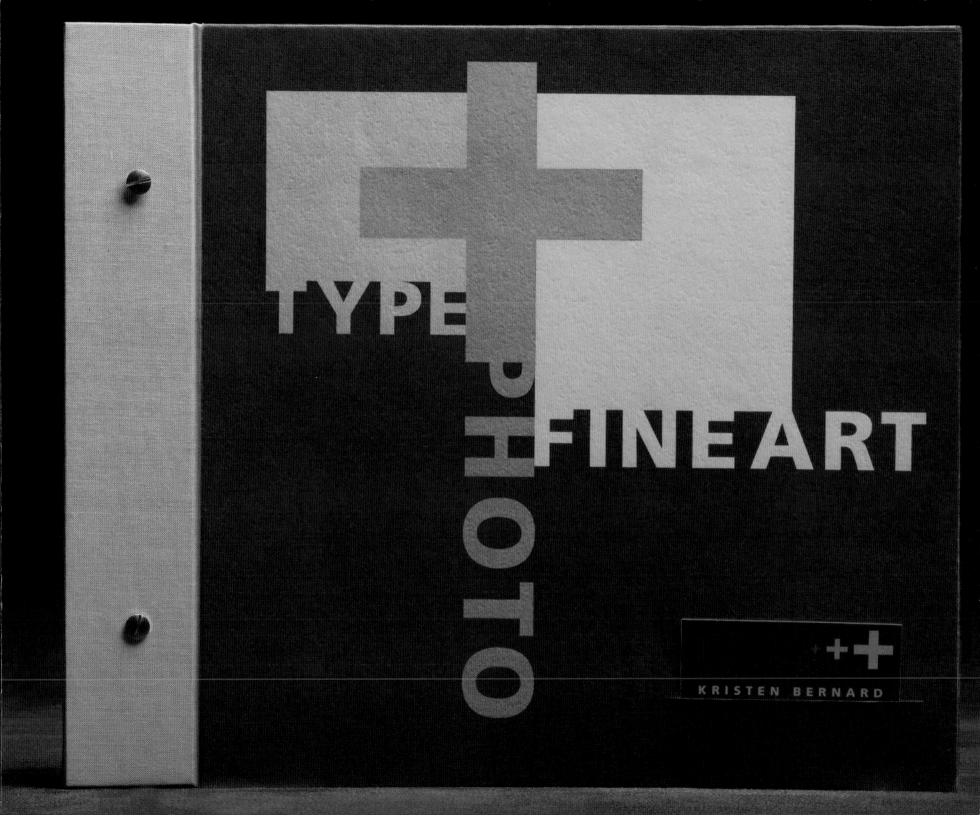

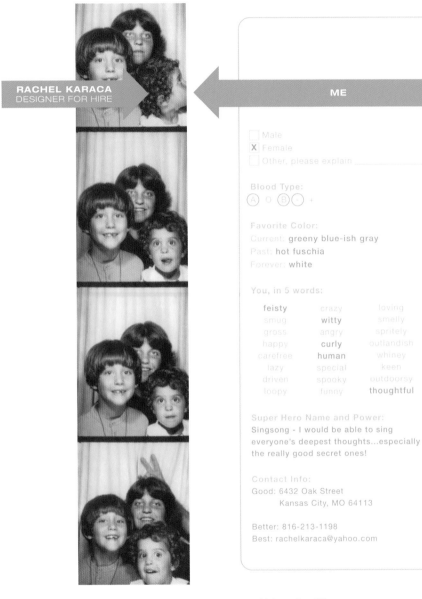

RACHEL KARACA
DESIGNER FOR HIRE

ME

☐ Male
☒ Female
☐ Other, please explain _____

Blood Type:
Ⓐ ○ Ⓑ ⊙ +

Favorite Color:
Current: greeny blue-ish gray
Past: hot fuschia
Forever: white

You, in 5 words:

feisty	crazy	loving
smug	**witty**	smelly
gross	angry	spritely
happy	**curly**	outlandish
carefree	**human**	whiney
lazy	special	keen
driven	spooky	outdoorsy
loopy	funny	**thoughtful**

Super Hero Name and Power:
Singsong - I would be able to sing
everyone's deepest thoughts...especially
the really good secret ones!

Contact Info:
Good: 6432 Oak Street
 Kansas City, MO 64113

Better: 816-213-1198
Best: rachelkaraca@yahoo.com

RACHEL KARACA, STUDENT PORTFOLIO, University of Kansas.

How to Identify Key Brand Attributes

However you come to determine your brand qualities, you will want to narrow down your list and focus on about three to five descriptive words. Choose qualities that best represent your unique capabilities and attitudes. Think about how you would envision translating these qualities into a more tangible "look and feel." Try to choose brand qualities that will lend themselves to creating a more **focused, positive,** and **memorable** impression that distinguishes you.

Words like witty, vintage, bold, intense, organized, daring, confident, imaginative, reflective, quirky, experimental, retro, edgy, outgoing, enthusiastic, focused, classic, raw, poetic, creative, playful, and wacky, are some choices you could use to describe your style.

A light-hearted and fun concept, this piece plays with the idea of identity. The design expresses Rachel's personality not only through the concept itself, but also through the copy and visuals used to support it. This unique concept and form is sure to stand out and be memorable. Indeed, it got her a job at Hallmark cards.

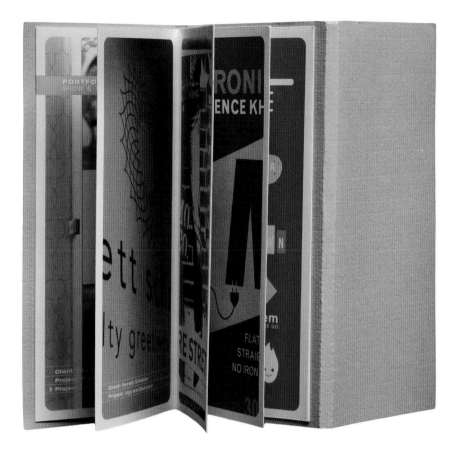

This little resume book is what I mailed to Hallmark Cards to get the position I currently (as of May 2008) hold as an associate art director for Shoebox, the humor division. I had to do something unexpected because they get over a thousand resumes a year. And the size was a result of wanting the piece to feel intimate and personal.

— Rachel Karaca

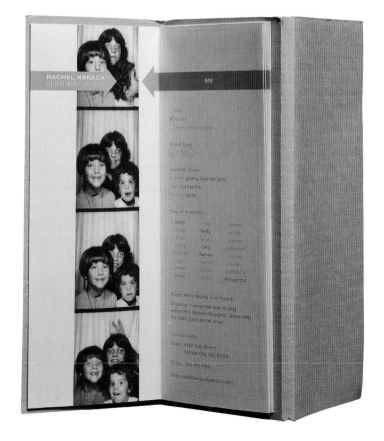

Brand Statements

A brand statement (sometimes known as a brand position) is a single statement that communicates quickly and succinctly the core values of an individual or company as they relate to its strategic positioning within a particular industry.

Personal brand statement: A single sentence that strategically promotes who you are, what you stand for, and what you're best at. It is a difficult process to develop such a statement as it challenges you to focus on your strongest positive attributes and then have the confidence to state them clearly and concisely. Be forward-thinking—take a stand, focus your message, and set yourself apart. A targeted message is guaranteed to make you more visible and memorable.

Don't worry about including *all* your talents and skills in this statement. You shouldn't include everything you can think of—this will only water down your message. Besides, there is a baseline level of skills and experience that should be true of most people in your industry. Such expectations should be demonstrated through the actual work in your portfolio. Your brand and subsequent portfolio design should, however, go above and beyond a generic description and focus on what makes you special. It's better to be targeted and have something more unique to say than to be too generalized and like everyone else.

Your brand statement will be used as a guide, a touchstone, in the expression of your portfolio concept and design. A personal brand statement can also provide the basis for the development of a visual identity if you decide to create one.

Sample statement:

I am a [state professional title (photographer, graphic designer, illustrator, etc.)] **with strong** (amazing, leading, etc.) **skills in** [list core skills] **who is** [list brand attributes (qualities)].

Exercise: Brand Book

Need help? Think about your brand like you're telling a story about it – one that captures the essence of who you are as a creative professional. In advertising, most brands have a "brand book" that tells their story. Check out Appendix A or our website for resources.

A brand book is the story and personification of a brand—it's ethos. It answers the questions: What does a brand sound like? Feel like? Look like? What's its purpose? It's mission? How is it different from its competitors? What's its unique personality and characteristics? How does it think and perceive the world? How does the world perceive it? Through visual elements and copy a brand book tells its story—written in the first-person narrative form as if the brand (or company it is representing) is speaking.

— Christine Pillsbury, Creative Director, Beam Interactive and Relationship Marketing

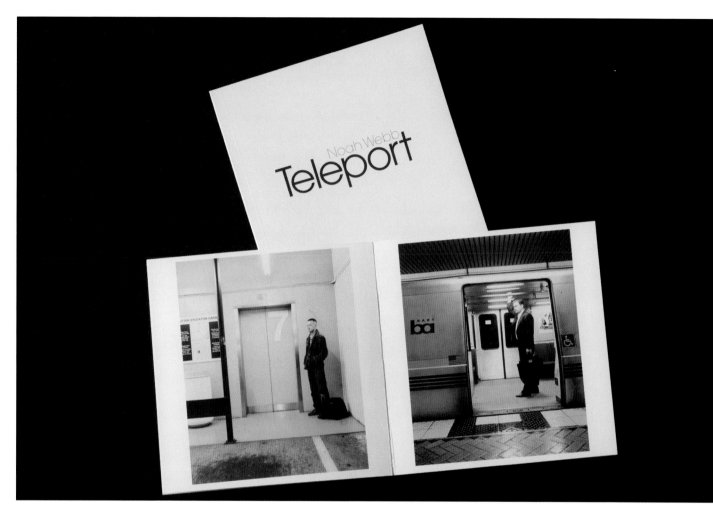

Noah Webb's promotional book is characteristic of clean, modern design. The typeface used is ITC Avant Garde, which was designed by the masterful Herb Lubalin as a logotype for a magazine collaboration. Its geometric precision references the postmodern art deco of the 1960s.

NOAH WEBB, PROMOTIONAL BOOK, CA.

Q&A: Interview with Will Bryant, Recent B.F.A. Graduate, Mississippi State University, Mississippi State, MS

Will Bryant makes stuff as a freelance creative at the shared studio space *Public School* in Austin, TX. Will is primarily an illustrator and artist, but also enjoys identity and print design. He graduated from Mississippi State University in 2008 with a B.F.A. in graphic design. Check out his website at *http://www.will-bryant.com/*.

Were you a student when you created this piece? Was it created in response to a course assignment?

Yes, my final semester of undergrad (December 2008) at Mississippi State University. As an existing senior graphic design student at MSU we are required to create a self-promo. Typically, these are difficult and expensive to reproduce.

How did you arrive at the idea or concept for your piece? What do you think it communicates about you?

I wanted to create something I could easily reproduce in order to distribute to more people. My inspiration came from Frank Chimero's "The Small Print" book. He was very helpful (always is)!

I think it definitely showcases my personality and infatuation with hand lettering, bright colors, and light-hearted content.

Did you target a particular area of the market or industry with this approach?

Yes and no. It definitely showcases my illustration work more than design, so I'm planning on self-publishing another book to showcase that aspect of my skills.

What was the most challenging part about creating this piece?

The hardest part was definitely laying it all out. I didn't take the time to really edit myself or construct a systematic way of ordering the book, which I will definitely do in the future.

Who have you sent it out to? How did you send it? What did you follow up with (call, email, etc.)?

I've sent my portfolio to WK12, Decoder Ring, John of Advice to Sink in Slowly, Chris of Gorilla vs. Bear, and Domy Books. I just mailed it in a standard envelope and included a print among other brightly colored collateral (buttons and moo cards).

I've definitely followed up with email for the most part. I've visited the fine folks at Decoder Ring, and I would say meeting in person is the best.

What was the response?

Generally it has been very pleasant. Most people are genuinely impressed and it has sparked an interest to use Lulu for their own projects. On the other hand, I haven't landed a full-time job from this book. It is getting recognition and selling well ... so high five!

Do you have any advice for a student currently work on his or her portfolio and/or other promotional materials?

Definitely try to showcase both your work and your personality.
Depending on what you're wanting to do in a creative field, that resume of yours can be secondary to the creation of your portfolio. Having it as a separate piece that just slips in something has been really nice. I've been able to show my book and then just leave behind a resume.

WILL BRYANT, STUDENT PORTFOLIO,
Mississippi State University.

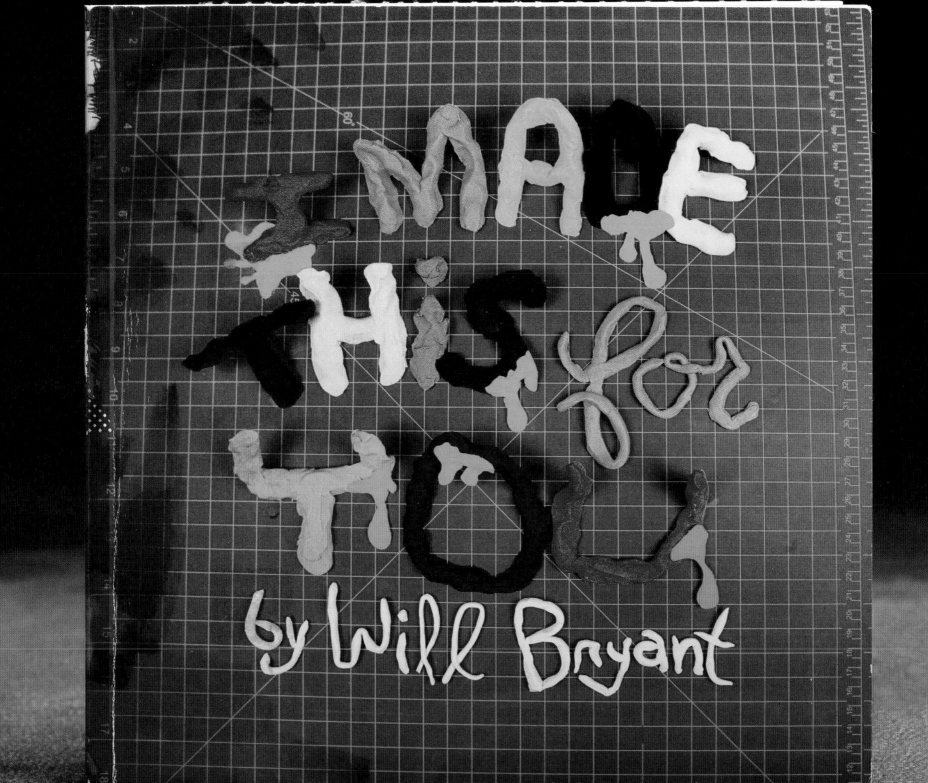

Design must seduce, shape, and perhaps more importantly, evoke an emotional response.

— April Greiman, Influential Designer

While brands speak to the mind and heart, the brand identity is tangible and appeals to the senses. Identity supports, expresses, communicates, synthesizes and visualizes the brand.[5]

— Alina Wheeler, Author, *Designing Brand Identity*

Once you have created a brand statement, you can begin to think about the visual and verbal properties that will best communicate your message. For some of you, that may develop into a brand identity.

A *brand identity* consists of both visual and verbal properties that work together to create a tangible representation of the qualities outlined by the brand. The best brand identities are **memorable**, **authentic,** and **differentiate** themselves from their competition. They assert the brand attitude with confidence and enthusiasm.

Note: A Brand Identity isn't for Everyone

The following discusses the traditional components of a brand identity. Depending on your specific discipline and relevant goals, some of these aspects may not be applicable to your needs. You don't, for example, need to create a company name or logotype in order to create a successful identity for yourself and your portfolio. In fact, many of you may decide not to create a formal, visible brand identity at all. However, with that said, it is still a good idea for you to have an understanding of how and why a brand identity is used and relevant to the development of your portfolio. *At the very least you should consider a visual aesthetic that will work best to represent you*—strategize and develop at least some visual and verbal properties that can remain consistent and be used *effectively* to communicate across multiple forms and mediums.

Even if the brand identity is not published or visible, to have one, to work to create one, is vital for making a coherent book. It is the guiding light that shapes the "flavor" of what one chooses to include in any portfolio.

— Valan Evers, Photographer and Faculty, The Art Institute of Fort Lauderdale

Verbal Components

The most prominent verbal components of a brand identity typically include name and tagline. However, all copy written for advertising concepts and marketing purposes contributes to a brand identity. Such copy communicates a specific *tone of voice* and *attitude* relevant to the brand. Keep in mind that a message is only ever as good as its delivery. While you probably don't need a company name or tagline (your own name will suffice) you should think about differentiating yourself with some engaging copy—perhaps simply as the title of your book.

The following examples (taken from portfolio and promotional pieces in this book) demonstrate effective copy; that is, the title is an integral part of the portfolio's brand and concept and works well to differentiate the book.

- *Body of Work* by Jessica Hische
- *Blood Makes the Grass Grow* by Anthony Georgis
- *I Made This* by Will Bryant
- *A Little Book of Inspirations* by Solvita Marriot

Visual Components

Key visual brand components typically include a logotype, specific color palette, particular stylization of imagery/iconography, and typographic selections. As creative individuals we are in the business of concerning ourselves with working to translate ideas and abstract qualities into tangible and cohesive visual messages. Such is the process of developing a visual identity from a brand statement. In the art and design world this is often referred to as the "look and feel." Visual properties as defined by color, image, symbol, material, typeface, and even composition are given significant consideration to make sure that the "look" accurately works to communicate the desired "feel" of the message. For example: The *look* of a fractured composition could *feel* edgy; the *look* of diagonally composed type could *feel* dynamic; and the *look* of a large red bull's eye could *feel* confident and bold.

For a visual identity to be successful it must do three things.

1. It must be *distinct* enough to stand out from the crowd—it must get you noticed. A successful visual identity should be unique enough to grab someone's attention and also hold his or her interest.

2. It must be *meaningful*. A visual identity should communicate something that is real. Like an overall brand identity, it projects an expectation that in order to be successful must be realized by the person or thing to which it is referring. In other words, the work in your portfolio should back up the attitudes and qualities expressed through your visual identity.

3. It must be *memorable*. To do this, the visual identity needs to be applied consistently to all aspects of the comprehensive portfolio. If someone were to view your portfolio book, website, or even business card for just a minute, it should make a solid enough impression that the "look and feel" could be described hours later. For example, that portfolio was "bold, dynamic, and witty—a perfect fit for our company!"

Additional Components

Audio and motion can be a powerful part of a brand identity and can help establish mood and tone. Such aspects should be especially thought about when you approach your online portfolio.

Style Guide

A brand identity is typically defined in a document called a *style guide*. This document is used as a reference for all aspects of a brand's marketing materials. A style guide is often very specific about how visual and verbal components of the brand should be used. It can include directions regarding logo and image placement, color palette, size and proportions, image stylization, grid systems, materials, typographic systems, and even types of media to be used. All of these aspects are meant to work together to establish a distinct and consistent brand style. This same strategy can be applied, more or less, to the creation of your comprehensive portfolio. In the next chapter you will explore applying your brand identity to your portfolio book's front and back cover design.

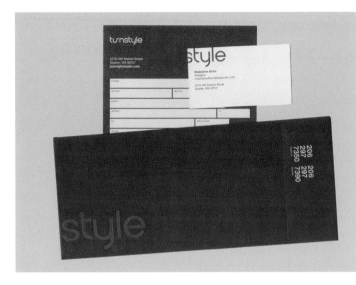

TURNSTYLE STUDIO, Seattle, WA.

STEPHANIE KATES, Endicott College.

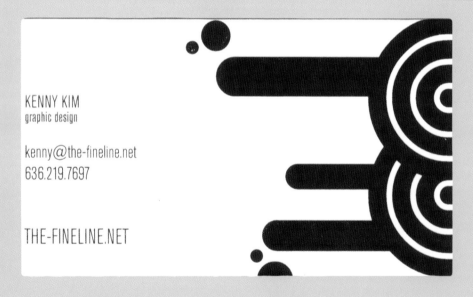

KENNY KIM, New York, NY.

Kenny Kim's logo and business card design style blends distinctly Asian and graffiti aesthetics.

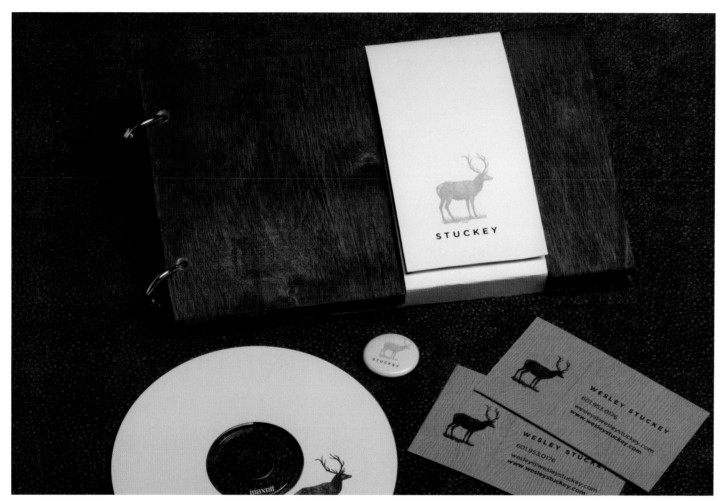

Inspired by his love of nature and printmaking, Wesley's portfolio package has a rustic, hands-on, and natural appeal. At the same time, his attention to detail and craftsmanship is quite evident.

WESLEY STUCKEY, STUDENT PORTFOLIO AND PROMOTIONAL MATERIALS, Mississippi State University.

Q&A: Interview with Christine Pillsbury, Creative Director, BEAM Interactive & Relationship Marketing

Christine Pillsbury is a creative director at BEAM Interactive & Relationship Marketing in Boston. She has held previous positions at Mullen, U.S. Interactive, and Ogilvy and Mather in New York. She is the recipient of numerous industry awards, including the London International Advertising award, One Show Interactive award, and HATCH award. Ms. Pillsbury has an M.F.A. in dynamic media from Massachusetts College of Art.

How important do you feel an online and/or print portfolio is in securing a creative position in the interactive design industry?

Essential—don't bother without it. Seriously.

As a creative director, what do you look for in an online portfolio? What contributes to an overall portfolio design that stands out and grabs your attention?

First and foremost, the work. But a half-thought-out "container" can definitely take away from good work, while a great portfolio concept can really differentiate you.

How important do you think a brand or overall visual identity is in the success of a portfolio design?

Brand is so much more important than branding. I'm not looking for your cool logo, but I am trying to find out who you are, what you can do, what's interesting about you, what makes you different, and where you are going.

In general, how many pieces of work do you think a student should include in his or her portfolio?

It depends ...12 is a good number. I definitely think quality over quantity. People aren't going to sift through project after project looking for "it." The best portfolios are full of individual projects that demonstrate multiple skills and talents at the same time.

Do you have any advice for someone (especially a student) who is working on his or her portfolio and/or other promotional materials?

The people reviewing your work probably don't have a lot of time to spare; first impressions are literally make it or break it in this industry.

Brand is so much more important than branding.

I'M NOT LOOKING FOR YOUR COOL LOGO, but I am trying to find out who you are, what you can do, what's interesting about you, what makes you different, and where you are going.

CHRISTINE PILLSBURY
Creative Director, BEAM Interactive & Relationship Marketing, Boston, MA

Q&A: Interview with Jeremie Dunning, Senior Web Designer, Burton Creative Services

Jeremie Dunning is a senior web designer with Burton Creative Services in Burlington, VT. Jeremie's background includes print, web, and film. He has worked for several ad agencies and as a film editor in Los Angeles, and owned his own creative shop for both print and web. Jeremie holds a B.A. in communications with a minor in marketing from SUNY Fredonia in New York.

How important do you feel an online and/or print portfolio is in securing a creative position in your industry?

It's a requirement even to be considered for the position. After that, it's really all about the interview.

I think both print and web portfolios are important. Both mediums can communicate who you are beyond just the work itself. The packaging and presentation of a portfolio can really say a lot about you.

On the web side at Burton, the online piece is obviously really important. I'm looking to see that a portfolio maintains the full integrity of a project, not just a JPEG of the project or a screen capture. I want to see interactivity and functionality—proof that you can make your vision successful online.

It's also great to have a book that you can carry with you (and not need a computer to view your work). A print portfolio has the potential to really stand out. This probably isn't something that's mass-produced, so the craftsmanship is really important. You should send your book to companies that you want to engage with. There may be only five of these books in the world, so there's something special about that.

What do you look for in a portfolio? What contributes to an overall portfolio design or construction that stands out and grabs your attention?

I really look at the portfolio's presentation—even more so than the work. I think it's important to see your personality come through so I can get a sense of who you are and what your potential is. I'm trying to figure out if you're a good fit for the company. From an art director's perspective it's important to know how your relationship to the company and to the team will be defined.

How important do you think a brand or overall visual identity is in the success of a portfolio design?

Top of the list—in essence you are selling yourself as a person, as a creative, and a talent. You are not selling the work you have previously done—you are not a salesman.

In general, how many pieces of work do you think a student should include in his or her portfolio?

It's all relative and depends on how you draw me in. If you show me your process I will probably look at more pieces. If you tell me a story with your work and engage me I will look at your portfolio in a more thorough way. It's about telling your story. I'm more interested in your process—the way you think and what you're passionate about. For that reason I'm less interested in the final result.

Professional works in a portfolio are usually art directed by someone else. So personal projects are of more interest to me—they show me where you can and want to go. It's really important for everyone's portfolio to include personal work—it shows me that you are passionate about what you do and that's key. I want to see sketches, brainstorming ideas—in multiple directions. Without this, I tend to trash the portfolio.

Do you have any advice for a student currently working on his or her portfolio and/or other promotional materials?

If you've seen it before, don't do it again. Odds are someone else will have seen it before too.

THE DIFFERENCE BETWEEN GOOD DESIGN AND GREAT DESIGN IS

intelligence.

TIBOR KALMAN
Influential Graphic Designer

COVER DESIGN

The creation of your own portfolio book is a creative statement about the value you place on your work and craft. It is important that your portfolio book function in two important yet different ways—addressing both the exterior and interior book design.

Cover Design

Your book cover design needs to get you noticed and distinguish you from "the crowd." It needs to communicate your unique talents and experiences in a positive and memorable way. To do this, you need to capitalize on your own unique creative vision. Distinguishing yourself from hundreds of other seemingly similar candidates will provide you with a vital competitive edge. Therefore, it is important that your portfolio book not simply be a container for your work, but act as a well-thought-out and well-crafted creative statement, in and of itself. Creating your own unique book will also demonstrate your commitment and dedication to your profession. This is especially true in our competitive creative industries where creative professionals distinguish themselves by taking the initiative to make sure that they show their very best right from the start. This chapter will guide you through a number of steps in order to help turn your brand statement into a visually compelling branded design.

A Note about the Interior Layout

The second way in which your portfolio book needs to function is by clearly and effectively presenting your work. The interior layout design needs to support the image of the work itself and allow it to be the focal point within the composition of each page. Information about the work and any other related visual elements will therefore be secondary. As part of our process, in the following chapter we will guide you through the organization and layout of elements within the layout of a page, including typographic and compositional issues.

Your Approach

There are a number of approaches you can take with the design of your portfolio book. Depending on where you enter this process, your approach may vary. Keep in mind that you should be making conscious decisions that will ultimately provide a means to get you noticed and differentiate you within the marketplace.

At the most basic level your portfolio book is a formal exercise in print design and bookmaking. In addition, your cover design should reflect consideration of your brand statement. The purpose of your cover design is to get you noticed and differentiate you from the crowd. The style or "look and feel" of it should connect with your target audience immediately and reference the type of work you've done and/or want to do. Explored further, your cover design has the potential to distinguish you as a creative professional and leave a lasting memorable impression. By referencing a conceptual idea and/or establishing a specific brand identity you can connect all the components of your comprehensive portfolio package together into one clear and concise statement.

There are a couple of ways to think about your cover design:

Level 1: As a formal print design and bookmaking solution.

Level 2: As a conceptual statement that leads to a visual direction and/or a brand identity solution.

Style, in its most general sense, is a specific or characteristic manner of expression, design, construction, or execution.[1]

– STEVEN HELLER and SEYMOUR CHWAST

Note: Consider the entirety of the book—front, back. and spine.

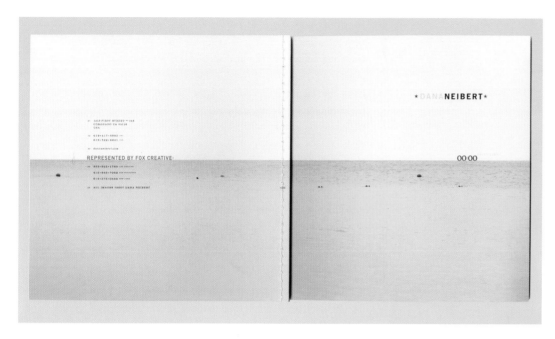

My design is usually simple and graphic much like my photography.

– DANA NEIBERT

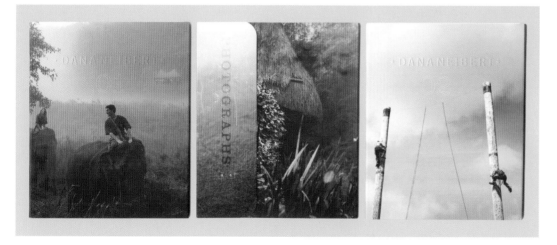

DANA NEIBERT, PORTFOLIO AND PROMOTIONAL MATERIALS, Coronado, CA.

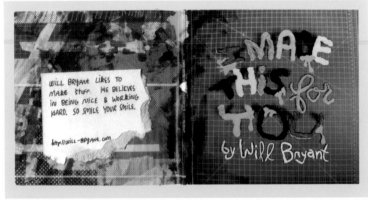

(TOP) *NICHOLAS FELTON,* New York, NY.

(BOTTOM) *WILL BRYANT,* Mississippi State University.

Now that you know what you want to say, you need to figure out how best to say it. To sell yourself you need a brand. To sell your brand you need a big idea. The next step in this process is to develop an overarching visual idea or concept—something that can provide the basis for the direction of your visual design. **A visual concept can be more loosely or tightly defined.** It can be a literal translation, or on the other extreme, act as an abstract reference to your brand statement. Whichever direction you head in, you should start by doing some thinking and sketching.

There are several ways to proceed:

- Connect your brand attributes to specific imagery or icons that are symbolic of you, your work, or simply your artistic vision.

- Reference a specific visual system or genre that works well to represent you.

- Utilize a conceptual methodology like satire or symbolism to develop an idea and take advantage of related visual systems and methods.

- Use your brand statement only as a launching point and work from there to brainstorm a concept or message.

Good design IS ALL ABOUT MAKING OTHER DESIGNERS FEEL LIKE IDIOTS BECAUSE THAT IDEA WASN'T THEIRS.

FRANK CHIMERO
Illustrator, Graphic Designer & Writer

Q&A: Interview with Gail Swanlund, Co-director and Faculty, CalArts, Graphic Design Program

Gail Swanlund is a designer and professor, and co-director of the graphic design program at CalArts in Valencia, CA. Her work has been exhibited at the San Francisco Museum of Modern Art and she has been recognized by the American Center for Design, AIGA, and The Type Directors Club. Her work has been featured in *Emigre*, *Eye*, *Print*, *IdN*, and *Zoo*, and has been published in various design anthologies, including *Graphic Radicals*, *Radical Graphics*, *The Graphic Edge*, and *Typographics 4*. Professor Swanlund received a master's degree from CalArts.

What kind of portfolio or bookmaking course do you teach? What's the course name? What level is it geared toward? Is it a required course?

In the B.F.A.4 year (the fourth year of the undergraduate program), students curate and design an exhibition catalog in their core design class. In the spring, the B.F.A. candidates prepare a portfolio, including resume, website, reel, and a printed book.

What do you think makes for an outstanding portfolio book?

Innovative work with a thoughtful concept supporting the thoughtful form.

How important is a print and/or online portfolio in securing a job in the industry?

It's essential. You can't hide anything with a printed book and it really helps support, for example, a reel, to show off typographic detailing, composition talents, skillfulness, and so forth.

In general, how many pieces of work do you think a student should include in his or her portfolio?

10–20 really great pieces. Get some advice from teachers, professionals, other pals. Don't overload the portfolio with too many projects, but do have some projects held in reserve in case the interviewer shows interest and wants to see more or something specific.

Understanding the Range of Possibilities

There are many ways to proceed with your approach. You need to discover what works best for you. You may perhaps decide to create a composition through illustration or photographic montage that references a narrative. Perhaps you are interested in developing a broader metaphor for your portfolio, like Jessica Hische's *Body of Work* [pgs. 42–43]. Perhaps poking fun at an idea, product, or company through a clever parody or witty satire is more suggestive of your personality. Or, you may simply want to reference certain qualities that can be expressed more abstractly. For example, an intricate pattern can communicate a sense of focus and attention to detail. While a composition developed from expressive lines and shapes can suggest a spontaneous dynamic energy. Even one image, be it witty or serious or bizarre or subtle, can communicate volumes about who you are as an artist. Whatever you decide, *be conscious of the images, symbols, shapes, and visual styles that you reference*. Don't just randomly choose things for no reason. Remember that out of all the concepts and subsequent visual references in the world, whoever views your portfolio will identify you with the ones you do choose. Make sure you know what your portfolio design will communicate about you.

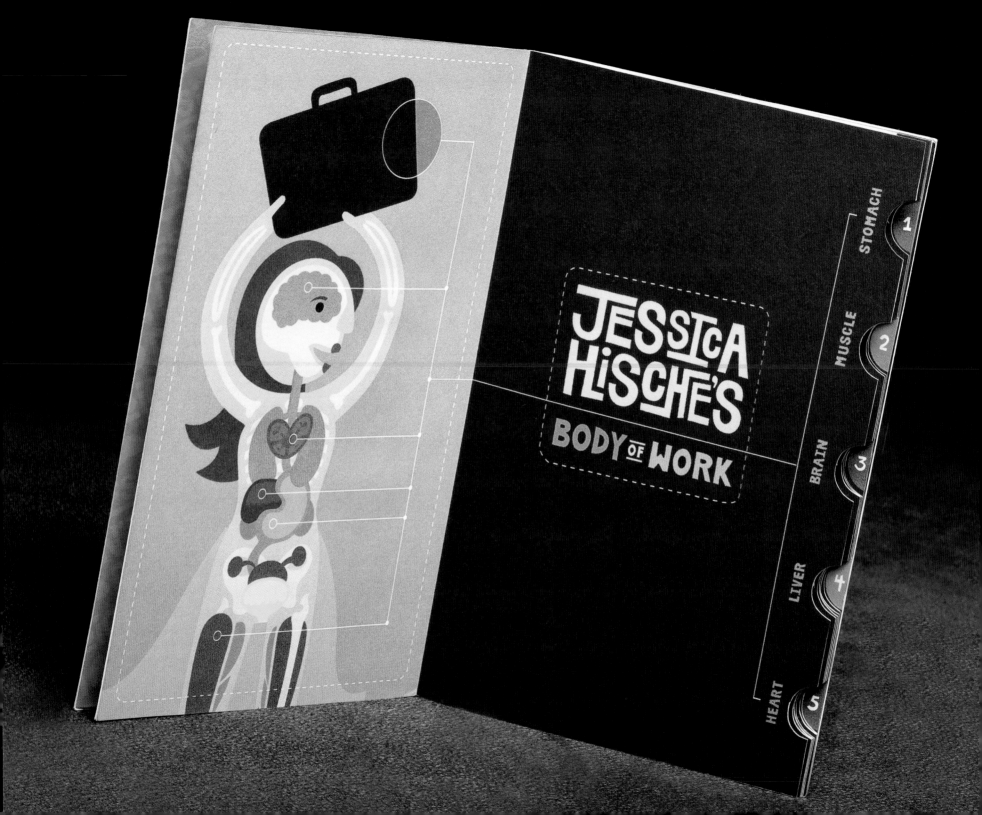

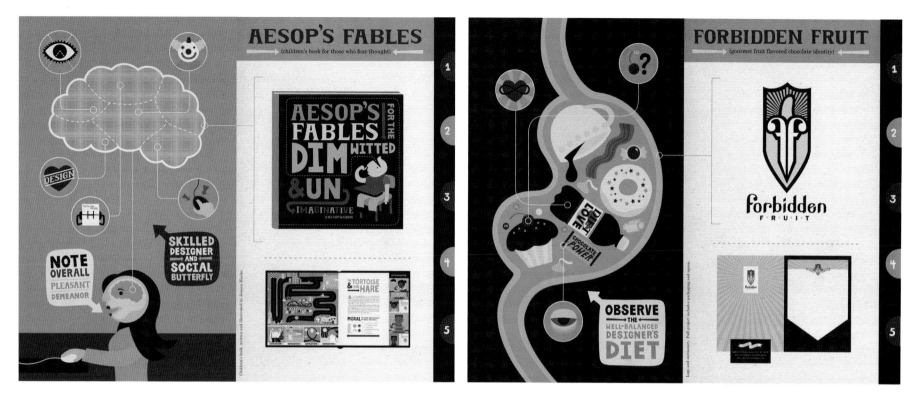

JESSICA HISCHE, STUDENT PORTFOLIO, Tyler School of Art.

Jessica's concept is developed through the use of a visual/verbal pun, playing with the phrase "body of work." The concept, color palette, illustrations, and typographic treatment all work beautifully together to communicate a whimsical, animated, and witty approach to her portfolio. This is also a great example of a portfolio that is a completed piece in and of itself. Clearly, it stands out and communicates Jessica's unique creative vision and artistic talents.

NOAH WEBB, PROMOTIONAL BOOK, Los Angeles, CA.

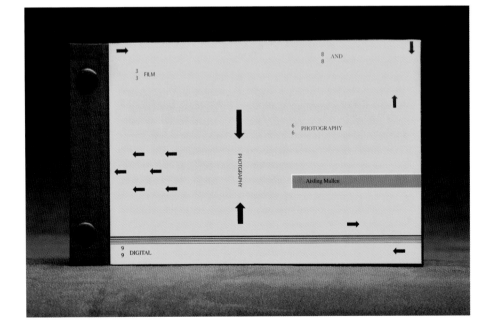

AISLING MULLEN, STUDENT PORTFOLIO, Endicott College.

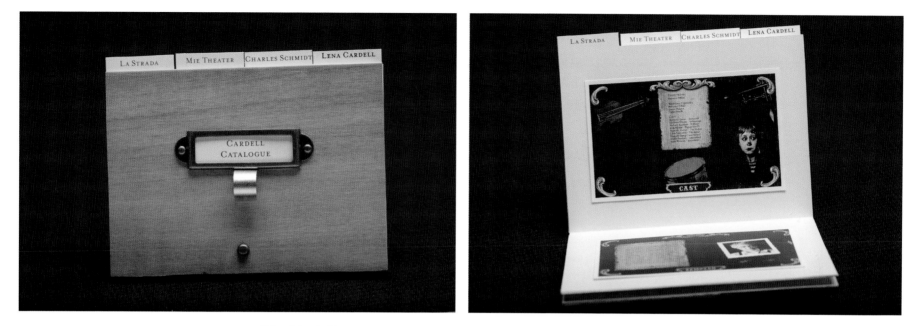

LENA CARDELL, STUDENT PORTFOLIO, Tyler School of Art.

Lena's portfolio is based on the concept of a card catalog. The piece itself showcases her superb and thoughtful craftsmanship.

Conceptual Methodologies Defined

If you want to create a more tightly defined concept, investigate the following conceptual methodologies:

- *Satire:* Works great as a strategy to create concepts that are witty, sarcastic, edgy, and relevant.

- *Parody:* Spoofs, caricatures, humorous imitations—it's always fun to poke fun of something at its own expense, but these concepts need to be relevant and meaningful in order to be successful.

- *Narrative:* Whether linearly defined stories or loosely strung together nonlinear references, narratives describe a sequence of fictional or nonfictional events.

- *Symbolism:* Symbols do well to connect to abstract ideas and nonliteral references. If used strategically, the use of symbolism can bring a lot of meaning to a piece.

- *Metaphor:* Metaphors are poetic in nature. They are often used to explore abstract ideas through an underlying connection to a (sometimes seemingly unconnected) tangible idea or object. For this reason, while difficult to achieve successfully, metaphors often make for the development of some very original and thoughtful concepts.

- *Visual pun:* Witty, relevant, and fun, visual and verbal puns can be a great method for grabbing someone's attention and remaining memorable. The usage of puns also references the field of advertising - as this technique has been historically used to great advantage in this industry.

KEN GEHLE, PROMOTIONAL BOOK, Decator, GA.

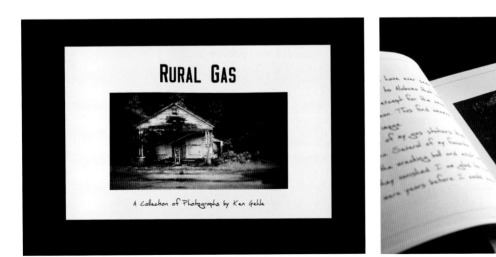

Ken's promotional book makes use of a narrative structure to pair photographic images with his own observations and comments.

Sketches and Word Associations

If you don't know where to begin, sketch out some ideas with paper and pencil. Brainstorming fresh and thoughtful ideas is difficult. You don't want to present a concept that is too generic or obvious. One way to get the ideas flowing is to do a word association (you can do the same thing with images too). Start with the words you wrote down in Step 1—those qualities that define you and your work. Write down each word across the top of a piece of paper, and underneath each create a list of associated words. Write down anything that comes to mind—be creative and let your mind wander! Think of places, people, objects, and symbols that might be associated with the qualities you defined. Then from this list of words, circle those that seem more interesting and less obvious. Do the same thing again with these words and try to think of other things that might relate. In this way you may discover references that may help you develop a more interesting and unique idea.

Moodboards

The creation of moodboards is common practice in design, advertising, and marketing. A moodboard is essentially a collection of found imagery that define a particular concept, style, or overall "look and feel". Moodboards are often used to inspire and communicate a sense of brand and visual direction. They should make an impact on the senses. The selection of imagery can be based on whatever strikes you—color palette, image, type, texture, composition, pattern, etc. It shouldn't be limited to subject matter. Seek out and derive materials from magazines, photographs, materials, fabrics, books, and other types of visual forms (if you don't want to cut up something, scan it and print it out first). If you come across something (say, a traffic sign or architectural detail) that you like, snap a photograph of it. Try to keep a visual log of things that inspire you. Keep in mind the brand attributes that you've used to describe yourself.

From the materials you are searching through, cut out the parts that relate to your vision and inspire you. Paste them onto something like poster board. Creating moodboards is often quick and easy so it's a great way to try out a variety of ideas and directions. Create as many moodboards as you like—trying out different "looks and feels"—and create a range of ideas that you can step back from and evaluate. It's a great way to decide what you do and don't like.

Promotional Exercise

Produce a single promotional piece that presents you or your work through a particular concept. This exercise is designed to expand your thinking and stimulate ideas that eventually could be used as the launching point in the development of a larger portfolio concept. Focus on: *Ideation—the generation of ideas*.

Rather than trying to conceive a portfolio concept from scratch (even if you have already developed one) this process will allow you to experiment with packaging or presenting your work through a thematic approach to a *concept-driven piece* on a smaller scale. The intention here is to use this smaller scale process as a sketch for a larger potential idea without the burden or pressure of having to consider this larger effort.

To help you through a process of generating concepts and ideas for your visual approach, work on a single targeted marketing piece. Your approach should make reference to your brand statement and utilize a concept or method targeted toward a particular client or market.

1. Pick a client or clients and a particular market.

2. Pick an approach—stylistic, conceptual, formal, etc.

3. Develop a single marketing promotional piece. Start with something small, such as a:

 - Two-sided postcard

 - Matchbook or box of matches

 - Mini CD with sleeve

 - Set of stickers

 - Small mailing

Q&A: Interview with Beverly Hayman, Recent B.F.A. Graduate, Mississippi State University

Beverly Hayman graduated summa cum laude with a B.F.A. in graphic design from Mississippi State University in May 2008.

Were you a student when you created this piece? Was it created in response to a course assignment?

Yes. I made the self-promos in an advanced graphics course my final semester of undergraduate work. The "self-promo" project is a course assignment allowing students the chance to create a comprehensive and well-crafted portfolio. In addition to the physical piece, we were required to create a promotional website (http://www.beverlyhayman.com). I feel that having a student's portfolio become a part of their curriculum allows them to focus and spend more time on it, as opposed to it being something they have to accomplish in addition to their classes.

How did you arrive at the idea or concept for your piece? What do you think it communicates about you?

"One man's trash is another man's treasure." I love repurposing materials. With my portfolio, in particular, I felt that reusing old books and their covers provided a lot of inspiration both conceptually and literally. I liked the idea of modeling my "self-promo" after a book in format: chapters, library card pocket, stamping, etc. ... In addition, reusing old book covers as the aesthetic for my portfolio says a lot about my style.

One thing that has always been important in my work is to never rely solely on one media, especially the computer. While graphic design has really been revolutionized with digital technology, I feel that it is best to use that technology to enhance your work, and not rely solely on its capabilities. I wanted to represent my skills and attention to detail in a way that really expressed who I was as a designer. Creating this handmade book that resembles a library book by repurposing materials really showcased my style and what I like to do.

Did you target a particular area of the market or industry with this approach?

No. Honestly I felt like this project should be seen as a culmination of my work as a student, and so I wanted to incorporate all of my skills into this one project, and hope that potential employers would appreciate that approach.

What was the most challenging part about creating this piece?

The whole piece was designed in a way that it really needed to be crafted delicately, so taking the time and effort to assemble all the various pieces was very tedious. In particular, the process of choosing books and removing their covers carefully was actually quite difficult.

Who have you sent it out to? How did you send it? What did you follow up with (call, email, etc.)? What was the response?

I've presented it to three firms in various interviews. All the meetings were in person, so I didn't have to package and mail them. A couple of the firms offered me a position during the interview, so no follow-up was required.

Do you have any advice for a student currently working on his or her portfolio and/or other promotional materials?

I would encourage them to really take ownership in their work and create something they can really be proud of. Promotional material may just be a snapshot of what you can do, but often it's the only way in which you can showcase your work.

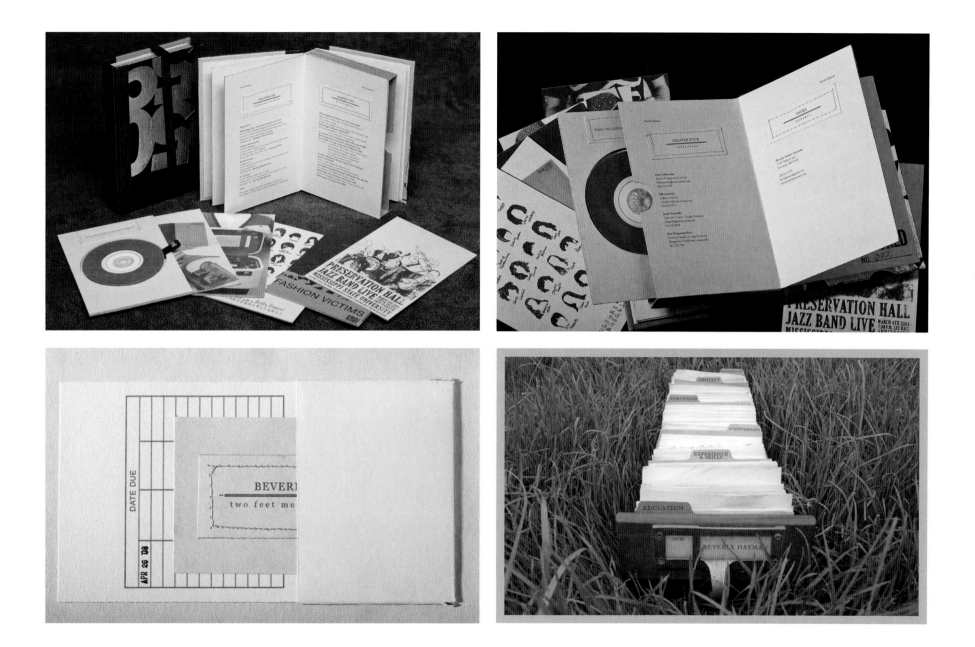

Q&A: Interview with Jamie Burwell Mixon, Professor, Mississippi State University

At MSU, Professor Jamie Burwell Mixon is the coordinator of the graphic design emphasis area, teaches graphic design, and continues to design for select clients. Mixon was named an MSU Grisham Master Teacher in 2004 and won an MSU Grisham Teaching Excellence Award in 1996. She has twice been selected as MSU's CASE Professor of the Year nominee. (She *loves* teaching.)

Over the years, student designs created in her classes have been published in *HOW* magazine, *CMYK*, and *Creative Quarterly*, as well as won awards in ADCMW's The REAL Show, the International Design Against Fur poster competition, *USA Today*'s Collegiate Challenge Competition, the AAF Addy Competition, and DSVC's National Show, among others. (She *loves* students who love design.)

What kind of portfolio course do you teach? What's the course name? What level is it geared toward? Is it a required course?

I teach ART4640 Advanced Graphics. This is a capstone portfolio course required by all MSU graphic design emphasis students. Students are required to take this course their last semester.

What do you think makes for an outstanding portfolio?

Wow! So many things go into the making of an outstanding portfolio! Certainly excellent design, concept, and perfect craft are expected. But also the ability to edit out your weaker work; a portfolio is judged by its weakest piece. When in doubt, throw it out! In my experience, when a student has complete confidence in their portfolio—without any doubt or hesitation—it shines bright!

How important is a print and/or online portfolio in securing a job in the industry?

Yes! Both are important. A student must be ready for all opportunities. If a student is in contact with a potential employer online and secures an interview, then the printed self-promo piece is used as a leave-behind. A printed piece may also be used as a foot-in-the-door technique to introduce the student to a firm and generate interest in their online portfolio, thus securing a face-to-face interview or portfolio review. Students must be quick on their feet, flexible and persistent in the search for a great design position! One thing is certain: The student must know all there is to know about the firm they are contacting and be genuinely interested in it!

SO MANY THINGS GO INTO THE MAKING OF AN
outstanding portfolio!
Certainly excellent design, concept and perfect craft are expected.

JAMIE BURWELL MIXON

How important is the brand or overall visual identity of the portfolio package (including book, website, resume, business card, etc.)?

In my portfolio course, students essentially create an entire brand for themselves. Self-promo, website, CD, and portfolio format are all visually and conceptually consistent with each other. It's not easy; the hardest, flakiest client is often yourself! The great thing is that a student can achieve amazing results by working hard and paying attention to detail. Students often feel overwhelmed at the beginning of their last semester. I encourage them to tackle one day at a time; check one thing off of their list each day. It works! Professors schedule due dates not to be cruel, but to create a framework for student success.

In general, how many pieces of work do you think a student should include in his or her portfolio?

MSU students have around 10–12, but some of those will be a series of 3 or a campaign of, say, 5 pieces. If a student has a few extra pieces, they can switch out what they carry to an interview, depending on what that firm is looking for. Always be in tune to the specific interview situation.

Do you have any advice for the student currently working on his or her portfolio and/or promotional materials?

After seeing lots of students go through the same portfolio process each semester, it's pretty easy to see why certain students are more successful than others. Hard work, passion for design, and attention to detail come to mind. I can see when a student's work is created out of *love* for design rather than fear of failure. Both get results, but I'd much rather work with the passionate designer! An excellent portfolio secures an interview; the designer behind that portfolio gets hired. I always tell my students to work hard, be brave, dream big, and aim high.

Dominant Elements

The visual focus of your cover design should reflect your brand statement and subsequent design concept. It may also refer to a brand identity that you have developed. As you visually translate your ideas you will need to decide how best to communicate your message through *specific design decisions*. Start by determining the *dominant elements* that you want to emphasize in your cover design. They should reflect the area of the industry you want to work in and communicate who you are as an individual creative. As such, the primary visual elements used in your design should be most closely associated with the type of work you want to do—that is, photography (the image rules), illustration (show off your drawing talent), brand (think logotype and brand scheme), advertising (such as witty image and word combinations), or design layout (think type and grid!). Establishing the right dominant visual elements to communicate your brand message is essential.

Subordinate Elements

You should spend some time thinking about the *subordinate elements* you would like to include in your cover design. The use of subordinate elements should of course be supportive to the visual message and not distract from the primary elements used. As mentioned before, the standard visual components of a "look and feel" include color palette, iconography, or stylization of imagery, and one or two specified typefaces. For brand designers, a logotype may also be a key element to consider. There are, however, less obvious aspects to consider as well. A visual identity should include the way in which the visual elements are joined together within the composition—like a composition that feels balanced and harmonious versus one that is full of dynamic energy and tension. In addition, a visual identity should address issues of scale and proportion.

Compose the Elements

Next, you need to take your design direction a step further and figure out how to compose each element within the overall cover design. For example, while a photographer may focus on the use of photographic imagery in his or her design, there are many, many visual techniques that can be used to interpret and communicate a specific message. So whether as montage, collage, sequence, digitally manipulated, large, small, abstract, close-up, etc. is totally dependent on what you want to communicate and the direction you decide to take in order to communicate it. As you sketch, comp, and work through this process, make sure to consider your design as a whole and work to integrate all the elements together as one cohesive statement.

Again, the foundation for this direction should come from the work you did in Step 2—defining your brand statement and big-picture concept. For example, a more "formal" brand does best with formal balance, classical text treatments, subtle color, and harmonious, proportional divisions of space. While a young, witty, dynamic brand relies more on asymmetry, dynamic forces, quirky balance, and bold color and typographic styles.

Consider Material and Formal References

As part of this exploration you should also consider material choices, especially for the front and back cover. What would vinyl, metal, or even canvas communicate about you and your work? You should consider all these aspects to some degree, depending on your discipline, background, and experience. As you continue to make choices, remember that the physical form of the portfolio is completely up to you; however, you should consider what forms best communicate for you purposes and also practical issues such as portability. As you consider the structure of the book, remember that there is just something tangible and reassuring about holding a book in your hands. Think about its weight, size, texture, and the types of materials used to construct it. All of these aspects are part of the design of your book (see Step 3B for more information on materials and forms).

Logos

Too often inexperienced designers think that a simple monogram, overlapping or combining two or more letters to form one symbol is a logotype. Simple monograms are things you see on fancy towels, not on visual communications portfolios. There are, of course, interesting ways to combine letterforms to make a logotype, but this requires careful study and practice. Logos can also be simplified pictorial symbols or abstract shapes. Creating a successful logo is challenging and difficult to do. A logo should be visually distinct enough so someone can immediately recognize it and relate it to a specific brand. It also needs to be abstracted and simplified enough so someone can remember it. If you've developed a personal logotype in the past and have received positive feedback about it, then it is perhaps a good idea to consider using it in the design of your portfolio. If you haven't, you may want to consider skipping this part and think more about the style of typeface that you will use to spell out your name or the title of your book. A poor personal logo is always an indication of overconfidence and inexperience. With that said, however, if you intend to pursue a career in brand design, you probably should consider developing your own logo and brand scheme to prove that you are capable of doing so. There are lots of great resources to help (see Appendix A for suggested resources).

THEORETICAL UNIVERSE, Boston, MA.

STEPHANIE KATES, Endicott College.

COLOR

Finding the right color combinations to establish tone and attitude is essential. Color is the first visual component we perceive and can be the most memorable (based on Gestalt cognitive theory!).

Certain color palettes can reference a specific genre or visual system. Color can be associated with a specific time, place, or culture. Think about the vibrant colors associated with 1970's punk verses the more formal palette of the Swiss Typographic style. Sometimes, it's only one or two colors that really capture the spirit of a genre, style, or time period. Consider if historic or contemporary color trends and styles make sense for your work.

You may decide to work with images or illustrations that include a multitude of colors. That's fine, but at some point you'll at least need to think about choosing a few specific colors for the typography and graphical elements. Aspects of your color palette should continue into the interior page design of your book in order to provide continuity throughout. A specific color palette can also be effective in order to unite other pieces of your comprehensive portfolio, such as a website, resume, and perhaps even a business card or promotional piece.

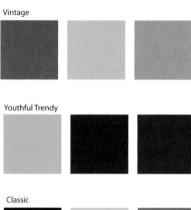

Vintage

Youthful Trendy

Classic

Earth Tones

Swiss Typographic Style

Punk

Note: Try the Color Guide palette in Adobe Illustrator for a variety of helpful color schemes and options, including tints/shades and split-compliments.

Color Palette: Dominant, Subordinate, Accent

A traditional color palette starts with three colors. In many cases two of the colors often harmonize with each other. This can be done by choosing colors that are near each other on the color wheel or by choosing colors with a similar tone (amount of gray). The third "accent" color is usually brighter and bolder. It is often used sparingly to call attention to important information and helps to establish a hierarchy of information.

Hue, Brightness, and Saturation

The perception of a color is greatly affected by its value and saturation; in planning a color combination, value and saturation are as important as hue.

- Saturation = intensity of color (hue). The saturation of a color is determined by the amount of gray added to it.

- Value = the lightness or darkness of a color. The value of a color is determined by its respective lightness or darkness.

Color that is more saturated tends to be described as bold, vivid, intense, clear, and rich. Color that is less saturated tends to be subtler and is often described as muted, neutral, timeless, and classic. Sepia tones are a good example of less saturated color.

Define the Palette
1. Dominant Color
2. Subordinate Color
3. Accent Color

Example = pink, red, maroon

Symbolic and Emotional

Color, more than any other visual property, tends to evoke the most visceral and immediate emotional reaction. It can be used to create symbolic meaning or reference a specific genre or style. Our psychological and emotional reactions to color may be based on cultural connotations or personal experience. Whatever the reason, color is an important aspect of establishing a mood and context to your work. It's important to know how certain color combinations will affect these reactions.

- *Symbolism and context:* Take red, for example. It can mean blood, stop, anger, or love—all very different meanings. One must look at its context in relationship to other colors, images, symbols, and text in order to understand its symbolic meaning.

- *Cultural color combinations are more locally understood:* For example, red, white, and blue can symbolize the United States to Americans or the United Kingdom to the British. Black is often associated with death, however, in parts of China and Japan, white is traditionally associated with death.

- *Universal colors:* These are more globally understood. For example, green is typically symbolic of the environment (although in the United States it can symbolize money as well).

- *Functional color:* Use color to establish visual emphasis and hierarchy.

- *Color as brand:* Such as McDonald's yellow and red combo, IBM's blue, UPS's brown, or Coca-Cola's red and white combo.

Need Help: Three Different Strategies

1. If you are using a specific image as a main element in your design, pull a dominant color from the image itself and build your palette around that. In Adobe Photoshop, go to Filter > Mosaic to pixelate the image and getter a better sense of the dominant colors.

Images and Iconography

Imagery and Visual References

When visual elements are used within a cover design they can function solely as formal devices designed to move the eye, and structure the composition. In this case visual elements may not have been intended to convey a specific meaning, but may reflect a style or visual approach. A visual, whether it is a photographic image or illustration, can be used to more concisely reflect your brand and contribute to your visual identity. There are many approaches to including visual elements and imagery that build meaning and references into your cover design. Beyond logos and known symbols, visual references and relationships between visual elements can come together to create a reading within the composition. With an understanding of how visual information can build meaning, a good design can be strengthened by informing it through thoughtful combinations of visual elements.

Look and Feel

The most fundamental method to build a characteristic reference or quality that will support your visual concept is through stylistic references. The incorporation of a visual style that is identifiable is one method of bringing visual character to your work. This can be done through formal elements that are associated with the particular style or the stylistic elements of a known movement in art.

Appropriation and Visual References

A very common practice today, appropriation has been fostered by the flexibility of digital information and imagery. It is a simple matter now to scan, photograph, and place visual material from any number of sources. The concept of appropriation is a grab-bag term to refer to any kind of repurposing and recontextualizing of photographs, stylistic elements, logos, and historical or culturally significant visuals. The essence of appropriation is the application and use of an image, or visual *in its entirety*, wherein the original reference or context is clearly recognizable and creates an association or identification. An appropriation can be an end unto itself, presenting you as a creative who taps into a broad and varied palette of ideas.

2. Split complimentary—a set of three colors forming a triangle on the color wheel. One color is coupled with a pair of colors adjacent to its compliment (usually the accent color). Work with the interrelationships (commonalities and variation) between hue, intensity, and value to develop a color palette that has strong visual contrast, but doesn't compete with too much tension.

3. Add a bit of gray to move away from more typical "crayon" colors. Work with color tone—matching the tone of two colors will help to relate them. Neutral tones often make for good background colors. They work well to accentuate bolder hues. In addition, earth tones such as brown, tan, and olive can also be used to make colors more neutral.

Note about Copyright and Appropriation

Appropriated imagery has been a part of visual works from artists dating back to the early 20th century. Shepard Fairey is an example of a contemporary artist whose work incorporates appropriated material. For different reasons his work has sparked controversy among the public and artist's alike. General questions of copyright violation have been raised with regard to Fairey's use of images and artwork from a variety of movements and eras. Artists, critics, and the public have raised questions about the merits of works that rely so heavily on appropriated source material, and legal ramifications of pushing the envelope of fair use. Ultimately, his use of imagery is subject to both legal and aesthetic interpretation and the judgments vary greatly. He has to date been taken to court for copyright violations, but he has not been found guilty of violating any held copyrights or required to pay penalties. In an ironic twist, Fairey has also used legal means to protect his copyright and prevent others from appropriating his work.

The bottom line: One cannot sidestep copyright and ownership in appropriating materials. While styles and characteristics can be used and referenced, **the appropriation of entire works that are not in the public domain, such as trademarks and copyrighted images, is illegal**, and you can be subject to lawsuits and financial penalties. While certain kinds of uses, such as parody and satire, are allowed under fair use definitions, you need to understand the degree to which your use of an original work is *legal or not*. It would not reflect well on you as a professional if a potential client were to recognize a copyright violation in your materials.

Web links (copyright and fair use):

- Editorial Photographers (EP) Resources:
 http://www.editorialphoto.com/copyright/

- U.S. Copyright Office:
 http://www.copyright.gov/

- AIGA Center for Practice Management:
 http://cpm.aiga.org/legal_issues/
 copyright-basics-for-graphic-designers

- Fair Use: http://en.wikipedia.org/wiki/
 Fair_use

Understanding Copyright Law: Basics and Resources

You should assume that any creative work is copyright protected. This would include images, trademarks, designs, written words, music, and so forth. Unless the work is in the public domain (and you must be certain that it is), someone owns the copyright. It doesn't have to be registered with the U.S. copyright office to fall under the protection of copyright law. Further, within a copyright protected work, other original elements are also protected. For example, you may own an image within which there is a logo for a particular retail business. Your copyright doesn't extend to the logo of that particular business. It is protected as well, and would require an agreement, or at least a release to be included in your work. This would also apply to individuals represented within your work, even private property.

Another issue is creating new works, while using other original works. If you are incorporating an original image in a new work, it must be different enough with respect to the original, or you must have transformed the original enough for it to not be recognizable (created a "transformative work"). This can fall into gray areas and the best policy is to avoid violating someone else's rights over any particular work.

There are many different aspects to copyright in relation to works that are for commercial purposes: works of fine artists, works of criticism and commentary, or works of satire, to name a few. This is a complex issue that has grown in complexity with the expansion of digitized resources, music, and materials. There are numerous and varied terms for copyright, and if in doubt, you can find many resources to assist you.

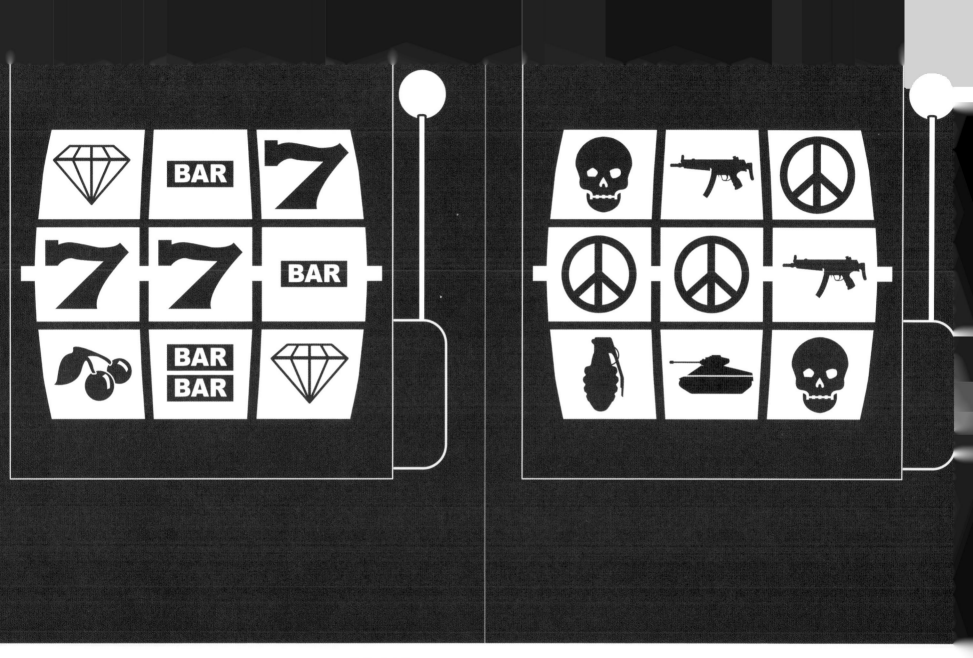

KRISTINA MANSOUR, STUDENT SENIOR THESIS, Endicott College.

Tip: Signs and symbols function most effectively as simplified reduced forms. By eliminating detail and reducing forms to basic elements, images and visuals can read more broadly.

Iconography

Iconography, in a nutshell, is the interpretation of signs and symbols in works of art. Traditionally, art historians have studied iconography to interpret the meaning and intent of historically significant works that reflect religious liturgy and incorporate symbols. The examination of iconography as applied to contemporary forms such as film and media involves interpreting images through the recognizable references within them. While this is fairly well established, it is not necessarily a uniform practice.

Attention to iconography and the allusions and associations to time, historical periods, styles, movements in design or art, as well as cultures or systems of information, can bring meaning to a work or design. Generally, visual icons are rooted in a culture or context and have clear, understandable associations. This differs from *appropriation*, in that appropriated visuals retain a *direct relationship to their origin*, whereas iconographic visuals tend to be general and have broader references that aren't necessarily rooted in one particular use or context.

Using Iconography versus Visual Icons

It is important to be able to make some distinctions between culturally determined *visual icons*, which are commonly understood symbols and signs, and the broader use of *iconography*. Commonly understood signs and symbols can be religious, part of corporate culture, or even linked to particular cohorts or communities.

For example, Christian crosses and the Star of David are religious icons. Flags and peace signs are icons rooted in a movement, or culture. Iconic images can be established through historical circumstances. The image of the Twin Towers in New York will forever be an iconographic reference to the tragedy of the September 11,

2001-terrorist attacks. The historical image of Uncle Sam is now an icon that has transformed. Originally linked with patriotism and service during World War II, it has a broad reference that can read as the paternal figure of "government." Numerous artists (Seymour Chwast and Micah Wright) have since used the image of Uncle Sam as shorthand for government when making a critical work that attempts to challenge or skewer government authority. Your use of iconography can be far reaching. Some examples that can be a reference include: cultures (Americana, British aristocracy, online networks), industries (medicine, automobile), processes (science, law), or time periods (Victorian era, the 1950s). The use of particular visual references in order to build an idea or association can work toward informing your visual identity or creating a specific association regarding your work.

A good example of the use of iconography to create a set of references that inform the presentation of the material is found in the website of photographer Naomi Harris (*http://www.naomiharris.com*). The visual elements are not directly linked to a particular origin, as in appropriation, nor are they specific visual icons connected to a particular culture or system. In this website the iconography is general. The look and feel, as well as the particular visual elements, create a reference to a period of time and a broader category of style, which could be loosely defined as "kitsch" from the 1960s and 1970s. Harris uses a collection of objects as visual elements for navigation that create the kitschy appearance and recall the family room, basement den, or recreation room. This reference to the particular era is reinforced by the visual of a slide projector and screen as the interface of viewing her portfolio, which recalls family vacation slideshows. All of this broadly places her look and feel in a period of time and gives her a quirky, playful visual identity.

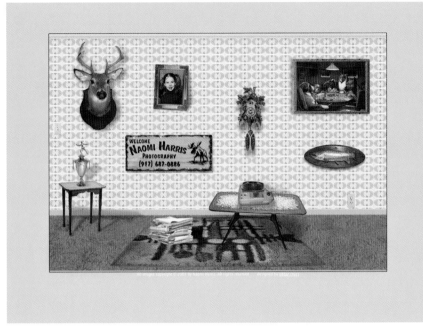

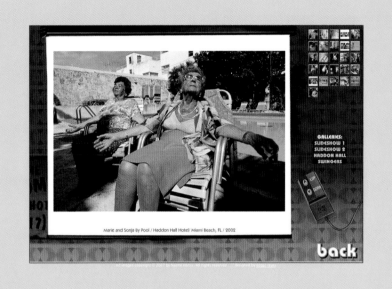

NAOMI HARRIS, WEBSITE, New York, NY.

Q&A: Interview with Naomi Harris, Photographer

What did you find that was lacking in websites that you had seen that led you to the concept for your website?

I found that many sites lacked originality or were based on a model where they would merely place their own photos on a predesigned site. I'm not opposed to simplicity but I'm not impressed by indistinguishable sites. One should take a little time out to figure out how to make themselves stand out and what it is they are trying to say about themselves and their work that makes them unique, and apply that to their web design. In this day and age of everyone having a website and everyone being familiar with how to navigate through them it's even more important to stand out and be original. I also hate websites that are difficult to navigate. Weird scroll bars, things that bounce around, buttons not staying stationary from one page to another really tick me off and often cause me to quit the site entirely. I imagine I'm not alone in that way of thinking.

You feel that websites need to convey something about the person as well as present the work so the potential client (or viewer) has a sense of who you are. What have you included in your website to make it more personable or characteristic of who you are?

I really dug the concept of making a rec room with all of the components working in order to show the slideshows, tell of my accomplishments, as well as a bio and how to contact me. It took some time to make it work and I did have to pay a designer to create it for me, but in the long run I'm very pleased with it. It completely reflects my sense of aesthetic and humor, and I hope people respond to that before even seeing the photos.

I decided to use a photo of myself at age six to be the intro to my bio and what I decided to share about myself. I wanted to have some seriousness but also a playful side. Yeah I'm a professional but I'm also not afraid to poke a little fun at myself and make myself more approachable. Including little bits of trivia that has nothing to do with photography sheds light on what I'm like as an individual (like being bitten by a monkey as a child).

You have a very fun website with great visual character. Did you have any concerns about visually competing with your photographs, and what did you do to address that in the way they are presented in your website?

While the home page is chockablock with different things, each representing a different section of the website, I didn't want it to be difficult for the viewer to navigate. That's why a white bold ring pops up around the icon with the name of what you would be searching through (bio, awards, news, contact, slideshow ...). Once you do click on one of these icons the page zooms into the info so as not to distract the viewer from what it is they are looking at. I also have a back button in the same spot on each page so one can return to the homepage easily and quickly.

I was concerned that with a busy background it might be difficult to actually look at the photos, the real reason for having a website. And to solve that problem I have a screen roll down and the rest of the page goes into darkness just like a real slideshow we had to endure as kids in our family's rec rooms.

What has the response been to your website and the "kitschy den" look and feel?

Most tell me how fun and original the site is. No bad responses as of yet!

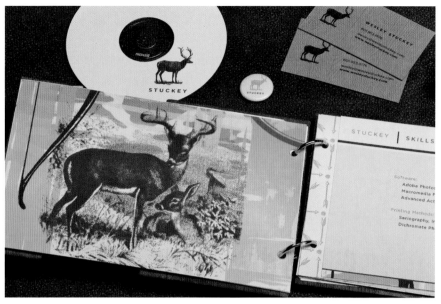

AISLING MULLEN, STUDENT PROMOTIONAL, Endicott College.

WESLEY STUCKEY, STUDENT PORTFOLIO, Mississippi State University.

Denotative and Connotative Meaning

The use of imagery to denote or connote meaning or ideas is an effective and well-known practice. While this isn't a separate aspect of image use, nor a subset, denotation and connotation have a direct relationship to iconography, references, symbolism, and visual metaphor. Denotative and connotative associations are descriptive of how iconography can function and generate meaning.

When imagery is a *direct reflection* of your intended idea it is denotative. In this example [above left], a photographer's inclusion of the film packaging in the cover design has a direct relationship to the work of that individual. Using the appearance and style of a particular photographic film packaging is denotative of photography in general. If the viewer is knowledgeable, he or she will recognize this reference to a particular film system.

The uses of rustic themes and images of deer [above right] do not carry literal meaning as much as *connote* a theme that has associations to hunting and backwoods cabins. While the overall effect is a result of the general iconography and appearance of the visuals, the deer or buck connotes hunting and backwoods life.

Connotative meaning is a secondary reference, wherein the *association* that results from what is presented or portrayed is the intention. In the examples at left a known visual icon is transformed. One association is transformed to create another entirely different or more pointed association. In both cases, the meaning is not literally represented (*denoted*) but through the manipulation of imagery builds an association (a *connotation*).

In this student thesis project, the meaning of known signs and symbols is investigated with the intention of bringing a new reading or particular context to the symbol. These symbols are well understood within the vocabulary of signs in western culture. The meaning of the symbol is changed by using the known reading and making deliberate alterations to it. In this example the visual image is a dove, which has a well-established connotation of peace. The connotation is transformed by the overlay of puzzle pieces on the symbol. The known meaning of the symbol is altered to reveal a broader idea: Peace as a puzzle to be "pieced" back together.

This example exploits the known meaning of the three colors presented in a stack: a stoplight, which in this configuration reads as red (stop), yellow (caution), and green (go). The stoplight structure and color is altered with the inclusion of images that refer to lighting and the earth. Seen in relation to each other, the lighting images and the earth direct the viewer to a reference about global warming. Taken further, and placed into the context of the stoplight, the entire image presents a connotative reading that speaks to the problem of global warming and suggests a direction solution.

CHRISTINA MANSOUR, Endicott College.

Building Visual Texts

Extending the relationships between images can be achieved through a reading of images or a visual text. Meaning is formed additively, wherein the denoted meaning of the imagery, or allusions and associations within the imagery, as well as stylistic or formal elements combine to suggest the larger whole; the "reading" of references and content found within the whole image builds to a particular idea or set of associations.

These combinations of *discreet images* need to be thought through in order to be sure that the viewer's reading is directed in the intended way. Essentially, this is an outcome of image relationships, and can be found in multiple image pieces such as compound images (see example p. 114). Depending on the cover design, the imagery can be structured and ordered in a number of different ways. A grid structure can invite reading between images, and the proportions of this grid and placement of the images will effect the direction of the reading. Linear placement can be expected to follow the conventions of reading a western text. Left to right and top to bottom reading is often the default starting point for a viewer.

In this image (at right) documents and photographs are combined to create a reading that references history, personal experience, and systems of identity. The use of photographic imagery identifies the content as derived from real events and experiences. A defective snapshot reads as a personal image, while documents and forms, with their dates, add another layer of authenticity. Finally, the handwritten text adds individual character, and the aged appearance of the images through their vintage color and tone creates a reading that speaks of the past.

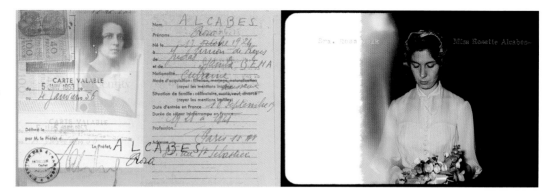

LARRY VOLK, from *A Story of Roses.*

Another form of combined imagery and visual elements in a contiguous space falls under the rough category of *photo collage, montage,* or *image compositing.* This is a common practice in which elements of appropriation and iconographic references are used to build meaning. Collage as a practice differs from montage in that the work is physically combined (typically glued) to create the image, and the material aspects of the work are as much of the reading as the combined whole itself. Montage is a seamless process and the visual whole is the emphasis. Photo montage has a long history within visual arts practice. Jerry Uelsmann is one of the most well-known pioneers of the seamless photo montage perfected in the darkroom. Currently, digital processes makes it fairly simple to create a seamless whole. Within a composite/montage or collage the viewer's reading of relationships between images and elements can be directed through common techniques that can include hierarchy, visual weight, contrast, and juxtaposition to name a few.

WILL BRYANT, STUDENT PORTFOLIO, Austin, TX.

In this example, Will Bryant combines a variety of styles and materials within the space of individual pages. The result has the reference and feel of collage, but digitally generated elements are integrated as well. As an illustrator, it reflects methodologies, style, as well as the ability to work more freely with an open page.

Building Imagery: Illustration versus Photographic Imagery

Digital systems along with traditional methods of image production allow artists incredibly broad-range approaches to create imagery, in some cases combining and converging these media. As a result, it is important to note the distinctions in reading such images.

A photographically based image carries its message quite differently than an illustration that has been hand drawn or digitally generated. Each method or system of image creation has a distinct reading and this effects the viewer's perception and understanding of the images. Photographs have a reference or index to an existing real object or scene, and as viewers we take the image to be real or derived from the real world. Viewers of an illustrated or drawn image enter the point of view of the artist in a different way because they suspend their disbelief, knowing this is an individual's creation.

Throughout his career, Andy Warhol deliberately used halftone images to reference media-based imagery. In addition, he chose to use materials of mass image production, such as silkscreen. Through these image and material choices he reinforced a reference to mass systems of imagery, reinforcing the pop art motifs and conceits.

In the following references, one finds distinctly different types of imagery being used for distinctly different ends. Barcinski & Jeanjean (pg 68, left) rely on photographic images to create a specific visual experience for their website. The rotating panoramic images and the hovering papers linking to specific projects in their portfolio are part of a visual whole. The photographic pictorial space and the effects of optically produced images create a reading that not only gives a perceptual experience of real space, but is reinforced by our knowledge that these images were derived from real space.

By contrast, Yvette Mohan (pg 68, right) uses hand-drawn illustrations in the home page and interface of her website. In this case, the marks, lines, and irregular nature of work produced by hand creates a reading that at minimum suggests that this work is unique and that of an individual. Further, the particular words and illustrations, through their quality, placement, and treatment, read as energetic, active, and free. In essence, one can interpret from a stylistic perspective that these suggest something about the personality and creativity of Yvette Mohan. The character of the marking reads iconographically as the "individualistic, personal, unique." By contrast, once one explores the examples of work within the website, you find very polished, professional design. The website and its hand-drawn elements and interface allow for a more personal and dynamic expression.

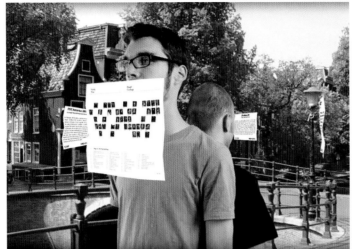

BARCINSKI & JEANJEAN, Amsterdam, The Netherlands.

YVETTE MAHON, Sydney, Australia.

We realized that by shooting the photo footage in stereo, using two identical cameras, and by modifying the 3D rendering engine we could generate interactive 3D scenes to be viewed with 3D glasses. That got us really excited.

The subject for the website, a panorama of us standing on a picturesque bridge in the heart of Amsterdam with our portfolio cases as paper flyers suspended in the air around us, came quite naturally and wasn't thought out at all. But somehow it perfectly suits what we want to tell about ourselves and our work. Barcinski & Jeanjean is us two, so you immediately see who you will be dealing with.

– BARCINSKI & JEANJEAN

The site was initiated by doodling ideas on scraps of paper that would identify what makes my work different from many other creative directors pitching their skills to potential employers. My objective was to illustrate to my target audience that my work originates from creating original great ideas, even if the idea is just a doodle on a napkin.

With this in mind, I commissioned an illustrator and Flash developer to produce the entire visual aspect of my portfolio site using doodles, which helped us develop a unique and exciting visual language for this project that perfectly illustrated a basic truth that I strive to instill in my work: True creativity stems from original thought developed through years of artistic observation and professional practice.

– YVETTE MAHON

Overview

Some compositions are more organized and structured. These can be referred to as "clean and clear." Such a composition may utilize a grid structure to subdivide the space evenly and organize visual elements so that they are aligned to each other and proportionally spaced apart. Other compositions are freer, or even more "chaotic," expressing a more dynamic energy and bold playfulness. There are, of course, compositions that communicate a little of both—it's not necessarily one or the other, but a continuum of choices. Perhaps one element breaks out of a grid structure and is thus itself a more expressive focal point. Compositions can also be symmetrical or asymmetrical, straight up and down or on an angle. Experiment with the possibilities.

Hierarchy

Use hierarchy to develop visual weight and balance to focus attention. All elements within a composition should interact with each other— they should feel like independent parts that are united within a larger whole—and some should be more dominant than others. Don't forget about the back of the book either: Design your cover as a spread, considering both the front and back at the same time.

Negative Space

Activate not only the positive space, but also the negative space in your composition. In most cases, in order to create a visually compelling composition you need to do more than just put an image in the center of the page. Work to activate the compositional space by cropping visual elements and utilizing scale, depth, and angle. Work on your composition so that it isn't static. Remember: Your design should be engaging and interesting to look at. If you get stuck, try subdividing the space or cropping a visual element. Use the space, don't just plop something down and forget about it.

Size and Proportion

Consider the *design and usability* of your portfolio book. Ask yourself if the size, orientation, and proportion could change when you work out the interior layout of the book. Remember that your work is the most important part of your portfolio and should be visually supported by the book's design. Try some example spreads now to see if this will be an issue.

Consider if a size or aspect ratio out of the ordinary would make a stronger and more memorable impact on your audience. However, you need to keep in mind the manner in which you intend to use and distribute your portfolio. Nonstandard design sizes can create additional costs for printing, construction, and shipping. For example, if you want to be able to mail your portfolio you should consider a slightly smaller, more standard size so as not to incur additional shipping costs. Such considerations present a challenge, but can also yield some interesting, inventive solutions.

Always print your design out to get an accurate feel for the physical size of the piece and manner in which the elements are reading!

Overview

Depending on your expertise in this area and the visual style of your cover design, you may want to push your use of typography or just keep it simple. Keep in mind that different typefaces say different things. Each genre of typeface has certain qualities associated with it. For example, there are sans-serif typefaces that are described as "modern" and "clean" (Univers, Futura, Helvetica Neue), and also serif typefaces that are described as "classic" and have more visual contrast to them (Bodoni, Garamound, Caslon). Sans-serif typefaces are usually great for short lines of text (titles, subtitles), while serif typefaces work best for longer paragraphs. There are also decorative typefaces to consider (distorted, techno, handwritten). These are often used in a limited fashion to call attention to a word or line of copy. They are also typically a bit more difficult to read and need to appear larger in scale.

As most designers know, there are times when type is not just part of the design, but the design itself. In this way typography can be the focus of your cover design or integrated into the composition with other visual elements. It could be used concretely as purely a visual component, like texture. In such cases, one is less concerned with readability and more concerned with how the type functions as part of the composition's overall "look and feel." On the other hand, you may very well decide to use type more pragmatically for informational purposes (like to state your name or the title of the book). Lastly, you may even decide to leave type out of the cover design entirely.

(TOP) *KYLIE THORN,* STUDENT PROMOTIONAL BOOK, Ohio University.

(BOTTOM) *LAIA ALBALADEJO,* STUDENT PROMOTIONAL, Suffolk University.

Words of Advice

- Decorative typefaces are not easy to read and typically need to be larger.

- If you're stuck, experiment with type, looking to different genres or people for inspiration. For example, David Carsons' typographic treatment is fairly notorious—fractured, flipped, pushed off the page, inverted, distorted, cut up, mix-matched, etc. (Of course, you need to make sure that the style you are referencing still reflects your brand statement.)

- Consider not only the positive, but also the negative space of letterforms.

- Use a typeface that is a little less ordinary. Don't just use one of the standard Microsoft typefaces, like Papyrus, just because you can't think of anything.

- Take a look at concrete type, using type as a visual element within the composition.

- Consider *tone of voice* by utilizing properties such as scale, color, bold, italic, and the style of typeface. Consider how typography can help give life to your message.

- Consider phrasing—think about the value of space in between letters (kerning) and lines of text (leading).

For the Designer

Nothing says both inexperienced and careless more than poor basic type skills. Don't forget to pay attention to:

- Kerning
- Leading
- The typographic rag

Tips

1. Perhaps there are typefaces associated with a particular visual genre that has influenced your brand. For example, the sleek and jazzy art deco typefaces of the early 20th century are quite distinctive with their stylized, geometric shapes and graceful lines. You should explore the kind of typeface that fits best with the brand style you are trying to communicate.

2. Check out type foundries online to browse through a large collection of typefaces.

3. Look around—books, signs, product packaging, clothing.

Web link: http://www.myfonts.com/WhatTheFont/.

Copy

It's not just what you say, but how you say it. Although you may be more visually than verbally minded, a significant component of a concept and/or brand identity is the copy associated with it. Copy can be an integral part of a design concept. It can take the form of a title, a tagline, or simply a more clever and creative way to refer to a piece of work. By using less typical words or phrases, you can be sure to make your portfolio that much more memorable. In this brainstorming phase, think about how you may want to refer to your portfolio. This process may even help you come up with an overall idea about how to proceed.

Consider:

- Writing with attitude as part of the brand. Consider your tone.

- Providing real information—making what you say meaningful and relevant to your target audience.

- Acknowledging that copy is an important aspect of design. Typical design and advertising agencies pair a designer with a copywriter as part of one integrated team.

- Being concise, relevant, and memorable (in a positive way).

- Trying to avoid the same old, bland, vague language.

- Being careful of using obvious clichés. While it's okay to start with a cliché as a means to spark an idea, make sure you work on taking it to the next level by coming up with your own unique twist.

Visual References

There are many visual processes and techniques that have references to art history and the broader cultural history that is part of our visual lexicon. These can be employed to inform the look and feel of your visual identity and make associations to certain ideas and themes. For example, one could use a photomontage and typographic technique that references the Dadaists and their sarcastically charged works-aimed to rebel against conformity and mock tradition.

Dada propagated a distinctive collage, montage, and typographic style that has been borrowed by less politically committed designers, then and now. Today the Dada style, as reflected in Punk and Neo-Expressionist design, is an effective code for conveying the tempests of contemporary youth.[2]

– STEVEN HELLER

As referenced in an earlier exercise, look to history, current trends, and your own work as inspiration. The key is to make your approach support the intention for your brand. Think about which references are important to utilize in order to communicate your concept and message.

Note: George's postcard series (right) reference the iconic visual simplicity of Saul Bass and Paul Rand. It's also an example of some great copy, which drove the concept for this self-promotional piece. George's portfolio book was then designed in a similar style.

GEORGE GRAVES, STUDENT PROMOTIONAL,
Endicott College.

People Call Me George

But You Can Call Me Anytime.

I Forgot My Number

Can I Get Yours?

Visual Properties and Techniques

In order to develop a more defined and unique visual statement you will need to do a lot more than just put an image down in the center of a composition. You will need to create a cover design that has style and communicates your brand in a manner that is both innovative and meaningful. Your "look and feel" should be created and defined through the emphasis of certain visual properties and the application of specific visual techniques.

Making Something New and Unique

Take this opportunity to make something new and unique. Don't just repurpose a work that is already in your portfolio and use it as the cover design. Instead, develop a design that works best for this specific design problem. Think about all of the visual properties you have to work with. Perhaps you will choose to be concerned with aspects of scale. Or perhaps color, texture, or shape. Perhaps you will focus on the balance of all three. Your visuals may tend to be more detailed in nature in order to make specific references, or more abstract and simplified, referencing broader more universal themes. You may choose to consider aspects of dimension, direction, or motion. You may decide to extrapolate aspects from a previously designed piece or pieces in order to arrive at a new solution. Perhaps there is even an approach that you have employed in a particular project that you can now carry over into this portfolio design.

Experiment

As a visual artist you should experiment with a variety of visual techniques in order to help characterize the meaning of your visual identity and concept. As tools in the visual communications process, each technique carries certain associations that can help express a visual tone or message. There are many diverse techniques and each one can be applied subtly or more dramatically, alone or in combination, depending on the desired aesthetic. However you determine—through techniques like variation, distortion, montage, simplicity, exaggeration, repetition, juxtaposition, intricacy, and fragmentation—you can continue to define and support your desired visual message.

Through the emphasis of some visual properties over others and the manipulation of those properties through various techniques you have the means to create many unique solutions. By working through the visual process you will find the one solution that works best for you.

Caution: Often Less Is More

Don't throw everything but the kitchen sink into this design. You need to make informed decisions about the visual properties and techniques you will utilize. Making decisions means deciding what to use and what not to use. The use of too many techniques will water down your visual voice and design style, and obliterate any associated meaning. If you are struggling because you have more than one specialty area, consider creating multiple books (one for each area), instead of trying to merge multiple references together.

Important Notes

You should use all your own original imagery in your design. If possible, don't rely on any stock or web imagery. If you do use stock imagery, make sure you buy the rights to use it.

Sketch, sketch, sketch!

Revisit the cover design after the interior page layout is determined – changes to size, proportion, etc. may need to be made.

As always, make sure you play with silly ideas on paper too, they get the creative juice flowing.[3]

– FERNANDO LINS, Art Director and Interface Designer

ART DOES NOT REPRODUCE THE VISIBLE; RATHER,
IT MAKES visible.

PAUL KLEE
Artist

MATERIALS & FORMS

There is a great deal of variety in the methods and construction of a book or portfolio. Our intention is not to turn you into book artists, as much as offer you a range of possibilities in an effort to support the visual identity and presentation you wish to create. The work of bookbinders and book artists can involve intricate detail and exquisite craftsmanship. While this may or may not be purposeful in relation to your intentions, an understanding of what can be designed and constructed is important for developing your portfolio.

Binding

The basic goal is to make a book that functions well and allows you to present your work in a context that you have designed. In exploring how your portfolio is to be bound, *flexibility* is a consideration. A standard binding with a hard board cover is not something that can be easily taken apart when you wish to change the content in six months. Simpler, flexible bindings allow you to be fluid and create materials that can be easily tailored to a specific audience on-the-fly.

Some of your choices may be determined by your skills. There are numerous binding methods that allow for clean presentation and function effectively without requiring extensive experience in book construction and book binding. Furthermore, even if you hire someone to build your book for you, an understanding of the types of bindings and materials will inform the process of having your book made.

The following books and bindings are easily constructed with a minimum of skills and materials. They all take the basic form of a codex, which is a set of pages, bound together.

Glued Back-to-Back Binding

A glued binding or adhesive binding that does not allow for page replacement, but is inexpensive and easily constructed [below, p.80]. This binding allows you to print all of your page spreads on single-sided paper, and avoid the complications of two-sided or duplex printing with a desktop printer. The limitation of this binding might be that of page size and page count. A book of 30 pages up to 8 × 10 inches is a workable size and page count, as beyond this the book may require a stronger binding and spine.

Spiral Binding

This can be a flexible and inexpensive choice that is readily available and can be easily replaced. While it is used as a common office report binder, the spiral itself can be an appropriate binding as long as it fits within the visual identity you have developed.

ROSIE FULTON, BACK-TO-BACK BINDING,
Endicott College.

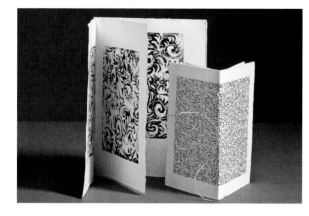

NICOLE GOBIEL, TWO SEWN PAMPHLETS,
Endicott College.

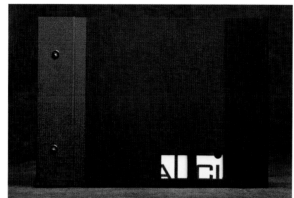

KELLY SAUCIER, POST AND SCREW
PORTFOLIO, Endicott College.

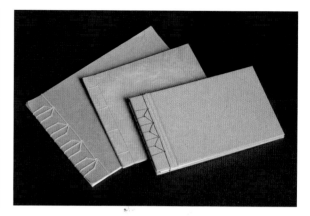

AMANDA NELSON, STAB BINDINGS,
Somerville, MA.

Stapled or sewn pamphlet or booklet. Similar to a back-to-back binding in that it has a limited number of total pages due to its method of construction, this method is easy to create and requires either a sewn or stapled closure to hold the pages together. It does require two-sided printing to create the page spreads. There are inexpensive staplers available that are designed to accommodate the depth of the page, allowing for center stapling in the gutter or fold of the booklet.

Post and screw. This is a removable binding for easy replacement of pages. The pages can be single-side printed or duplex printed. These are easy-to-create bindings with hard board covers that can be opened and changed when needed without very much effort. They each have a particular appearance, but are not substantial enough as to overshadow a cover treatment.

Japanese or stab binding. This binding incorporates similar board covers as the post and screw, but has a slightly different appearance since the binding is sewn together with a three-, four-, or five-hole pattern.

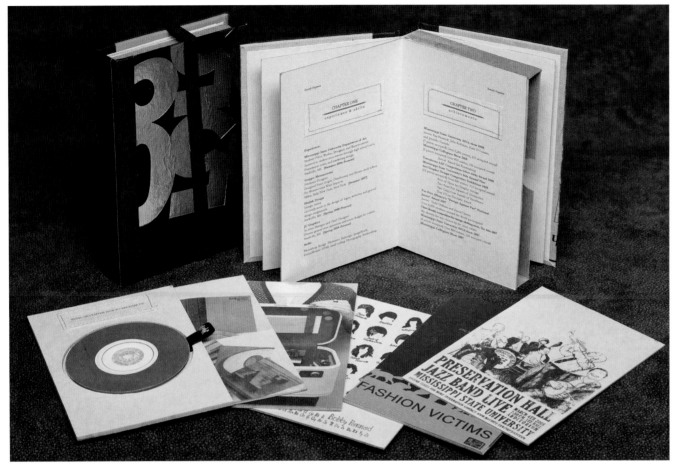

Unconstructed binding or folio—portfolio that is not formally bound together, but held in a container as loose materials.

BEVERLY HAYMAN, STUDENT PORTFOLIO, Mississippi State University.

As seen in Beverly Hayman's portfolio, the works are presented as an unbound set of examples in a finely crafted container that makes a professional statement.

Covers: Softbound versus Hardbound

Constructing you own covers allows you a range of options for page design and form. Literally, you can bind anything from a standard rectangular format to a round book with round covers. Traditional hardcover books are made with "board covers." Board covers are commonly made with book binder's or Davey board that is easily cut and glued together. Typically, binder's board is covered with book cloth, buckram (leatherette), or printed paper, but can be used raw or uncovered. Book cloth is available in a variety of colors, and is quite flexible and strong. It has a backing to prevent glue from seeping through the cloth when making covers. In designing and making your covers, standard-issue book cloth is a starting point, but take a trip to any store that has custom-made papers, or a fabric store, and you will realize that there is a rich variety of choices available to you. You can use sizing or backing on a variety of cloth to utilize it as a book covering material. Covers with materials such as metal, vinyl, wood, and plastic are all options that can be exercised as long as they feel relevant to your concept and design.

ALLISON V. SMITH, PROMOTIONAL MATERIALS, New York.

Softcovers can be made of any paper, they can be printed, and, as with board covers, made to any size you determine. Because softcovers are lighter, you can utilize a less robust binding. They offer a great deal of flexibility since any printed page can be used as a cover. Referencing the appearance of a particular type of softcover book can drive a concept as well. *Comic books* and *Zines* are good examples of softcover productions that could be utilized as a portfolio concept. Essentially a stapled pamphlet, they are easy to produce and offer great flexibility.

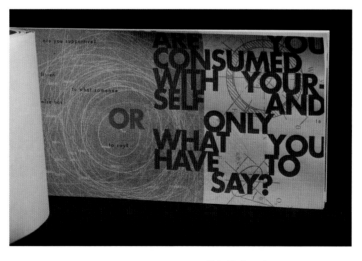

KYLIE THORN, STUDENT BOOK, Ohio University.

Spine, Hinge, and Clasp: Closed versus Open

The spine is the back edge of the book, where the pages and covers are joined. Depending on the number of pages in the book, the spine can vary in thickness. Spines can be open, as seen in a stab binding and post and screw (p. 77) and the back-to-back binding [right]. Closed-spine books don't necessarily require tying or some kind of closure. A closed spine can be made of book cloth and can be functional or decorative.

Just as the spine can be open or closed, the leading edge (fore edge) of the book can be open or closed. The leading edge of the book can have a cover or "flap" that can close via a magnet, a clasp, or any number of methods.

The limitation of closed-spine and closed leading edge books is that the width either of the spine or the closure needs to be made to accommodate the width of the book's assembled pages, or book block. This does not allow for significant changes to the number of pages in the book. If the book gets thinner or thicker, the binding will appear too lose, or be difficult to open and close.

As simple cloth tie can be an elegant way to create a closure for a bound book, or folio. Book artists often create **custom clasps from wood, plastic, bone, and metal**. Common hardware and closures can be repurposed into book binding clasps and hinges and are worth exploring as well.

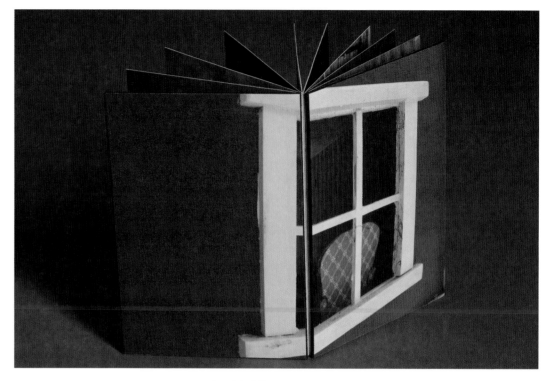

ANN PELIKAN, ARTIST'S BOOK, Ipswich, MA.

KELLY SAUCIER, MAGNETIC CLOSURE, Endicott College.

AMANDA NELSON, CLASP CLOSURES, Somerville, MA.

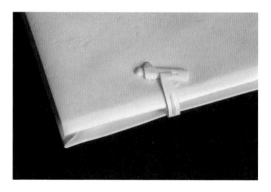

AMANDA NELSON, BONE CLOSURES, Somerville, MA.

Variation: Sewn or Stitched Bindings or Nonadhesive Bindings

There are a great many intricate nonadhesive bindings that incorporate decorative sewing of the spine to construct the book. These can be elaborate and elegant. The nature of this binding style can create an emphasis on the craft and material of the book, as the method of binding is distinct and a visible element. Depending on the body of work and the concept behind the portfolio, this element of the book's construction and structure can contribute to the visual identity of the individual who incorporates it. This example (right) is a sampler of sewn binding stitches. From left to right: kettle, coptic, double cord (raised cord), single cord (raised cord), recessed cords, tapes, kettle.

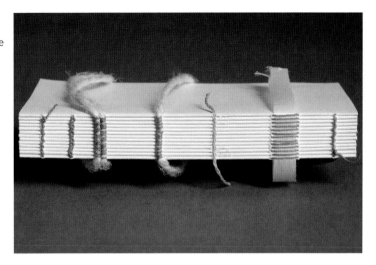

AMANDA NELSON, STITCHING SAMPLER, Somerville, MA.

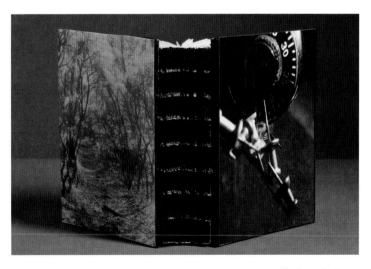

AMY GRIGG, COPTIC STITCHED BINDING, Endicott College.

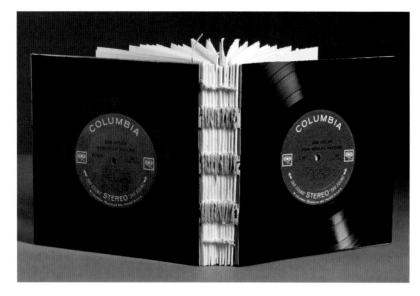

AMY GRIGG, COPTIC STITCHED BINDING, Endicott College.

Wood, Metal, and Alternative Materials

Cover materials do not have to be derived from standard book binding supplies. The choices are unlimited if you wish to explore other kinds of fabrication and book covers can be made out of a variety of materials other than traditional board and cover stock. Metals can be hinged and fabricated to create a unique look and feel. Plastic and vinyl can form colorful and durable covers that can contribute to a unique visual identity. The range of such choices is a function of the visual concept you wish to explore and the practicality of making and maintaining the book. Making a unique object can be an effective way to have your work stand out from the other portfolios that are being reviewed. We recommend exploring the book binding resources in Appendix A as well as online resources to learn about the possibilities for book construction.

Windows, Cutouts, and Insets

In making a custom cover, you can embellish the cover form with various elements. Beyond the cover cloth or papers used, a cover can have windows revealing an inner page, and those can vary in size depending on the relationship of the cover image to the interior page. Making a cutout in a board cover is a simple matter of cutting and measuring prior to construction. The layout and content of the interior page behind the cover needs to be designed and considered to work with the cutout or window.

Inset images, labels, or other visual elements can be built into a cover design as well. The inset can create a focal point on the cover and allow for a custom label or title. This again is a simple matter of preparing the book board prior to covering it (see Step 5: Book Construction).

CARRIE BINETTE, GALVANIZED STEEL COVER, Endicott College.

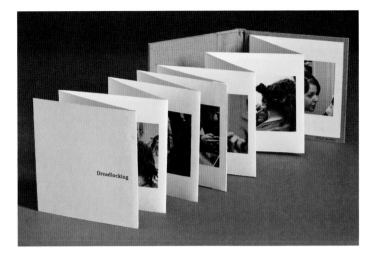

HILARY BOVAY, ACCORDION-FOLD BOOK,
Endicott College.

Accordion-Fold Bindings and Concertina Bindings

Accordion-fold or fan-fold books provide an opportunity to present a sequence of images or images and text that can be easily printed and assembled. Covers can be glued or nonglued, and made of board or papers. There are many variations and printing is simplified by having to only print to one side of a page. Longer sequences can be achieved by joining folded sections with glued tabs or folded pieces.

In this variation (left), **wraparound board covers** with a hinged spine are built and the folded book is attached to one end panel. Once opened, the book can be extended out to be seen in its entirety, or can be viewed folded as sets of facing pages.

For folded pleat or expanded pleat [bottom left], a strip of paper is folded and pages are attached to the fan-folded strip. This allows for spacing between each page depending on how thick the folds are in the pleated strip.

Separate covers: In this variation [bottom right] by David Le, the accordion-folded sequence is adhered by the end pages to two separate board covers. This book can have closures, which can wrap the book or an independent closure for each edge.

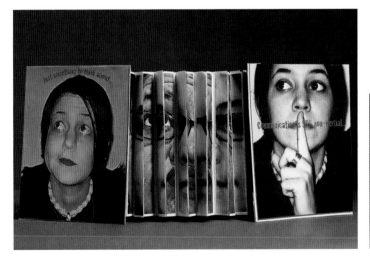

MEGHAN PHILLIPS, ACCORDION-FOLD BOOK,
Endicott College.

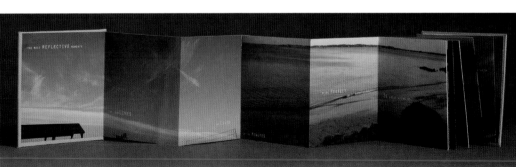

DAVID LE, PANORAMIC IMAGE, ACCORDION-FOLD BOOK,
Endicott College.

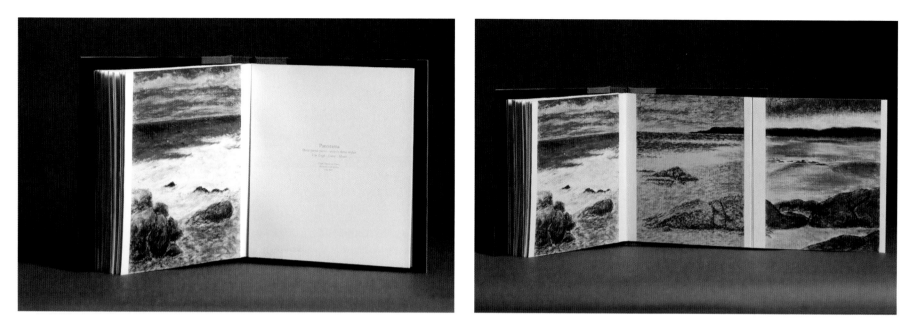

KATHERINE KING, STUDENT PORTFOLIO, Endicott College.

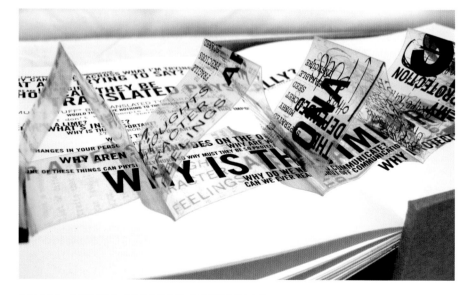

ALISON MURPHY, STUDENT PORTFOLIO,
Massachusetts College of Art & Design.

DANA NEIBERT, PROMOTIONAL WITH EMBOSSED FLAP, Coronado, CA.

Folded Pages and Inserts

A folded page can be built into a single set of pages or as a component of the entire book. This allows for the presentation of multiple images or a series of works without having to distribute them over multiple pages. Images that may require a longer aspect ratio than that of the overall book can also be presented with an extended page that is folded [opposite page top left and right]. Inserts allow one to include additional pieces within the portfolio. These can be constructed items, or samples of a particular piece, or a leave-behind, such as an electronic version of the portfolio.

Flag Books

Flag books represent more complex page construction and visual interaction as a result of the binding method. They reflect the potential for books to be more than simply a device to hold and organize images or text, but a complex object.

Pop-Up Books

Taken further, the pop-up book extends the physicality of the flag book. Again, the possibilities are numerous, and if appropriate, allow for unique presentations. In the example [opposite page lower left], a project by, Allison Murphy creates a variation on the pop-up by the use of a pull-out transparency element which is built into a page.

Embossing

With embossing [opposite page, lower right], text is imprinted into the paper, creating a raised impression. Commercial printers can create custom dies to emboss (or deboss creating a depressed imprint) paper.

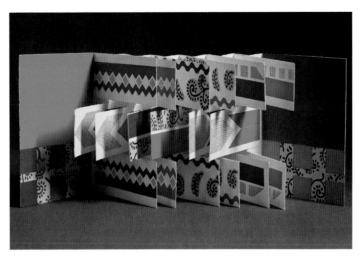

NICOLE GOBIEL, F L A G B O O K, Endicott College.

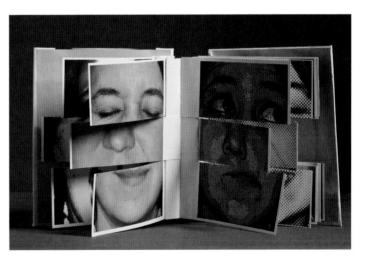

MEGHAN PHILLIPS, F L A G B O O K, Endicott College.

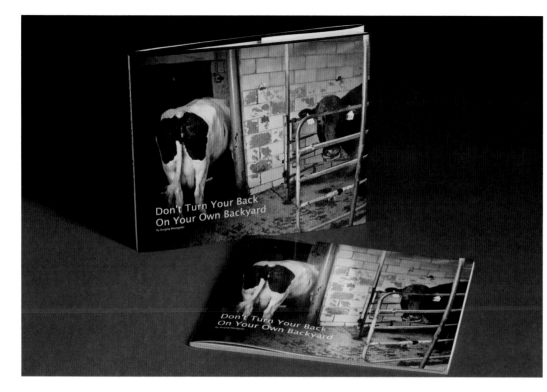

Commercially Available Book Binding

Many individuals and artists are using book printing services through online retailers. With the development of digital short-run printing, online book printing services have grown. These services run the gamut from consumer-oriented low-cost book creation options via online photo hosting and finishing sites, to those which are aimed at professional photographers and artists. The range of options in terms of format, customization, paper stock, and print quality is quite varied. Frequently referred to as "print on demand," the greatest advantage of these services is lower cost than traditional book printing and the ability to create one-off versions. This allows for tests and adjustments as well as changes, and creating books tailored to specific work and clients. There are numerous services, and one should seek out those who specialize in photo books or image-based books. Self-publishing services for text-based books are less likely to consider issues of design or the quality the reproductions.

Consumer Retail Services

Online photo-finishing services offer book or album creation options that usually are perfect bindings or hardcover bindings. These are a relatively new phenomenon and can offer interesting alternatives that are inexpensive and of reasonable quality. They typically use proprietary software for layout and uploading your book and have a number of standard-size book/page combinations. The limitations of these providers are often the paper stock and image quality. The biggest issue for the designer is the lack of fine control over the placement and treatment of type. Most of the software systems used to create books are not intended for sophisticated and precise control of image and text. All that being said, they can provide an option for limited-run multiple editions and are inexpensive even when printing only one book at a time.

Apple's iPhoto, Shutterfly, Kodak Gallery, and Snapfish are a few examples. They are very inexpensive, and with a little diligence one can produce a fairly good product. The consistency of the finished product may be an issue here as well but they are so low cost one could probably print multiple tests to work out the bugs if necessary. What you produce becomes your face in the world, so if better control over the design and production is needed, there are a number of options.

Blurb, Shared Ink, LuLu, and VioVio offer low-cost options, with good quality and choices of hard and softcover bindings.

Blurb, for example, uses a proprietary formatting software that can be downloaded for free and makes it fairly simple to work to put together your book. They have a number of fixed formats and options, including text formatting, multiple-image page layouts, hard or softcover from the same layout, and uploading directly from the software. With a little bit of work, one can produce a high-quality single book or inexpensive multiples that could even be used as leave-behinds.

Vio Vio offers options to create a book with browser-based software, and for better control, you can create PDF files that can be uploaded. They have specifications for the PDF allowing you to work in Indesign, Illustrator, or Photoshop with much greater control over the page design and typography.

Professional Services: Asukabook, Paperchase, and Pitko Photobooks

These are examples of print-on-demand services that are oriented toward professional photographers and artists. They have higher-quality papers and inks and offer professional services such as proofing, custom stamping, and embossing. In each case, books can be designed, and built with templates or with custom-designed variations. The costs here are at least 50 percent more per book, but one has the ability to proof, select paper stock, and make a much higher-quality product.

Color Management

The use of ICC (International Color Consortium) workflows is becoming more of the norm with online publishing services. Asukabook does offer ICC profiles, or in the case of Blurb, you are directed to customers who have employed a color-managed workflow with some success. In both cases this is recommended, because reproduction quality is essential. The use of color profiling allows you to preview or soft proof all your images in relation to the type of printer to be used by the service. Color management and ICC workflows are discussed more in Step 5, Book Construction.

Web Links

Apple Photo Books: http://www.apple.com/ilife/iphoto/print-products.html

Shutterfly: http://www.shutterfly.com/

Kodak Gallery: http://www.kodakgallery.com/

Snapfish: http://www.snapfish.com/

Blurb: http://www.blurb.com

Shared Ink: http://www.sharedink.com

LuLu: http://www.lulu.com/

VioVio: http://www.viovio.com/

Asukabook: http://asukabook.com/

Paperchase: http://www.paperchase.net/

Pitko Photobooks: http://www.pikto.com/books)

Design is a plan

FOR ARRANGING ELEMENTS IN SUCH A WAY AS BEST TO ACCOMPLISH A

PARTICULAR PURPOSE.

CHARLES EAMES
Architect, Graphic and Industrial Designer, Filmmaker

LAYOUT

The main objective of the interior page layout is to demonstrate your abilities and experience by showcasing visual examples of your work. This constitutes the "body" of your portfolio and serves a different purpose from the cover design. Examples of your work should provide the tangible proof of all the promises your cover design implied—that you are indeed talented, skillful, and knowledgeable! So, the primary visual focus of your page layout should be on the work itself. Additional compositional elements and textual information should not distract or undermine your efforts to establish a clean and clear visual presentation of your work.

Q&A: Interview with Hyun Sun Alex Cho, Associate Creative Director, Ogilvy and Mather, New York, NY

Alex Cho is an innovator in graphic design. Her strength comes from her ability to communicate the needs of the client through creative ideas that deliver strong visual identity and message. Ms. Cho is focused on creating unique experiences through multiple media and channels, producing outstanding results for her clients. In her current position, she has created digital advertising campaigns for major brands like Unilever, IBM, DHL, Kodak, SAP, Motorola, Aflac, and Wyeth.

How important do you feel an online and/or print portfolio is in securing a creative position in your industry?

It's very important to have an up-to-date portfolio early on in your career. It's the only way to prove you've got the skills and talent.

How important do you think a brand concept or overall visual identity is in the success of a portfolio design?

I believe that the work is the most important part of a portfolio. However, a portfolio that has a strong concept and identity can showcase the strength of one's talent. Having a strong visual identity can also help you stand out from the crowd, so it's more memorable. This should not be distracting to the presentation of the work itself though.

In general, how many pieces of work do you think a student should include in his or her portfolio?

I recommend around 15 pieces for the student portfolio.

Do you have any advice for a student currently working on his or her portfolio and/or other promotional materials?

It's important to show confidence in your work. Make it simple and easy to view the work and let the work speak for itself. Also, include some variety but show the best pieces that best reflect your talent. If there's a certain area of the industry that you are interested in, make sure to include more pieces for that area of expertise.

Visual hierarchy is used to establish an "order of importance" for various visual and textual elements within a compositional layout. Through the use of visual emphasis you can direct someone's attention to certain elements on the page and even direct what he or she will see first, then second, and so forth. **Visual emphasis essentially draws your attention to a particular area through the use of contrast and highlights certain aspects by making them visually dominant.** This can be done simply through the use of a bold color, larger scale, or an area of texture within a flat field. Visual emphasis can also be achieved through more complex means, such as creating visual tension between juxtaposing elements or by creating a more intricate shape or image. Whatever the visual technique, this is one of the most important aspects to consider when beginning the layout of your interior pages. In designing these pages it will be important to establish a clear visual hierarchy while also providing continuity and consistency among pages throughout the interior sequence.

One Page versus the Page Spread

You should consider whether or not you want to make use of the entire page spread (both the left and right page together) or just one page (typically the right side). In part, your decision should be based on how you intend the book to open and whether or not it will lie flat. If it won't, although working with the entire page spread gives your composition more "room to breath," it may feel awkward if both pages can't be viewed together. Your decision may also be influenced by the page size and proportion you choose for your overall portfolio. If you are working with a larger page size, perhaps you don't need any extra room. Just keep in mind that you shouldn't crowd images of your work, and you will need to leave a healthy margin of space around them.

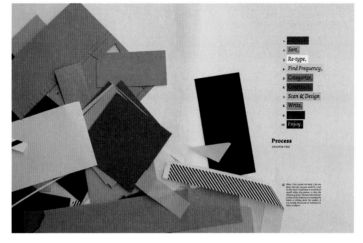

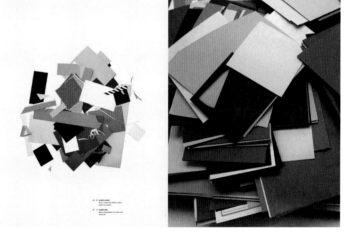

GRETCHEN NASH, STUDENT BOOK,
California Institute of the Arts.

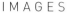

IMAGES

See our website at www.noplasticsleeves.com for a
diagram on how to shoot 3D work.

The first step is to figure out what elements you want to include for each work. At a minimum you should of course include at least one image for each piece and some contextualizing information.

Number and Size

You should decide up front the number and size of imagery you want to include for each project. So, for example, you may decide that all landscape photographs are displayed at 7 × 5 inches and 300 dpi (dots per inch). Perhaps for certain types of work you decide to include a series of images or thumbnails in order to showcase important aspects, close-up details, or even sketches of the work at various stages. When presenting a three-dimensional (3D) piece, you may want to include a number of images that showcase the work from various angles. For an animated film or motion graphics piece you may decide to include multiple "key" frames as part of a sequence of images. You may decide to showcase interactive work as two 320 × 240-pixel screenshots of a homepage and a secondary page.

Keep in mind that the orientation (and aspect ratio) of each piece should remain as close as possible to the original. While the physical size of the imagery within the composition is somewhat dependent on the overall page size, remember that the work itself should be the focus and should probably take up the greatest amount of space. However you decide, it's usually a good idea to keep each piece to one page (or page spread) within the portfolio. In some cases, a very involved project could potentially be displayed over multiple pages if there were a number of parts to it.

Quality

Images of your work should be reproduced directly from their native digital file format and then converted (if need be) to a high-quality standard bitmap format. If a work is three dimensional, it is recommended that you digitally photograph it (or ask someone who can). Your images should be physically large enough on the page to see some actual detail within the work itself. There is nothing worse than opening up a portfolio and not really being able to see the work because the images are physically too small or simply poor quality. Potential employers shouldn't have to squint or hold your book up to the light in order to see your work.

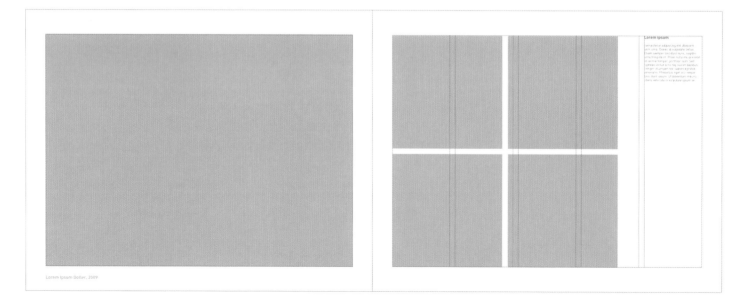

You should include at least a title or some other system of identifying each work, like simply numbering. The size of the work is often included, especially for larger-scale projects. You may want to consider providing a reference to the date, season, or year in which the work was completed. Often it is appropriate to include the medium and even materials used, especially if significant to the process or creation of the work. For interactive work, you should also include a URL to the live website.

Remember that the focus of each layout should be on the work itself. Include only as much information as you think is really necessary to appreciate the work and/or the manner in which you organized it. Say, for example, you are organizing your portfolio as a timeline, demonstrating the progression of your capabilities over a period of time. It would then of course be important to include a reference to the date or year (junior year, senior year) in which the work was completed. You could, for example, decide to include dimensions for all your work, or just for those pieces for which you feel scale is an important aspect.

As you figure this out, try to be as consistent as possible with the types of information you are providing throughout the book. Depending on how you group and organize your work, it may also be appropriate to contextualize a series of work with an introductory statement or title. Such information could be presented on its own separate page preceding the series. This can be especially useful to help explain the thinking behind a more complex or lengthy endeavor, such as a senior thesis project.

One of the biggest challenges that designers have to overcome is simply deciding on the amount of content and information to use.[1]

– STEVEN SNELL, *Smashing Pumpkin Magazine*

Composition: The Grid

One of the most broadly used techniques in page layout design is the utilization of a *grid structure*. A grid divides the compositional space into proportional units and is used in almost all magazine, book, and newspaper layouts. They provide a strong means of grouping and organizing information and ensure both consistency and flexibility across a multi-page sequence. A grid structure consists of evenly spaced horizontal and vertical lines that interconnect to form uniform grid modules that can be proportionally subdivided even further. Together, the grid modules form a number of columns and rows, creating an underlying structure that can guide the placement of content on the page. Content-related elements, and sometimes even compositionally, related elements, align to the intersecting points on a grid. Typically, grids also include a consistent margin along the outer edge of the page and in-between individual columns (called "gutter space," which is necessary when dealing with multiple paragraphs of text). In a traditional layout, it would be considered "bad form" to place content outside of this outer margin.

Note: Label each piece in a manner that is meaningful to the target audience. Titles or labels specific to an educational institution (like a course number) are problematic because they don't mean anything outside of that institution.

Number of Columns and Rows

The number of columns and rows within a grid structure is entirely dependent on the content itself—amount, groups, and variation. It is best to avoid having all your content clustered together, and at the other extreme, making it all into separate little parts. The amount of content and number of groups usually determines how many columns and rows you need.

Typically, as the number of rows and columns increases, so too does the flexibility of the grid system. However, grids that are more complex than need be (too many columns and rows) often defeat their organizational purpose. Too many smaller grid modules can render spatial relationships unclear to the eye and make it difficult to see what the positive and negative spatial relationships are supposed to be.

Within a portfolio book, the amount of content needed for each page layout is probably not very great. Most often you are working with a few images, a couple of lines of text, and a compositional element or two. So in most cases, a simple grid structure (a range of three to six columns/rows) will do the trick. Keep in mind that the number of columns versus the number of rows will be different unless you are working with a square format.

If you find you need greater flexibility in terms of positioning content within a particular page layout, cut a column or row in half (or even thirds). As long as you always subdivide the space proportionally, your grid structure will hold up.

margins

spatial zone

flow line

gutter space

grid module

Grouping: Alignment and Proximity

When elements are broken up and interspersed throughout the composition those elements and the spaces between them appear disorganized and unrelated. By grouping elements you can create stronger, more organized relationships. In turn, the negative space becomes better consolidated. This creates a more simplified and cohesive perception of the composition and its elements. While there is an implied connection between all elements in a composition, if you study the content closely you will discover that some elements functionally belong more closely together than others. Keep in mind that you should place more emphasis on some groups and less on others (hierarchy).

The grid provides a strong organizational structure that can help group and connect various types of content together. This is done through the use of *alignment* and *proximity*. By putting elements in closer proximity to each other you create a perceived contextual relationship between them. A grid module represents a fixed unit of space that can be multiplied and divided proportionally in order to group and separate content by means of a consistent increment. When you align content you place elements along the same vertical or horizontal axis (grid line). This creates an invisible line connecting those elements together. This "line" also creates a sense of movement and direction as it activates the composition. Using alignment is an especially useful technique when you have a limited number of elements to work with, but still need to break up enough of the negative space within the composition. Through the use of alignment you can physically separate elements across the composition while still implying a connection between them.

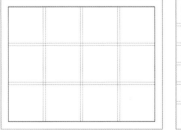

Image Layouts

As you review your work, decide which pieces can be displayed in a similar manner, either because they are part of a series or simply because they are in the same category of form or medium. This will allow you to begin narrowing down the different types of image layouts needed. There should be consistency in the number and size of imagery within work that falls under the same category. At the same time, you'll still need to allow for enough flexibility from layout to layout to account for a variety of work. You should, though, try to limit the variation between layouts as much as possible. You want your portfolio to feel cohesive and a big part of that is deciding on a limited number of possibilities. This doesn't mean that there can't be exceptions, but it does mean that you should be consciously making decisions about how the layout of your work will fit together as a whole. Keep the book's size and orientation in mind—it's unprofessional to make someone have to rotate a vertical book to see a horizontal image (or vice versa). Account for all the sizes and variations needed to display your work properly.

You could also consider the addition of special inserts within your portfolio book. These can be used to make the book more interesting and feature something in an unexpected way, such as a close-up, full-page bleed (all the way to the edges, or pop-up image.

WILL BRYANT, Mississippi State University.

In this example, while the size and number of images varies, the placement of both the title and the top left corner of the image is consistently placed in the same spot within the grid structure. This systematic approach provides for a well organized visual layout, achieving cohesiveness and unity across multiple pages.

Negative Space

Layout design is as much a consideration of the arrangement of elements you add into the composition as it is a consideration of the spaces left between them. In general, compositions become more visually active when they are subdivided into discrete areas of positive and negative space. By breaking up larger areas of negative space with visual elements (a title, an image, a compositional graphic, etc.), you can start to activate these "empty" areas and engage the entire composition. Furthermore, when you subdivide the composition into proportionally equal parts (such as with a grid) you can interconnect the positive and negative spaces by establishing a geometric relationship between their relative sizes and the increments of space between them. Through repetition, these areas of positive and negative space compliment each and establish a rhythmic pattern throughout the composition and even entire sequence of pages. Through this organizational scheme a sense of unity is created and content is not just left "floating" in an empty background.

Design is as much an act of spacing as an act of marking.[2]
 – ELLEN LUPTON, Author
 Thinking with Type: A Critical Guide for Designers, Writers, Editors, and Students

Margins of Space

It is important to provide negative space around images of your work (and any bodies of text explaining that work) so that each can be viewed as cleanly and clearly as possible. Figure out the margin needed and then be sure to apply that consistently to images and text throughout the portfolio sequence. It is recommended that you additionally avoid heavy frames or outlines around images of work, as these can be distracting. Let each piece speak for itself and be seen as is, devoid of anything taking away from it.

Single-Column Grid

Consider the following for a single-column grid structure:

- Most basic positional framework.

- Need to pay attention to margins.

- Classical approach: margins are larger on the side and bottom and smaller at the top, and the inner margin is half the outer margin.

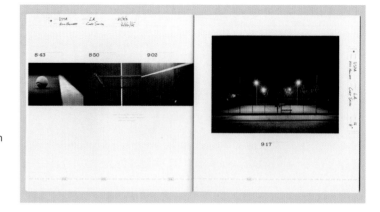

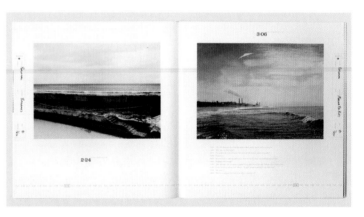

DANA NEIBERT, PROMOTIONAL BOOK, Coronado, CA.

Don't let the materials become the focus of the communication—your images need to be the focus.

– DANA NEIBERT

Examples: (top) equal margins & full bleed,
(middle) classical margins with page balance,
(bottom) wider inner margin & horizontal image
alignment.

Spreads & Margins

Two adjacent facing pages are together called a spread (also
referred to as a double-page spread). Traditionally a text block rests
in a consistent spot on each page and margins are of equal size
around that page. The inner margin can appear larger (double the
outer margin) because the inner margin from both pages are seen
together on the interior of the spread. In general, narrow margins
create a sense of tension as elements interact with the edge of the
page. Wider margins establish a sense of stability and calm.

The margins around the page however do not have to be equal. In
fact, there are classical page designs that set the outer and bottom
margins wider. In addition and especially if you are considering a
hand-bound book, you may want to set the inner margin generously
wider than the outer margin. In doing so you won't have to worry
about content getting pushed into the gutter – the place where
the two pages meet in the middle and where the book is bound.
Typically, unequal margins create a more dynamic visual tension
throughout the spread.

If the page margins are not equal you will need to consider that the
recto (right) and verso (left) pages have slightly different layouts –
essentially mirror images of each other. As such, an image on
the left side page aligns to the grid from its top *left* corner and an
image on the right side page aligns to the grid from its top *right*
corner. This way, content on both sides are spaced equidistant from
the outer margin – which should be the same width. In any case,
the gutter margins should take into consideration the amount of
space needed for binding.

In addition, the order and arrangement of pages in a book (termed
pagination) also needs to be considered.

Sequence

As mentioned before, the use of a grid can be a vital component in providing continuity among pages, structurally connecting each page together in a sequence. **A grid structure can provide a guide in the consistent placement of elements, especially those that will repeat throughout a sequence.** Doing so often unifies pages together and creates an expectation that certain elements will remain in certain "zones" from page to page. This allows the reader to concentrate on the important stuff and not get distracted by page numbers that jump around or blocks of text that move randomly about from page to page.

Through the utilization of a grid structure you can easily move elements based on the proportional increments of the grid module. In this manner, the movement of elements from page to page will not seem random, but will reference an underlying visual system that can be repeated. By referencing the grid and moving elements by proportional and consistent increments you can create variation and flexibility across a sequence while still establishing a unifying and discernible interconnected pattern.

In most publications there are at least some elements within a layout that remain in the same spot throughout. This is especially true for those publications that are more densely populated with content. However, even with more sparsely populated layouts, it is a good idea not to allow elements, whether content related or compositionally related, to move slightly and randomly from page to page. This can make the elements appear as if they jerk around in an awkward, sloppy, and unprofessional manner. So, try to keep at least some elements in the same exact spot from page to page (or start in the same spot from page to page).

By using a consistent start point for varying image sizes and a consistent increment of space to adjust for the placement of text, you can account for a variety of sizes and aspect ratios. In fact, some variation can make for a much more interesting sequence. Additionally, as previously discussed, keep in mind any differences between recto and verso pages layouts when working with a spread. If you do move elements around from page to page, do so with consideration and intent.

Print, Print, Print

Make sure you print out your layouts so that you can get an accurate sense of the size and proportions of your work within the compositional space. If need be, go back and make adjustments to the size and proportion of your book design, including altering the cover design to fit. It's important that the images of your work read well, so make sure it all works.

INTERNAL / EXTERNAL
Dexterity and outsider details.

Since I have outlined my relationship with everyone included in this book, it is only fair if I tell you a bit about myself first. My full name is Gretchen Jean Nash. I am 21 years old at the moment and I grew up in Saginaw, Michigan. My immediate family consists of my mother (Janet), my father (Jack), and my brother (Philip). May parents still live in Saginaw, and my brother lives in Seattle. I am very close with all of them and honestly it breaks my heart that we all live so far away from each other. My father has lived in Michigan all of his life and was raised in Saginaw, my mother has been in Michigan for most of her life and moved to Saginaw after college.

The population of my hometown is about 70,000. It's not wealthy city by any means and is also a center of intense racial segregation and gang violence. I was fortunate enough to never face any of the violence there, but whenever I read the news or watched it on TV the reports only seemed to be depressing stories about how so and so got shot and killed with their baby, or how another person went missing. Saginaw's violence rating was 4.5 times higher than the national average, and is ranked the 14th most dangerous metropolitan area in the United States. The population has been consistently declining over the past few decades as a result of job cuts. On a brighter note, Stevie Wonder is from Saginaw and it has also been mentioned in the Simon and Garfunkel song "America."

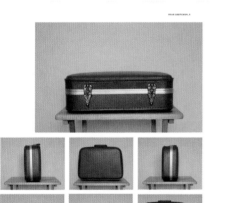

LUGGAGE ANGLES
A view of the luggage unit from all possible angles.

I currently live in Valencia, California. I moved here to go to college for graphic design and I am currently in my last semester of my undergraduate studies. The hardest part about living far away from Michigan is that I get homesick a lot, but whenever I go back home to visit I feel extremely disconnected because not many of my friends live there anymore. After high school, most of my friends moved out of Saginaw and most of my ties with them were severed. It is a very unfortunate reality because I always went to a small school, and for some reason I always felt like those friendships would last a lot longer than they did.

In a lot of ways, the friendships that I had in my childhood seem so much more real and genuine to me than most of the friendships that I came across after I moved away. That is mostly because things were much more simple back then. A friend backstabbing you in elementary school by calling you a jerk is so much better than a friend backstabbing you by sleeping with your boyfriend in college. My childhood friends are people that I actually grew up with, people that can relate to where I came from, and people that know my history. Michigan was the place that defined who all of us were and who we would grow up to be. There will always be an undeniable connection with all of them because of this, regardless of whether we still talk or not.

I was once told that you have fully developed who you are by age 8. At first I was skeptical, but after the completion of this project I cannot tell you how true that statement really is. I truly am the product of everyone that I have ever interacted with. Of course we all continue to grow throughout our lifetimes, but there is just something so powerful about childhood that seems to define everything that we do as adults.

Yours Truly,

GRETCHEN NASH, STUDENT BOOK, California Institute of the Arts.

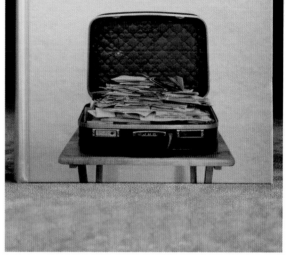

Software note: Use the grid system available in Adobe InDesign to help you work out proportions and lay out the page.

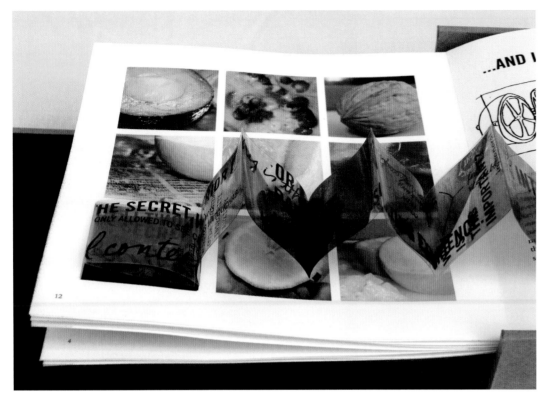

ALISON MURPHY, STUDENT PORTFOLIO, Massachusetts College of Art and Design.

Rule of Thirds

A popular compositional method in photography is the *rule of thirds*. The same principle can be applied quite easily to layout design. Subdivide the page evenly into three columns and three rows. This will create nine grid modules. You can use these as a guide when grouping and separating text and imagery on the page.

- Use the horizontal and vertical grid lines to align content. Focal areas are created at the four intersecting points in the center.

- Each module can be subdivided even further—in halves or thirds, both horizontally and/or vertically, if you need more versatility within the page layout.

- Don't forget that you may still need a margin of space around the outside of the page, especially for text.

PHOTOS

KRISTEN BERNARD, STUDENT PORTFOLIO, Endicott College.

Extending the Visual Identity

A visual brand identity works through repetition of specific visual elements. It's important to make sure that there is consistency throughout the entire portfolio book and other related parts so that your visual voice is communicated in a consistent and cohesive manner. Consider which visual aspects from your visual identity and cover design should be carried over into the interior layout. At the very least you should consider using a consistent color and typographic reference from cover design to interior layout. These aspects will also be useful in visually uniting your resume and any other promotional pieces. Keep in mind that while *you should not incorporate distracting graphics into the interior layout*, you can make more subtle secondary visual references. Graphical and linear elements can activate the compositional space and support the primary content by creating movement and directing the eye's focus. Work to ensure that all elements are cohesive and well integrated.

Text on the page functions as not just information alone; it is also a visual element that must be considered within the overall design. It has weight, texture, movement, and an implied sense of direction within the composition. Be conscious of how the typography will affect the overall hierarchy and balance of your layout. Keep in mind that the text should be secondary to images of your work, so try to keep it simple. When working with typography, especially as part of a multipage sequence, it is important to develop a typographic system that can be applied consistently throughout.

Typographic Systems

You will need to create a *style guide* of sorts that determines typeface specifications—typeface, weight, size, color, and any limited variations depending on function and usage. You should limit the number of typefaces to probably one or two throughout the portfolio. If you are using more than one typeface, don't use it randomly, but decide which typeface to use for which elements, and keep that consistent throughout the book. As a rule, serif typefaces are easier to read for larger blocks of text. While given a shorter amount of text, sans-serif typefaces are usually considered "cleaner" and look more modern on the page. For informational kinds of text, always keep legibility in mind. For this reason, the use of decorative fonts, if used at all, should be used sparingly and reserved for special titles or other more graphical typographic treatments. Keep in mind that you can also work with the space between lines of type (leading). Doing so can prove aesthetically and functionally useful at times.

Typographic Range

For a limited amount of textual information, a single type family with a range of styles should suffice. However, if you decide to extend the typographic possibilities, you will need to pay close attention to how well the individual typefaces integrate and harmonize with each other. Typically, the use of multiple type families, usually limited to one serif and one sans serif, can help with hierarchy and create more visual contrast, color, rhythm, and texture. Working with a greater typographic range can also appear more "sophisticated," but only, of course, if done well. Most serif/sans-serif typeface combinations are based on their comparative letterform characteristics, such as similar width, x-height, or other proportional relationships. It is possible to combine two serif or sans-serif typefaces, but only if they are considerably different from each other.

+ **PHOTOGRAPHY | PORTRAITS**

+ **TYPE | ENSIGHT PUBLICATION**

Growing Up Veggie | InDesign and Illustrator | Published Fall 2008

Typographic Hierarchy

A typographic system determines the hierarchy of information within the overall text on the page and even within each grouping of text. You should determine which types of information are most important to emphasize. If you are including three lines of text—say title, medium, and date—you will need to determine which of these three to make the most visually prominent. Keep in mind that we usually de-emphasize the types of information that are most redundant (such as page numbers in a book). In this example, if most of the work is of the same medium or the medium is quite obvious by looking at the image, it may be a good idea to make this bit of textual information less prominent.

If you are not organizing your work as a progression, perhaps the date is not as relevant either. So, in this case, we are left with the title as the primary bit of text, used to identify each individual piece by name. The title in this case can then be emphasized in a variety of ways. It is a good idea, however, to keep it simple and only emphasize through one visual means. This can be done by simply making the text bold, using an accent color, or even making it a point size (or two) larger. This differentiation does not need to be too complicated. A simple shift can be enough contrast to distinguish it. Remember that you don't want to create too much contrast, because such visual tension would draw the eye away from the image of your work. **Use a limited number of fonts and type styles to create contrast and direct the eye. Changing the contrast can be accomplished by altering not only the typeface, but also weight, color, form, and structure. To the right are three different typographic systems, all using the same type family.**

Legibility

Legibility is of concern when placing text along a vertical or diagonal axis. While such orientations can certainly make a composition feel more dynamic, keep in mind that it makes the copy more difficult to read and should probably be limited to simple lines of text. Another concern with legibility is, of course, size. One of the biggest mistakes made in layout design is in making the size of the text too large or too small. The typical size of body copy (paragraphs of text) is 9, 10, or 11 point, varying slightly depending on the typeface used. This is a rule of thumb to consider for multiple lines of type, such as for image captions.

Titles of course can get much larger, but again, shouldn't detract from the work itself. You'll need to find a balance between size, placement, weight, color, and opacity that works within your composition. Of course there are always exceptions and you should think about how you want your type to function. If you are creating title pages or experimenting with inserts you may very well want to utilize the typography as a more prominent feature.

Title of Piece
Medium
Year

Title of Piece
Medium
Year

Title of Piece
Medium
Year

Tips and References

- When using more than one typeface, make sure they are very different.

- Never use all caps for body copy or for highly decorative typefaces.

- Always have someone else proof your copy.

- Always proof your own copy at least twice.

Look to historic design masters and reliable texts for guidance and inspiration. Some to check out are: *Swiss Graphic Design* by Richard Hollis; *The Elements of Typographic Style* by Robert Bringhurt; *Grid Systems in Graphic Design* by Josef Muller-Brockmann; *The New Typography* by Jan Tschichold; *Typographic Design: Form and Communication* by Rob Carter, Ben Day, and Philip B. Meggs; *Thinking with Type: A Critical Guide for Designers, Writers, Editors, and Students (Design Briefs)* by Ellen Lupton; and *Typographic Systems of Design* by Kimberly Elam.

Paragraphs

Finally, for multiple lines of text, try experimenting with leading. Leading is a term that comes from the "old" days of typesetting and letterpress. It refers to the amount of space between lines of text. As you open up the space between these lines you lighten their combined textural appearance, making each line function on more of an individual level. This works for identifying information (title, date, etc.) since each line is able to function on its own. Such an approach can sometimes be useful since it allows you to activate more of the compositional space.

Also, **align** and **justify** (left, right, or forced).

From all these experiences the most important thing I have learned is that

LEGIBILITY AND BEAUTY STAND CLOSE TOGETHER

and that type design, in its restraint, should be only felt but not perceived by the reader.

ADRIAN FRUTIGER

For the Nondesigner

If you are less experienced with typography, using a sans-serif typeface family can be a good option. Such typefaces provide a number of dynamic variations in weight (bold, thin) and proportion (extended, condensed). Since each variation is part of the same family, they retain properties of the same underlying letterform anatomy. This means that all the variations will work together in complete harmony. Some of the most commonly used typeface families are: Univers, Helvetica, Frutiger, and Futura.

Need Help: Recommendations

Try these time-honored typefaces; most designers would agree that they are industry standards. (There are many, many excellent typefaces out there and this list is only a partial list, meant to provide you with a few suggestions.)

Avenir, sans serif, *designed by Adrian Frutiger in 1988*

Bodoni, serif, *designed by Giambattista Bodoni in 1798*

Caslon, serif, *designed by William Caslon in 1734*

Clarendon, serif, *designed by Robert Besley in 1845*

DIN, sans serif, *designed by the D Stempel AG foundry in 1923*

Franklin Gothic, sans serif, *designed by Morris Fuller Benton in 1902*

Frutiger, sans serif, *designed by Adrian Frutiger in 1968*

Futura, sans serif, *designed by Paul Renner in 1927*

Garamond, serif, *designed by Claude Garamond in the 1540s*

Gill Sans, sans serif, *designed by Eric Gill in 1927–1930*

Gotham, sans serif, *designed by Tobias Frere-Jones in 2000*

Helvetica, sans serif, *designed by Max Miedinger and Eduard Hoffmann in 1957*

Helvetica Neue, sans serif, *designed by the D Stempel AG foundry in 1983*

Sabon, serif, *designed by Jan Tschichold in 1967*

Univers, sans serif, *designed by Adrian Frutiger in 1956*

Note: This material applies to any creative who is working with images. However, for photographers this is especially significant; thoughtful consideration of picture relationships can make for a much stronger photographic portfolio.

Traditionally, photographic books and portfolios have emphasized the image above all else, and tradition continues to dictate that photographs are presented in a very stark, single-image-per-page fashion. There has even been reticence concerning facing pages, and you can see this if you stop in any bookstore and examine books in print today. This is not to say that there aren't valid reasons for following this approach, in addition to numerous examples that explore a broad range of layouts and designs. This still leaves the question: How do you best present photographs and find the approach that will maximize their viewing? All too frequently portfolios present a static design that doesn't reflect the inventiveness of the individual and doesn't exploit the potential of the images.

Photographers by training have frequently presented images on a singular basis, and often the assignments and projects undertaken dictate that they do so. Yet a portfolio, if it is going to function as a statement, needs to be considered as a presentation of a body of work, a set of related images that comprise a whole. Thus, at minimum, sequence and page-to-page (picture-to-picture) relationships need to be considered. Can you order the work in a manner other than by the type of image or subject category? Are there ways to build relationships among multiple images seen adjacent to each other in one spread, rather than each on individual pages? Can one image provide the context for another? If you have a series based on a narrative, or a multiple-image project, can you present them in a more connected way, allowing the images to build on each other?

By working with multiple images and thinking beyond a single-image presentation, one can demonstrate an ability to build more complex photographic pieces. The intention is not simply to use an image sequence structure gratuitously, but as a way to enhance the experience of your images. You are trying to break out of the expected norm of image presentation. By working out sequences you demonstrate a greater understanding of the use of images in a larger context and you present an understanding of design that extends beyond the construction through the use of a single image.

Note to designers: Creating a sequence for a portfolio of your works, even if they are varied by type of design or media, can contribute to a stronger, cohesive presentation. Just as with a sequence of photographs, the relationships within a page spread as well as the pace and flow of your sequence are not something to be overlooked.

All books are a combination of physical, visual, and conceptual transitions. The book may emphasize one extreme, ... while downplaying the other extreme. ... But the visual book remains a combination of all three, with visual transitions at the center.

– KEITH SMITH, Author, The Structure of the Visual Book,[3]

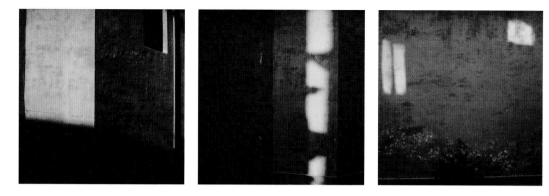

LARRY VOLK, SUFFRAGIO TRIPTYCH, SX70 Series.

Creating Interplay and Image Relationships

Images placed together can build on each other by having connections based on formal elements, such as color, line, negative and positive space, pattern, and repetition. Images can also be linked by content and subject matter. Movement between images can be achieved by drawing the viewer's eye through pattern, or a progression of content. The content can present a narrative, or simply an interaction around related content. A larger creative leap can be taken by creating relationships and readings of disparate images, which hold together on formal terms or otherwise wouldn't be seen together.

In the first example (top, left), the formal structure of the photograph is the basis for the *triptych*. There is movement within the frame: A single element (light on the wall) or multiple elements positioned within the frame shift across the three images.

In the second example (below left), you have a narrative progression or a progression that implies the passage of time—a progression builds from left to right around a specific content or action. The figure in the image changes position within the first and third frames, suggesting movement into view and out of view. The middle frame, being empty, exaggerates the shifting position of the figure by creating a gap in the reading, as if the figure had moved through the frame.

LARRY VOLK, SWAMPSCOTT, SX70 Series.

In this example, an extended narrative about a girl's rugby team is built through image pairs. Formally, the pairings allow shifts in viewing the subject, creating movement within pairings. The images paired together can be tensioned through differences or unified through common elements. The pairing above left, uses the color red as well as the raised hands carry the viewer's eye from one image to the next. The paring above right, is tensioned by the of shifting vantage points within the images.

ANTHONY GEORGIS, "BLOOD MAKES THE GRASS GROW,"
Promotional Book.

LARRY VOLK, VITERBO DIPTYCH, SX70 Series.

In this, *diptych* (top left), the images are related by a formal element (color, shape, negative or positive space) even though the content of these images is unconnected. The formal similarity unifies the pairing and draws the viewer's attention, while the dissimilarity of content requires the viewer to consider the images again and creates a more complex reading. Ultimately, the intention is to build a larger impression or association, in this case to a particular place or environment.

In the second example (bottom left), the images are connected by related content and formal elements: the physical spaces and the play of light and shadow. The pair of images builds on each other and allows the photographer more flexibility in representing the subject because the individual frames do not have to convey the entirety of the subject. The use of two frames allows for more range in composition, and the possibility of movement between them. The interplay between the combined images is intended again to build to a larger whole, while still reading as a pair of individual images.

LARRY VOLK, SHADOW BOCCE, SX70 Series.

MEREDITH LINDSEY, STUDENT PROJECT, Endicott College.

RACHEL LANDIS, STUDENT PROJECT, Endicott College.

Image Sequencing across Multiple Pages

Photographers frequently make extended bodies of work and their organization within a book format can be key to effectively conveying the idea or expression intended in the photographs. Ordering (sequencing) photographs across multiple pages requires attention to both relationships within facing page, as well as those from one page set to another.

True sequencing of photographs is not a simple linear progression or order within a book. It is worth making some distinctions. One of the most useful texts on the subject of image sequencing is Keith Smith's *The Structure of the Visual Book*. Smith characterizes *sequencing* as "several pictures that react or act upon each other, but not necessarily with the adjacent picture" (Smith, p. 46). This interaction between images is based on what Smith defines as "referral." Direct referral is "an intentional relationship set by the picture maker from one specific element within a picture to another element within the same or another picture" (Smith, p. 45).

Simple movement from one image to another based on proximity is not a sequence. When placing images in a progression, the ordering is made more complex and substantive by having the elements within the photographs reference each other. This is the true function of a sequence by Smith's definition. Working from aspects found within the photographs themselves allows one to create relationships between photographs that aren't necessarily adjacent to each other. "Movement," as Smith describes it, occurs image to image as well as between images through these references.

Subsequently, your ideas and the experience of the photographs are richer and more complex by incorporating these references within and between the photographs.

Applying Sequencing

The most common application of sequence can be found a in narrative or time-based progression. In each case the movement through the images is additive; development of an expression or concept builds as one reads through the images. In one case the content of the images can suggest a change of state, implying time. In another, the images reveal a progression, again through the changing content and what is suggested by reading the images.

Much like the triptychs, diptychs, and compound images, relationships and the subsequent sequence can be based on formal elements of the photographs. Progressions can be made based on color tone, negative and positive space, or a particular compositional choice.

Subject matter, themes, or motifs can be threaded through ordering your images. Themes can allow for the idea of referral, where a visual element, a motif, or a combination of formal elements and content appear throughout the progression of a body of images.

Depending on the body of imagery, more complexity can be brought to the work if symbols and visual metaphors are woven through the imagery. Many of the great sequenced photographic books have systems of signification within the sequence. Robert Frank's *The Americans* is probably the most compelling example of a system of referral within a complex sequence. This photographic exploration of 1950's United States is an example of a complex sequence of themes or ideas represented through elements in the photographs, which repeat and *refer back to each other* throughout the book. A few of the major themes are: the flag (as an iconic symbol of the ideal America), religion (referenced in various objects and activities), the car (in a variety of images and contexts), and race and class (as seen through different subjects). As one reads through the photographs, these themes repeat and refer back to earlier images. Far more than a list or presentation of a body of images taken throughout the United States, Frank's book is a masterful application of complex sequencing.

top left: a narrative sequence involving a walk to the beach.

lower left: a sequence which uses referral with water as a theme. Images of water, are repeated with images of water systems.

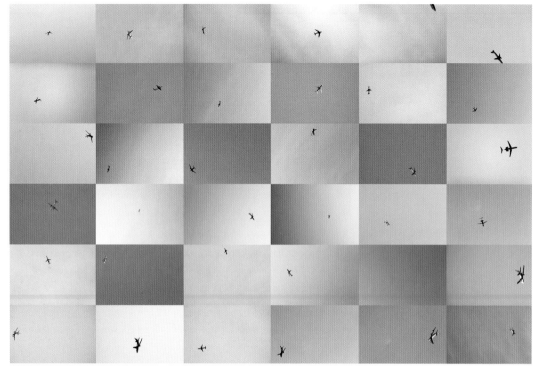

RON DIRITO, COMPOUND IMAGE,
"An Accumulated Experience of 36 Discrepant Observations [in Blue]," Salem, MA.

Compound Image on a Single Page

A compound image is a photograph formed of multiple individual photographs. The intention here is to maximize the ability to form relationships between a larger number of images than a diptych or triptych and to present a more expansive photographic expression. Grid structures are well suited to form a compound presentation, because the grid organizes the photographs, and within the grid one can effect movement and readings between multiples. In this situation one can form what might be considered a complex list. On the other hand, a grid can offer a progression that is directed, effecting a narrative on one page.

Compound images can function a number of ways:

- As a unified whole built of multiple pieces. The grid implies a whole even though we can see it is made up of unique parts.

- As a complex array of individual images with relationships between components that don't necessarily form a coherent whole.

- As a serial or time-based array of individual images, such as a document or narrative.

Note: A *mosaic* is not a compound image in that the emphasis is on viewing the larger image that is implied through the use of the individual pieces. In a compound image, the intent would be to read the individual images as well as the larger composite. In the mosaic, the pieces are meant to be small, and while visible as individual images, we generally don't read between them. Diptychs and triptychs are not compound images by our definition, as they are sets of images that are interrelated by physical proximity, content, form, or all of these, yet do not necessarily imply a larger whole.

EMILY NATHAN, W E B S I T E, New York, NY.

Getting Beyond Categories

In putting together a body of work, picture relationships such as diptychs and complex sequences may not be appropriate for your portfolio. However, it is still possible to take a fresh approach to presenting your work, beyond simply presenting subjects (portrait, still-life), formal aspects (color, black and white), or type of commissions (editorial, advertising). You can use more idiosyncratic ways of labeling, which can direct the viewer to your work. In the end, your work will be understood when encountered, so fear not, your audience will still get it. That being said, *test your ideas* and make sure the language you choose has some connection to the attitude and approach of your visual identity and your work.

A simple exploration of language is a good example of bringing some variety to the tried-and-true default ways of defining your work. Emily Nathan's website provides an example of using language to create sections within a website that might normally be categorized as "lifestyle" and "fashion," or "portrait and still life." The words, such as "time," "materials," and "local," are links to groups of images. These word choices refer to larger ideas, rather than specific subjects, and bring the viewer to the images in a fresh and off-center manner.

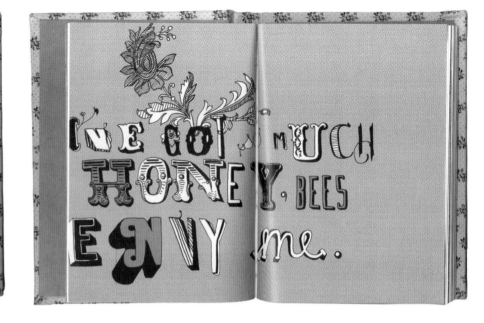

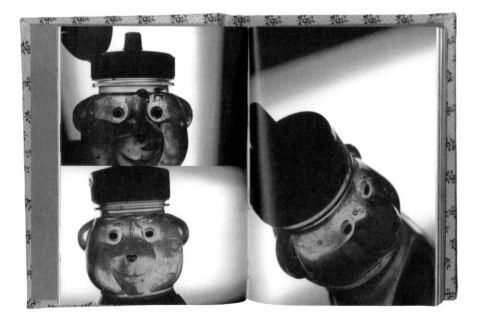

GRETCHEN NASH, STUDENT BOOK, California Institute of the Arts.

Breaking out of the box with a free visual journal approach requires trust in your vision and your work, and it is an approach you would want to apply to the overall portfolio. Here, sketches, ideas, and examples are combined in a free open format that has a personal, less produced quality. It allows the artist to move easily between styles of imagery and a variety of ideas.

Tip: Always print a dummy. If you are trying out sample page layouts and image combinations, print sample pages to scale. This will help in determining how your images are reading. In particular, if you are creating an extended sequence, print it out to see how it reads through the entire sequence. Pin it up on a work board, live with it. Make dummies and proofs to see if your work on the screen is working well on the printed page.

Scaling and Legibility

As any photographer or designer knows, the printed size of your images is going to have an effect on how they read and one should be conscious of how the scale of your image impacts its legibility. Some images benefit from running full page as large as possible. However, bigger is not necessarily better and some work is more effective at a smaller scale because this creates a more intimate viewing. Rather than bowl someone over with your large images, you can engage them in a subtler fashion. Certain images can be presented smaller, without having a dramatic effect on the viewer's experience of that image. A simple, more isolated subject will read better at a smaller scale than an image which has a densely packed frame or is finely detailed. Ultimately, you know your work, and how it should be presented. You should consider what size is going to be most beneficial within the limits of putting it into a reasonably sized portfolio.

Things to Consider

- For all of the ideas concerning "breaking out of the box" of traditional photographic presentation, you must be careful and consider how you put together your work. If it isn't consistent with your visual identity and isn't appropriate to your work and your intentions, don't do it.

- Photographs seen on a page or facing pages should be there for a reason. You shouldn't be putting together images that compete with each other. Don't consider grouping images together unless they can build on each other. Saving space by creating multiple-image layouts is not the best rationale.

- Unless you are making an example of a family photo album, or a bridal album, don't make your work look like one, with multiple formats in a combination page structure. At best, this will feel like an overlay of a stock template; demonstrate that you put thoughtful care and attention into your work.

- Consistency will create a stronger presentation. If you employ image pairings or a narrative sequence, it is important to have a consistent plan of layout for the overall book where these different approaches can be highlighted and seen as distinct from the other images in a well-considered layout.

The type of book CANNOT BE ARBITRARILY CHOSEN AND THE CONTENTS STUCK INTO IT.

The binding and display will alter the contents and one type of book will allow better development of an idea than another.[1]

KEITH SMITH
Book Artist p. 10

CONSTRUCTION

The primary advantage of constructing your own portfolio is that it allows you to build a presentation that is tailored to your needs from the standpoint of visual identity, your particular work, and even your budget. Beyond this, designing and building your own book reflects your ability to create and concept from start to finish, including the ability to craft your own book. While your goals may not necessarily be a print-oriented career, the fact that you can concept and design through a variety of forms, including a book, will reflect positively on your skills as a creative.

Finally, the portfolio book itself is a way for you to distinguish your portfolio from all of the other presentations. At minimum, it shows that you put thought, time, and energy into your work, and at best, it will be a unique presentation that will separate you from all of the others. The goal then in this chapter is to introduce some basic methods that can go a long way to making a portfolio that stands out and brings you attention.

Note: Considerations. From a practical standpoint, simplicity and flexibility are key here. Assume that you will be adding new materials and pieces to the portfolio over time and choose a design that allows for replacing or changing parts of the portfolio. One approach is to find a simple binding that can be easily recreated if necessary. This would allow you to:

- Update your portfolio easily and quickly.

- Make multiple versions of your portfolio.

- Make variations of your portfolio in relation to the particular client.

Your binding should, in all cases, reflect and serve the intentions of your visual identity as developed in your cover and page design.

Methods to Construct a Book and Book Terminology

Books Created by Sewing Folded Pages Together

- A *signature* is a gathering of pages folded together.

- A *pamphlet* is a one-signature book. The cover of the signature is folded around the gathering of pages. The signature and cover, or the signature itself, are sewn together through holes in the pierced fold.

- A *multisignature book* is a number of folded signatures that are sewn together with endpapers that attach the text block to the covers.

Books That Are Single Sheets Bound Together

- *Side-sewn books:* A group of individual pages (the book block) are bound together with stitching the block of pages to a set of board covers.

- *Post and screw bindings:* A group of individual pages (the book block) are bound together with binding posts to a set of board covers.

Books That Are Created by Folding

- One-page books.

- Accordion and concertina books.

- Back-to-back bindings.

GRETCHEN NASH, STUDENT BOOK, California Institute of the Arts.

Parts of a Book

1. *Book block or text block:* Contains all of the pages and content.

2. *Cover or case:* A nonboard cover book is a soft cover.

3. *Head:* The top of a book or page.

4. *Tail:* The bottom of a book or page.

5. *Spine:* Generally refers to the bound edge of the book.

6. *Hinge:* The flexible gap between the board covers and the spine.

7. *Fore edge:* The leading edge of the book, opposite of the spine.

8. *Gutter :* The valley in the center of the book that forms at the binding and spine.

Other parts include:

- *Signature or folio:* A group on or more folded pages stacked together.

- *Endpaper:* Papers that are on the inside of the covers; these can be decorative.

Materials

- Davey board, or book binder's board, 0.070 thickness, or four-ply mat board.

- PVA glue (polyvinyl acetate); Sobo is a common brand. Other adhesives can be used, however, PVA forms strong bonds while retaining some flexibility.

- Methyl cellulose or wallpaper paste, which can be used as an adhesive, or added to PVA to extend it and slow down the drying time of the glue and make it more workable.

- Double-stick tape or ATG adhesive (see tip p.133).

- Book cloth is prepared with a paper lining to prevent glue from seeping through the fabric.

- Papers are used for accents on covers, endpapers, and cover stocks.

- Posts, screws, and bolts or fasteners.

Tools

- A snap-blade utility knife (Olfa or X-acto). The snap blade makes it easier to maintain a sharp edge.

- Self-healing cutting mat.

- Metal or plastic triangle.

- Metal straight edge for cutting board and paper.

- Bone folder.

- Flat bristle brush for application of glue.

- Two-inch paint roller, also for glue application.

Printing Your Books

Printers

The number of digital printers and inkjet devices that are capable of reasonable image reproduction is dizzying. In printing a portfolio, you want to use a printer that is going to give you industry-standard quality. Anything less, and you are undermining your success before you even begin. Beyond commercial printing, the best-quality printers available are those designed for photographic reproduction. They use pigment ink sets that provide the broadest color gamut, the highest black density, and image stability. This will ensure that your portfolio will be produced and appear in the manner you intended. Canon, HP, and Epson are the industry leaders in digital photographic imaging.

If you are going to employ a printer it is recommended that they support inks that offer longevity and ICC workflows, both of which we will address in the following sections.

Papers

With the development of digital imaging for photography, the digital printer is now a high-quality tool for printing, and as a result there are numerous papers that could be used for printing a portfolio. Bright-white matte papers intended for photographic printing are inexpensive, easy to work with, and very high quality. Papers such as these are standardized, come in a variety of weights and surfaces, and have paper surface settings that tailor the printer's ink distribution to that particular paper.

There are other kinds of media available such as high-quality inkjet printable vellum, canvas, and papers that have a higher tooth or texture. These could be incorporated in a variety of ways depending on your design. Coatings such as InkAid™ are also available to allow one to prepare a surface for inkjet printing. A large-format digital printer can even accommodate "poster boards" up to 1.5-mm thick.

Note: Working with papers intended for the type of printer you have or the specific printer you are using has a number of benefits. The papers have coatings that are designed to absorb the inks from the printers consistently for the best tone and color reproduction. High-quality digital printing papers rarely absorb the ink into the paper substrate, but rather, absorb it into the coating. An uncoated paper is not optimized for the inks and may not print well or consistently with every color. An additional and important fact is that the coatings are designed to work with the inks to ensure color stability, and in some cases, archival longevity. It is possible to end up with a distinct color shift in your printed portfolio six months after you completed it as a result of an unstable paper and ink interaction.

When choosing a paper there are some caveats you should consider:

- Coated glossy or luster papers have coatings which can crack when folded.

- The coatings of matte papers can wear and scuff with use and handling. It is a good idea to have another copy of your portfolio available if your active copy shows wear or gets damaged.

- One option is to laminate the cover, which will protect the coating, but result in a different surface from that of a matte paper.

- Another option is to use a protective spray that is designed to make the matte surface more durable and extend the archival longevity of the print. Premier, Lyson, and Hahnemühle all offer products that have been used with good results.

- Heavier stock over 150 g, while wonderful for individual prints, can be harder to work with and will build into a thicker book.

Color Management

A well-designed book that is poorly crafted will not present you effectively. You should assume that the standard of printing for your book must meet the expectations of your target market—anything less and you will undermine your intentions. Best practices, using ICC workflows, allow for high-quality image reproduction of vector-based graphics, type, and color. Even though color management can be difficult to understand, it is well integrated into high-quality inkjet printing systems by manufacturers such as HP, Canon, and Epson. When printing your book you could make adjustments and changes as you print, but color management offers a far more efficient method of working that wastes less materials, time, and energy.

Color management essentially enables you to go from screen to print with consistency and predictability. By employing color management one is able to take a file from one condition to another, maintaining accurate color even when the mechanism for reproducing it changes; the intention here is to go from A to B and not have significant shifts in color or tone.

Using an *ICC workflow* and *profiles* enables you to take your InDesign layout, in a CMYK (cyan, magenta, yellow, black) color space, and send it to a printer wherein the color information will be converted and reproduced accurately.

Profiles are characterizations of the color of a particular device with a particular material (paper). They allow you to orient the software to the kind of color gamut and conditions in which your file is going to be produced and to make adjustments to the color based on those conditions. High-quality desktop and large-format digital printers use *destination* or *printer profiles* to correctly reproduce the color and tone of the files that are being printed. Generally, when a printer driver is installed, the color profiles provided by the manufacturer are installed as well. Aftermarket paper manufacturers provide free profiles that need to be installed by you.

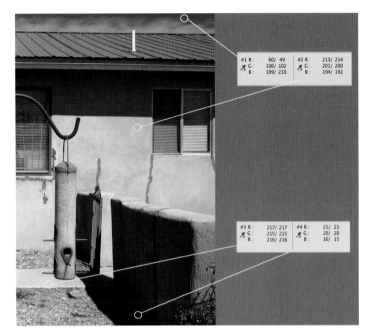

Software and Color-Managed Workflows

To employ color management with high-quality inkjet printers, you must have software that supports an ICC workflow. The Adobe Creative Suite, for example, supports the ICC workflow.

Below is a screen capture of the CS4 color settings dialog box, which determines color space preferences and color management policies within the CS4 suite.

A *color space* defines the range of color based on a standard of measure known as the standard observer. Colors are mapped within this standard, and this allows color to be understood in relative terms. When you are working with software such as InDesign, Illustrator, or Photoshop, the color and tone of your content is represented by numerical values in RGB (red, green, blue) color or percentages in CMYK color. In the example above, the numbered color samples in the image are represented with their corresponding RGB values as indicated from the Photoshop Info palette.

Those color descriptions are only of value if they are placed within a framework, or some kind of constant as a point of reference. That point of reference is the color space of your file. Some of the standard working color spaces are: Adobe RGB (1998), ProPhoto RGB, and CMYK (U.S. Web-coated SWOP).

Therefore, color management allows one to take a file from one particular color space and, using a destination or printer profile, the color is reproduced with a degree of accuracy even though the device or system representing those colors has changed.

Color Settings

Unsynchronized: Your Creative Suite applications are not synchronized for consistent color.

Settings: Custom

Working Spaces
RGB: ProPhoto RGB
CMYK: U.S. Web Coated (SWOP) v2
Gray: Dot Gain 20%
Spot: Dot Gain 20%

Color Management Policies
RGB: Preserve Embedded Profiles
CMYK: Preserve Embedded Profiles
Gray: Preserve Embedded Profiles
Profile Mismatches: ☑ Ask When Opening ☐ Ask When Pasting
Missing Profiles: ☑ Ask When Opening

OK
Cancel
Load...
Save...
More Options
☑ Preview

Description
Color Management Policies: Policies specify how you want colors in a particular color model managed. Policies handle the reading and embedding of color profiles, mismatches between embedded color profiles and the working space, and the moving of colors from one document to another.

Print

Printer: Deskjet D4100 series

Copies: 1

[Page Setup...]

Position

☑ Center Image

Top: 1.083

Left: 1.25

Scaled Print Size

☐ Scale to Fit Media

Scale: 100%

Height: 8.833

Width: 6

Print Resolution: 72 PPI

☐ Print Selected Area

☑ Bounding Box

Units: inches

Color Management

⦿ Document
 (Profile: sRGB IEC61966-2.1)
◯ Proof
 (Profile: N/A)

Color Handling:

Photoshop Manages Colors

ⓘ Remember to disable color management in the printer dialog box.

Printer Profile:

Pro4880 EMP_MK

Rendering Intent:

Relative Colorimetric

☑ Black Point Compensation

Proof Setup:

Working CMYK

☐ Simulate Paper Color

☑ Simulate Black Ink

[Cancel] [Done] [Print...]

As previously noted, most papers produced by the manufacturers intended for photographic reproduction have ICC profiles available online for free. If you choose to employ an off-brand paper, or material that is not manufactured for printing, it will not have ICC profiles available, and will require you to go through some trial and error. Unless you have a very specific need, the challenges of going this route can outweigh the benefits.

The color settings and color-managed workflow vary with each manufacturer. Most manufacturers have prescribed setups for their particular printer driver and for employing output profiles.

Note: Profile installation. Installation varies between Mac and PC, but is a relatively simple task. Mac-based installation is drag and drop. The profiles reside in the Library > ColorSynch > Profiles folder. For a PC the files are found in the Windows > system32 > spool > drivers > co lor folder. A profile can be installed by right-clicking on the profile and selecting "install profile."

At left is the print dialog box for Adobe Photoshop where you would indicate a destination profile. In this example an Epson paper has been selected. You must have destination profiles that are generated for your particular paper and printer.

Tip: Get Help!

Most photographers should have experience with color management at this point if they are printing to inkjet devices. As designers frequently work with commercial printers, color management is often left to the printing professionals. Get help, if you are over your head. The workflows are easy to employ to those who are knowledgeable and can save you much hair-pulling and frustration. You may have color management tools available with your own printer and have not yet employed them. If in doubt, test, test, and retest.

Duplex Printing

Duplex or double-sided printing is necessary when making a sewn or stapled pamphlet. It can be incorporated in the post and screw binding as well. Printers that are designed for duplex printing will allow you to use pamphlet and imposition features of software such as InDesign. Most high-quality inkjet printers are not duplex enabled.

If you do not have a duplex-enabled printer, you will have to print single-sided pages, printing the backside spreads individually. Usually with a printer that is designed for single-sided printing, registering the backside to the front side can present some challenges. It is highly recommended that you *test your printer* to see if your sides are registering, and if not, figure out what adjustments need to be made. You may have to shift contents or page position to achieve good front to back alignment.

Alternatives to Duplex Printing

Lighter-weight papers can be adhered together in a similar fashion to a perfect binding, creating a single page that is printed on both sides. For our purposes we call this a *back-to-back binding* and instructions on how to produce a back-to-back binding are found later in this chapter.

In a similar manner, some books incorporate a back-folded page. The fore edge of the page would be the folded edge, with the open ends of the folded page bound into the spine. This is easy to apply to a post and screw binding. In both cases the result is a slightly heavier page, depending on the paper stock.

Tip: Finding grain direction and gluing. All papers have a "grain" in which the fibers that make up the papers are aligned in one direction. Generally the grain of all paper and board should run parallel to the direction of the spine. By aligning all papers, cloth, and board in relation to their grain, the book will be less prone to warping when gluing.

To determine the direction of the grain, bend the paper or board slightly in a vertical direction and then horizontally. Whichever bend offers the least resistance is the one that runs parallel to the grain.

Tip: Again, make a dummy! As mentioned previously, making working versions or dummies will always lead to better books. You can print and roughly bind a version, which allows you to practice your binding skills and test out methods of construction. More important, you can check for the overall reading and sequence of your book, and see a real version of your final design.

In this construction board covers are made separately with flexible hinged spines. The simplest design is to have two sets of boards, for back and front covers. The spine is open and the book, covers, and boards are joined with posts and screws. The same board covers can be used for a tied version of the binding, often called a stab binding or Japanese tie.

Materials: Chipboard, book cloth, endpapers, accent paper, glue/ methyl cellulose, bone folder, brush, utility knife, and waste paper for gluing.

Note: When designing your pages for post and screw binding, add 1½ inches additional width to the left edge of your page to account for the spine and area of the gutter. This total length then reflects the size of the cover, which includes the flexible spine [see example, right].

Cutting Your Boards

When cutting your boards, a metal triangle or t-square is essential to make sure your cuts are square and consistent. Cut the height of the boards first. Then cut the overall length of the board, and then cut the 1½-inch spine out, marking both pieces so they are easily identified with the other set of boards.

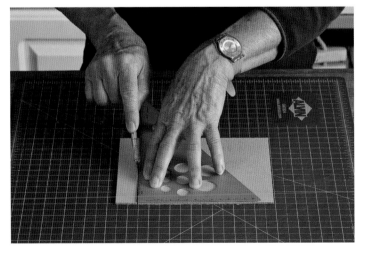

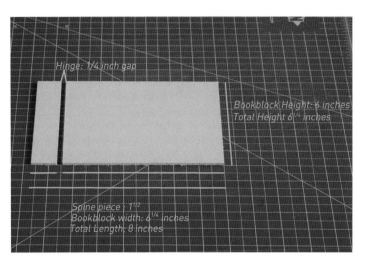

Hinge: 1/4 inch gap

Bookblock Height: 6 inches
Total Height 6¼ inches

Spine piece : 1¹²
Bookblock width: 6¹⁴ inches
Total Length: 8 inches

Measurements: The cover boards should overhang by ¹/₈-inch from the edge book block.

- *Height:* Add ¼ inch to the height of the boards to create the overhang for the top and bottom edges.

- *Width:* Measure the cover to the same width as the book block plus 1½-inches for the spine. When the spine is cut from the width, the spine will have an additional ¼-inch gap (this is for the hinge) when glued together and this will produce the ¹/₈-inch overhang on the width.

For example, If the printed area of your book is 6¼ inches wide, your book should have an additional 1½ inches for the spine, plus ¼ for the gap making it 8 inches wide in total. If the height of the book is 6 inches, ¼ inch would be added to the height, making the dimension 6¼ inches.

Tip: Any fabric can be used for book covers by sizing it prior to gluing. Sizing is available in most fabric stores, the simplest of which can be ironed on allowing for alternative fabrics to be used in lieu of book cloth. One can also make custom-printed fabrics and materials by purchasing coatings that will allow inkjet printing inks to adhere to any surface. There are also fabrics that are designed to be printable, and can be used to create a printed cloth cover. Inkjet printable book cloth is now available as well. (See Appendix A for suppliers.)

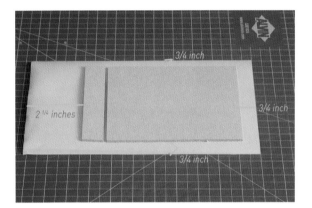

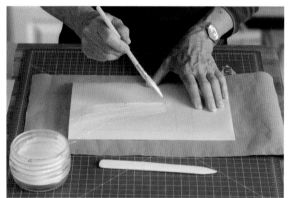

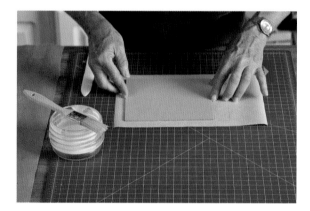

Measure and Cut the Book Cloth

Lay the book cloth face down on your table or work surface. Lay the cover boards and spine on the cloth. Make a ¼-inch gap between the spine and the larger cover board to form the hinge.

- *Height:* Add 1½ inches to the height of the cloth. This will create a ¾-inch edge that can be folded over the edge of the board and glued down. This is called a turn-in.

- *Width:* Add 3 inches to the width. This will allow ¾ inches for the turn-in on the fore edge and 2¼ inches for the turn-in on the spine edge. This *longer piece* will be folded over the end of the spine, onto the inside of the book, across the gap of the spine, to create a complete hinge.

Gluing

When you glue be sure to have plenty of scrap paper, or kraft paper, covering your work surface. You can use small pieces that equal the dimension of your book as waste sheets to sit under your materials catching excess glue. Be sure to remove the waste sheets from your work surface as you work to avoid getting stray glue on the book cloth or paper. Use an even, thorough coat of glue to the area of the cloth that you are gluing up. There should be complete coverage to all surfaces to prevent any puckering or bubbling where the paper and book cloth might not stick. Spread the glue from the center of the cloth out to the edge. Think of the pattern of the British flag, the Union Jack. If the cloth or paper curls, keep brushing and it will eventually lie flat and relax. Wait, as it will be easier to handle.

1. Take a new waste sheet.

2. Set down the book cloth.

3. Smooth the boards down with the bone folder.

Tip: If you draw pencil marks outlining the position of the boards prior to gluing, it makes it easier to place them down on the cloth once it has been glued.

Use two small scraps of book board adhered together, to check the gap for the hinge between the spine board and the cover board.

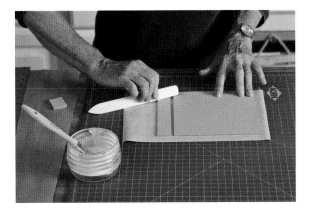

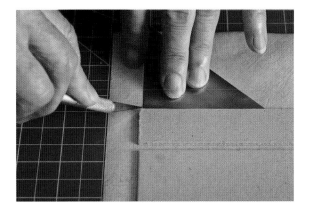

The *bone folder* is an essential tool in this part of the process for working the cloth or paper, as it should be smoothed out with no air bubbles, assuring complete adhesion. The edge of the cloth needs to be pushed and somewhat stretched over the ends of the board to create tight, clean edges.

Trim the corners of the fore edge with scissors as above. You will cut a triangle off the corner, leaving an ⅛ inch.

Trim the cloth at the spine edge. Use a small triangle to align your knife. Place the triangle ⅛ inch to the inside of the end of the spine board. Cut a straight cut back, and then cut outward at an angle away from the bottom edge of the board, as shown in the example above.

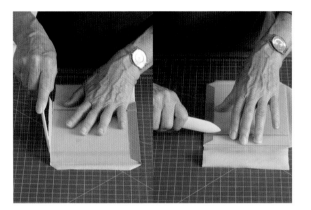

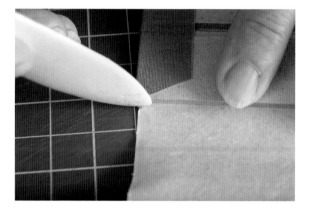

Now reapply glue if needed to the turn-ins on the top and bottom edges of the board. Use a bone folder to work the cloth over the top and bottom edges of the board.

At the fore edge, pinch the cloth in at the corners with a bone folder. Then turn the cloth over the board as you have done with the top and bottom turn-ins to finish the fore edge.

At the spine end, pinch the cloth at the corners as you have with the fore edge. Reapply glue if necessary (use your finger to see if it has started to dry). Fold the cloth over the edges of the spine and the hinge.

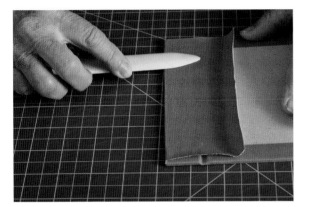 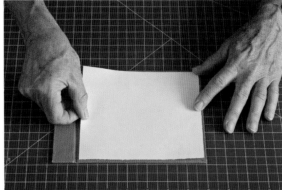 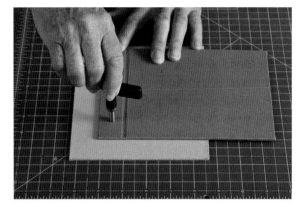

Use a bone folder to work the cloth over the spine board and across the gap of the hinge. Then work the cloth into the gap or valley of the hinge.

Measure your endpaper, or lining paper, to ¼-inch less than the height of the cover and ¼-inch less than the width of the board from the fore edge up to the hinge or gap in the spine. You will not cover the spine with paper.

Coat the paper with glue as you did the book cloth and apply it carefully to the inside of your cover, making sure you have ⅛-inch inset on all sides.

Once the boards are covered and endpapers applied, place them between paper or board and let them dry overnight under heavy weight.

Punching Holes in Your Covers and Book Block

There are a variety of ways to punch through the book block and covers. Frequently, the whole book, covers, and book block are clamped together, having been marked for drilling. A sharp drill bit is used with a drill to cut a hole through the covers and book block.

Other alternatives are a paper drill and a punch with a hammer. In the case of these options, it is good practice to mark one cover, drill the holes, and then align and mark the other cover via the holes you just punched. This assures that the holes on the front and back covers are aligned. The covers can be used to mark individual pages for punching, which insures that they will fit correctly.

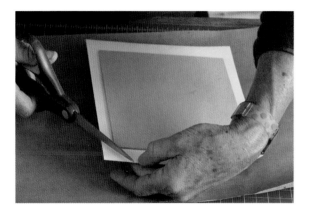
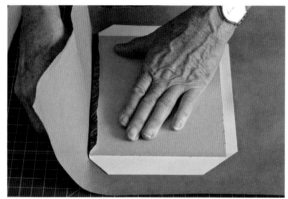
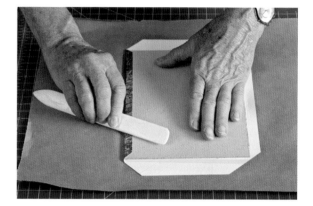

Good-quality inkjet papers can be used to make a book cover and can be applied in the same manner as book cloth. Lighter-weight paper, 160–190 grams, is recommended, as it is easier to turn over the edges of the binder's board. Matte paper is also recommended, as glossy coatings will more than likely crack when folded.

The measurements and proportions for using paper to cover boards are the same as using cloth. It is recommended, in the case of any book with a flexible hinge and spine, that you use book cloth in this area. The paper would not be strong or durable enough to tolerate the movement of the hinge. You cut the corners and pinch the edges just as you would a book cloth cover.

The trick to creating turn-ins on the top and bottom edges of the cover is to use the scratch paper as a support to bring the paper over the edge. This avoids possible abrasion from the bone folder. The bone folder can then be used to do the final smoothing out of the turn-ins.

Tip: The use of double-stick tape or ATG adhesive makes for much easier construction when adhering pages together. It eliminates the problem of moisture, which can cause warping and pulling of the pages. Spray adhesive can be used but presents far too many problems, not the least of which is the need for ventilation.

Heavy-duty double-stick tape is available in a variety of widths and is easily applied to pages. The advantage of these tapes is that only one side of the adhesive is exposed when applied. The second side is exposed when the covering is peeled away (see Appendix A).

ATG is a 3M product and must be applied with an ATG dispenser or gun. It is available in ¼-, ½-, and ¾-inch widths, and is a product often used in the picture framing industry. (See Appendix A for suppliers.) While it can be used to adhere cloth, glue is still the preferred method for applying book cloth to board.

This binding with soft or hard covers is a simple construction that is easily reproduced and assembled. This allows for simple single-sided printing, without the registration problems of two-sided or duplex printing. Standard papers result in a glued page of a reasonable thickness. Each pair of pages is scored down the center to allow for better turning and folding. The cover can be made of slightly heavier stock.

The result is a simple, clean soft-cover book. This is well suited to books up to 8.5 × 11 inches. As the books get larger, the covers must be more durable to handle the weight and size of larger glued pages.

Each set of pages is printed one sided in pairs. It is helpful that you print in light score marks at the center of each page, which makes it easier to trim and fold the pages.

Once you have printed your page sets, you can trim and fold them. When printing, leave some margin of extra space at the edges of the page to allow for some trimming of the entire book once assembled.

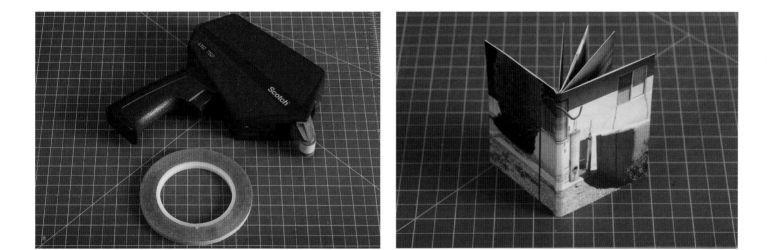

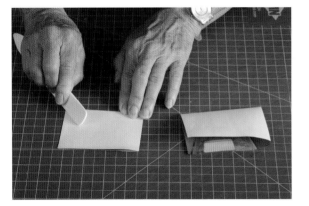

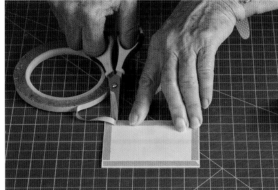

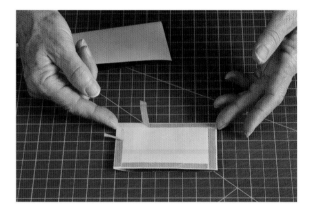

Use the bone folder to smooth the fold. Sometimes scoring the page will aid in folding, but you can only score the backside of the printed page, as the coating on the printed side can be broken by the bone folder.

The backs of the page pairs are then glued to each other to form a set of joined pages. Here is where double-stick tape or ATG adhesive is the best choice. For example, pages 3 and 4, left and right respectively, are joined to pages 5 and 6 by adhering the back of page 4 to the back of page 5.

Tape all of the outside edges, spine edge, and fore edge, top and bottom, with the double-stick tape. At this point do not peel the covering off the tape to expose the adhesive.

Peel back the covering tape to expose the adhesive at 2 opposite corners. [see next example.]

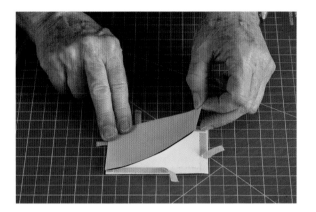 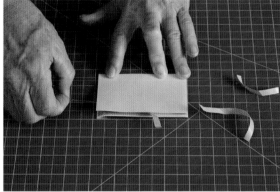 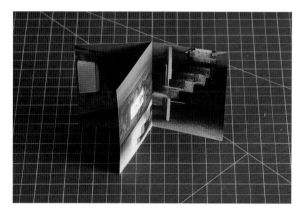

Align the edges of two folded sections. Align the two corners and place them down to adhere them.

At this point you can gently peel away the remaining tape covering by pulling it away from the edges of the pages and then smooth the edges together.

Continue adding folded page pairs to the back of the glued set to build the book block.

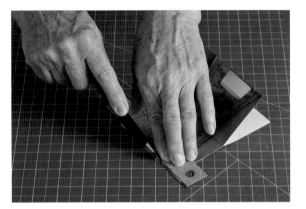 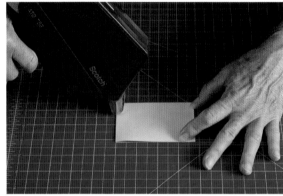 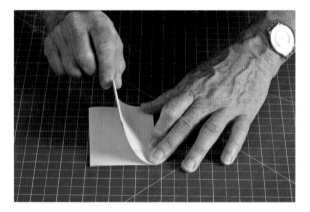

Once the page sets are glued a large cutting ruler and a heavy mat knife are needed. You must carefully cut through the pages to square up and trim your book. A book bindery, or a school that teaches book binding, may have a large guillotine cutter that is very handy for this particular purpose. A matte knife with a ruler can work just as well with a little patience.

The ATG gun is as effective as double-stick tape, with the one difference being that the adhesive is exposed once applied. As such, you have to be careful to align your page sets. The procedure is similar, but rather than taping all sides, you progressively glue edges starting with the fore edge.

Combine the pages at the glued fore edge. Then apply adhesive to the remaining three edges and carefully adhere the two page sides together.

Measure and Cut the Cover

For a smaller book of 10- to 15-page spreads, the same papers used to create the pages should provide an adequate cover. This material can be doubled up as well to create a stiffer cover, which will be stronger and provides better support for the book block.

The pages of the cover generally are sized to sit flush to the edges of the book's pages, however, if you use a heavier stock for the cover you could have an overrun of about ⅛ inch. The risk here is that edge is exposed and vulnerable to being bent or damaged.

The cover page is glued on to the endpapers in the same manner as the page sets in the book block. Start with the front side of the cover. Use double-stick tape or ATG adhesive along the fore edge and spine edge. Do not tape beyond the dimension of the page. You don't necessarily need to apply adhesive to the top and bottom edges of the cover. Make sure you have the book block in the correct orientation. Align the first page of the book and adhere it to the inside of the cover.

Now measure the width of the spine, using the book block. The width of the spine should be the thickness of the book block. You will need to score the paper of the cover along the edge of the spine at either side of the book block. A ruler can help get the folded edge of the paper.

Make an additional score an ⅛ inch from the edge of the spine on the back cover. This third score creates a *gusset*. The gusset will move freely with the spine, creating flexibility when the book is opened.

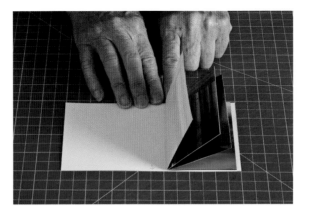

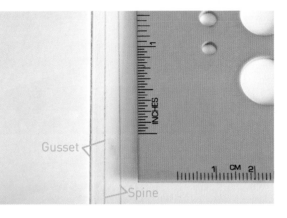

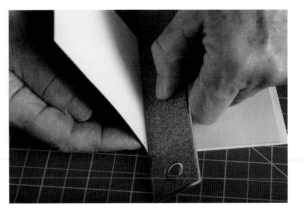

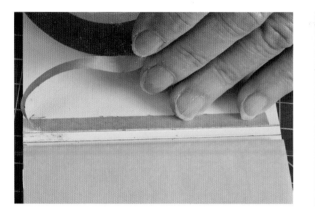

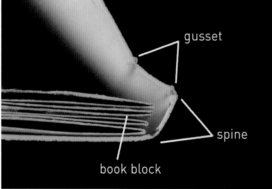

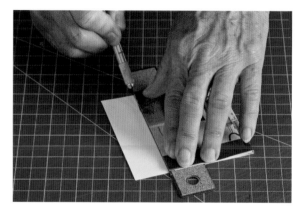

Apply double-sick tape or ATG along the gusset, but not in it, nor should you glue the spine.

With the spine of the book block unglued, it will move and bend freely as the book is turned.

You can make the cover slightly larger to allow for some misalignment, then carefully trim it flush to the page edges.

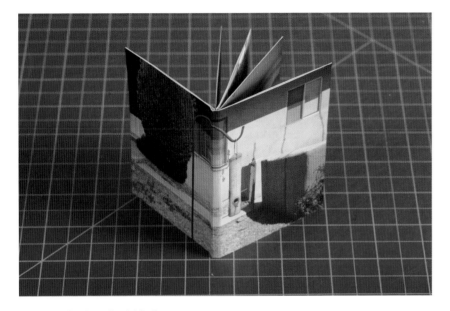

A finished back-to-back binding

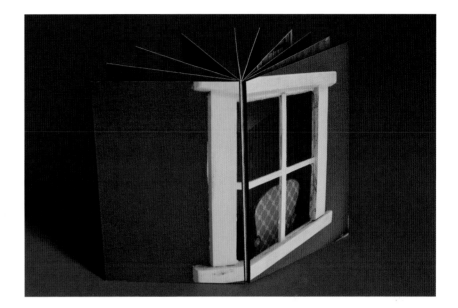

ANN PELIKAN, A R T I S T ' S B O O K, Ipswich, MA.

A variation in the same configuration is a book block with board covers, rather than a paper cover. A printed page can be adhered to the board and trimmed. One can use mat board or book binder's board (though this might be rather heavy). Cut the boards to the trim size of the book block. The spine is left open allowing for movment and laying the book flat. Apply double-stick tape or ATG adhesive to all four edges of the front page of the book block and the back page. Align the edges and adhere.

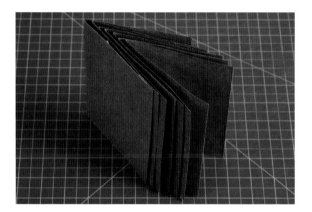

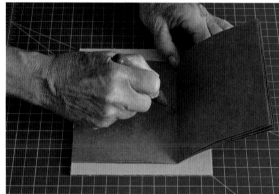

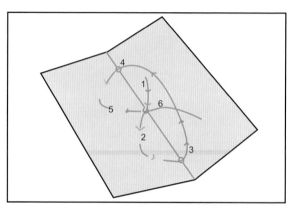

This is a simple way to make a bound book, or more accurately a booklet/pamphlet. The binding itself is easy and relatively innocuous. The printing of the book requires that you duplex the pages, and this can be a little more involved depending on your type of printer. You must be sure you *paginate correctly*.

Score each page (using a bone folder) and fold the page along its center. Then each folded page, or folio, is stacked with another folio, forming a set of stacked folded pages, or a signature.

The number of pages you combine could be 10–12 depending on the thickness of your paper. This would allow for 20–24 page sides. The page sides will always be an even number.

Just as in the perfect bind, once joined, the page edges can be trimmed, allowing for some irregularity when sewing or stapling. You can also trim the fore edges of the stacked signature to make the edges flush. Remember to print to an oversize paper, which allows for printing crop marks that can be used later to guide trimming.

You must align the pages carefully before piercing the center fold of each folio. An awl or needle can be used to pierce the paper.

A three-hole sewing pattern. The thread or twine is tied in the center of the book.

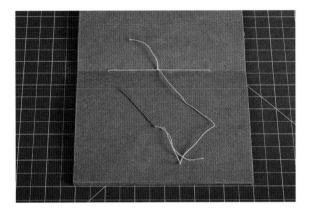

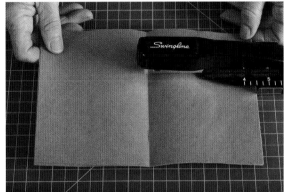

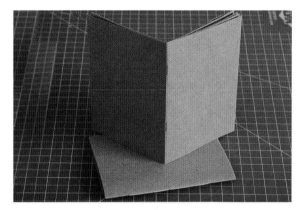

To have the knot reside on the inside of the signature, you must start it on the inside. Once thread is worked through, finish the sewing by securing the thread with a knot and trimming it.

The stapled signature is created the same way as the sewn signature, but it is finished with staples. This stapler is designed to accommodate the depth of the page. These are available at office supply stores and are reasonably priced. The number of staples used can vary depending on the size of the signature. Stapling from the outside creates a smooth appearance to the finished staple. Be sure to align the stapler along the fold carefully.

INSETS AND WINDOWS

An *inset* creates a depression in which an image, or even a brandmark, could be placed after the cover is glued up.

Window and insets need to be cut prior to covering your boards. Measure and mark the position of the inset on the cover. As most book binder's board is laminated, one can score into the board and carefully peel up the layers of material, making the inset's depth about one-half the thickness of the board.

Note: Methyl cellulose added to your PVA glue extends the drying time of the glue and is particularly helpful when having to smooth a complex edge such as a window.

When gluing, the cloth or paper needs to be carefully set into the depression and worked with a bone folder to smooth out the inset. Use the bone folder carefully to smooth the cloth into the corners and over the edges of the inset. Then work the cloth outward from that point to smooth and finish the remainder of the cover.

The image is then placed and adhered into the depression created in the cover.

The next step is to adhere small triangular pieces of cloth over the corners of the window. This will ensure that no raw board will be visible once the entire board is finished.

As is the case with the inset, you will cover the entire board, including the window. Once covered, the cloth is cut out of the window, leaving pieces as turn-ins for each side of the window. A diagonal cut is made from the corner pulling toward the center.

The turn-ins are then glued and smoothed over the edge of the window.

Windows need to be marked and measured in relation to elements on the interior page, which sit directly below the cover. This requires that the inner page be laid out and considered prior to cutting the window. The binder's board then needs to be marked and measured, creating a clean opening in the cover board prior to covering it with book cloth. Careful measurement is necessary here in addition to clean cutting.

Design is not just what it looks like and feels like.

Design is how it works.

STEVE JOBS

Steve Jobs, co-founder of Apple and Pixar (2003)

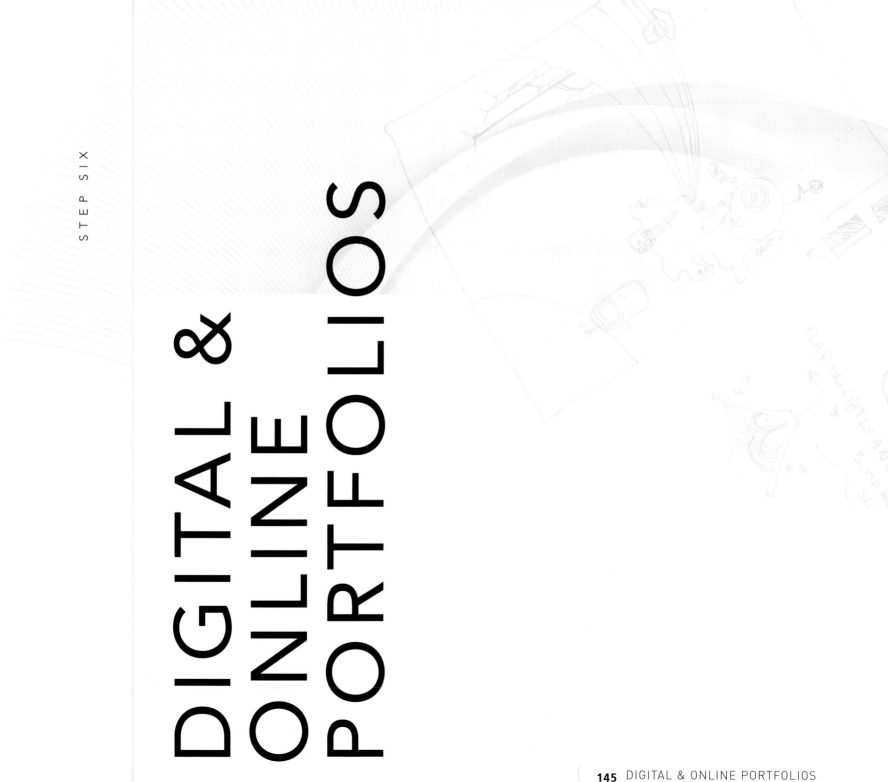

DIGITAL & ONLINE PORTFOLIOS

INTRODUCTION

Note: This chapter discusses the issues surrounding the strategy, branding, and design of an online portfolio. It does not go into depth about how to build and develop one. While web development issues will be touched on, it is a thing unto itself, and there are a number of excellent books and online resources devoted to this subject. Many of these are referenced through the online companion to this book, available at www.noplasticsleeves.com. Much of the content written in this chapter is targeted toward someone who has at least some experience designing and developing a website. However, for someone with little experience, this chapter can be a great place to start.

Tip: It's a great idea to include the URL to your online portfolio on your printed promotional materials – this allows someone a fast and easy way to find out more if they are interested.

Your digital and/or online portfolio is a very important part of your comprehensive portfolio package. Some may argue that it is even more critical than a portfolio book, as chances are a lot more people will see it. The fact is that for most artists, designers, and photographers, both a print and digital portfolio are essential. Both serve an important function as part of a comprehensive portfolio package. Along with your resume, your digital portfolio will probably be your best means of getting your foot in the door with a potential employer or client. When you show up for your interview, think how impressive it will be when you arrive with your own portfolio book. And one that looks and feels the same as your website—identifying you and reinforcing your message**. It's guaranteed to be impressive if all the components of your portfolio are designed with the same conceptual and visual brand in mind. In the design and advertising industries, messages are consistently and cohesively conveyed through both print and digital contexts—tailoring the message for each medium's strengths.**

The creation of one's online portfolio is an important task that affects pretty much anyone in the creative industries. It is also a process that relies heavily on a unique balance and integration of both visual form and technology. The web itself has a number of unique inherent characteristics—all of which need to be carefully considered in order to design a portfolio that works effectively for the online experience. Whether an artist, illustrator, designer or photographer there are a number of core approaches and strategies that should be understood when approaching an online portfolio. There are also a number of current trends and web 2.0 standards that should be considered.

Digital portfolios have their benefits:

1. You can make unlimited copies at virtually no cost.
2. They are easily accessible through email or the Internet.
3. They are easily updatable.
4. They show that you are capable of working with web and interactive media.

A digital portfolio, in the most basic sense, can take the form of a digital document, such as a portable document format (PDF). To move beyond the basics (which is recommended), you should consider an online portfolio website.

You've probably noticed that almost everyone has a website these days. With so many online portfolios out there, it's tough to get noticed. Your online portfolio has an important job to do:

1. To establish or extend a memorable brand voice and concept through an online presence.
2. To function effortlessly and present project work in a clear and effective manner.
3. To provide access to important information, such as portfolio work, contact, and resume.
4. To utilize interactive and multimedia elements that don't detract from, but instead support and enhance the online experience.

Skill Level

As you consider your digital portfolio, an important first step is to assess the level of your web technical and design abilities. Not everyone is capable of designing and developing a website, and doing so requires a certain amount of skill and knowledge. In fact, it will not serve you well to just throw together a website that doesn't look or function well—sometimes you have to know and appreciate your limitations. However, anyone at any level can develop a successful digital version of their portfolio and create at least some type of effective presence online. On the flip side, if you are currently or intent in the future to work in the interactive industry (which is required of more and more designers and photographers these days), it's important that you spend the time and energy necessary on your online presence to ensure that it represents you just as well as your book.

For those with little to no experience creating web and interactive content, the idea can seem quite daunting. The good news is that there are a number of really great options out there that can get you online in no time. You should at the very least create a digital version of your portfolio book—one that you can post online or email. A PDF version is recommended. If you composed the layout for your book in InDesign, just export the document as a web-ready PDF.

Here are some options for the novice:

Premade web templates available for purchase:
- Populate with your own content.
- Limited ability to customize, but can still include imagery related to your visual identity (perhaps as opening image).
- Pros: Able to customize many features of the "look and feel"; functions as a real website with navigation and subsections.
- Cons: Costs money; need to have some limited understanding of the web, as a "canned" solution may limit your ability to express your own unique concept and vision.
- Resources: Check out the resources page at *www.noplasticsleeves.com* for current recommendations.

Create a blog:
- Pros: Fairly easy to setup, populate with content and update. Provides an "out-of-the-box" solution with a content management system. There are a number of "themes" available for free and purchase that focus more on typography, grids and a magazine style look.
- Cons: Design layout, formatting and interactivity is limited unless you have some coding knowledge – especially with CSS. Format is best suited for textual and image based content that is updated on a regular basis. (May not be an appropriate venue for your work.)
- Resources: http://wordpress.org/.

PDF:
- Digital version of portfolio book made web ready as a multipage electronic document.

- Pros: Everyone should make one of these. It's very easy to export a PDF from InDesign, or composite Illustrator/Photoshop files or images together in Adobe Acrobat. Easy to email or post online and even has some interactive navigational options if you want to take it to that level in Adobe Acrobat. Be careful of file size; reduce file size in order to send through email.
- Cons: Can't include multimedia or more sophisticated levels of interactivity; still functions more like a book than a website.

Image/video sequence:
- Pros: Good option for photographers and video/film projects. No need to build a website or deal with navigation and multiple pages.
- Cons: Will need to know how to use a program like iMovie, Final Cut, Premiere, Flash, etc. Be careful of file size; work with codecs to compress files.

Flickr account:
- Pros: Free—allows you to post your portfolio images online so anyone can view them. Very easy to use.
- Cons: Little control over the look or functionality—not customizable. Should be a last resort, as not considered professional.

Online portfolio directory (additional information at end of this chapter):
- Pros: Nominal fee if you become a member. Can easily post and share work. Clients and employers will search the website and may happen upon your work; searchable by geographic location and expertise.
- Cons: No control over formatting or functionality; not an individual URL—grouped along with others in your industry.

Software export:
- Use Adobe Photoshop, Adobe Bridge, Adobe Lightroom, or another piece of software to create a web portfolio (typically an SWF file). Additional software like SiteGrinder lets you design web pages in Illustrator or Photoshop, then it generates web pages for you, code and all.

Tips for the Moderately Experienced

- Keep it simple. Use software like Adobe Dreamweaver or Adobe Flash to create a few basic templates that can be used multiple times. Use simple interactive features that support and enhance showcasing your work.

- Keep the focus on your portfolio work. On portfolio pages limit the physical size of navigation, other graphical elements, and text.

- Do some research and look at lots of portfolio websites in order to figure out what the possibilities are.

- If you need help get it. Work with someone who can help you develop your website and/or check out the resources available to you. Online resources like *http://www.computerarts.co.uk/* and *http://www.lynda.com* are highly recommended.

Tips for the Experienced

- Make this your quintessential piece, especially if you don't have a lot of impressive interactive work in your portfolio already.

- Show off your abilities, both technically and conceptually, as they make sense to enhance the purpose of the website. Consider how you can enhance the online experience, not detract from it with gratuitous bells and whistles.

- Use the most current technologies, applications, coding languages, etc. Make sure you build to web standards, test, and debug!

Defining Your Goals

In the professional world, project goals are usually defined in something akin to a *creative brief*. A creative brief literally "briefs" someone as to what a project is all about. It generally outlines the goals and objectives of a project. Typically, it starts by defining what the problem is, including a brief overview of who, what, where, when, and why. Briefs (especially client ones) will also include project scope, deliverables, timeline, and budget. It's probably a good idea for you to define all of these aspects too, even though your portfolio is for you and not someone else. Start with bullet points of key objectives and

goals. This should help you focus in on the crux of the design problem in a clear and concise manner.

Your design should provide accessibility to your portfolio work, while at the same time supporting and enhancing your brand statement and portfolio concept. Make sure to create visual continuity with your portfolio book—all aspects of your portfolio should function together as one. You will need to be strategic and plan accordingly. The design of your website—the look and feel from the color palette to the visual look of the navigation—should all serve your communication goals.

It should be noted that most online projects also include a *technical brief*, which outlines the technical scope and requirements for a web project. While you don't need something as robust as a technical document, you will need to eventually define the kinds of technologies that you intend to design and develop online content for.

Target Audience

Consider the following:

- Who are you trying to reach with your message?

- What do you want them to know about you?

Clarity of message is important. Consider the top three things you want someone to think about you upon viewing your website for the first time. Consider your homepage: What images, navigation, and copy would you include in introducing yourself? How will you stand out and remain memorable? Keep in mind that a potential employer or client will sum you up very quickly. Such people are adept at looking at portfolios—give them a reason to spend the time to get to know what you have to offer. Remember why someone is at your website—to view your portfolio of work. Make sure doing so effectively is your first priority. Second, you should consider your brand statement and continue to establish a consistent visual link to your other portfolio materials, projecting a clear and concise visual statement about yourself. Also, don't forget to provide information about how to contact you and learn more!

Some great online portfolio collections are available at:

http://www.thefwa.com/

http://www.designcharts.com/

http://www.moluv.com/

http://www.websitedesignawards.com/

Some great resources are:

http://www.lynda.com/

http://www.computerarts.co.uk/

http://www.tutorialmagazine.com/

Usability

Consider how your portfolio website will be used. What kinds of *functionality* (means for someone to navigate and experience the website) will be included? Focus on your goals and the website's "ease of use." Navigation should allow someone quick, easy access to what you have to offer—clearly labeled and consistently applied throughout the website. Any interactivity, audio, or motion should be used to enhance and support the experience, not detract from your main goals. Don't overdesign the experience and make it difficult for someone to find what he or she is looking for. There is a tendency with interactive work to do something just because you can—to use technology for technology's sake. Communicate only what is key—don't detract from that purpose.

The study of usability is also concerned with *user testing*. It's recommended that you ask several people to try out your website before you launch it. Watch carefully as they try to navigate around. Are they having difficulty knowing where to go and/or how to get there? Test your website out on different operating systems and the most likely levels of connectivity. Is the website downloading quickly? Is the playback smooth? With online content, you need to weigh the quality, quantity, and types of content you include with download and playback speed, both of which are very important. If someone has to wait or if the experience isn't smooth, a potential employer or client may very well get frustrated and move on.

For more information on interactivity, interface design, and navigation continue to read through this chapter.

Research

You can't design in a vacuum. Take the time to research online portfolio examples. There are many websites out there that include directories of the latest and greatest. You should know what the possibilities are.

You may also need to research how to create certain types of content that you may want to include in your online portfolio. Hopefully you've taken at least a rudimentary web course or taught yourself the basics. There are a number of great resources out there that can help you learn how to develop online content. Just because you might not currently know how to do something doesn't mean you can't learn.

Design Considerations: Taking Your Brand from Print to Web

The web is an entirely different medium than print. So, your print design can't just directly translate into your online portfolio. There are some huge differences. Obviously, the web is interactive, it can include multimedia (motion, animation, video, and sound), it's not tactile (at least not like a book is), and you view it on a computer screen from inside a browser (or on your PDA, phone, etc). These differences can make for some interesting challenges and solutions as you approach your online portfolio design.

Keep in mind that the overarching ideas and concepts that you have already established for your portfolio book should remain consistent with your online portfolio. However, think about new ways in which the online portfolio concept can be expanded, varied, or taken in a slightly new direction—one that is more appropriately suited for the web.

Q&A: Interview with Mark Barcinski, Partner, and Adrien Jeanjean, Partner, Barcinski & Jeanjean Interactive Studio, *http://www. barcinski-jeanjean.com/*

How did you arrive at the idea or concept for your website? What do you think it communicates about you or your company?

The idea for our website was actually born in the concept phase of another project in which we started to experiment with 3D in Flash and experimental photography techniques. We soon realized that when combining those two we could create something really unusual and immersive. Then we had another epiphany. We realized that by shooting the photo footage in stereo, using two identical cameras, and by modifying the 3D rendering engine, we could generate interactive 3D scenes to be viewed with 3D glasses. That got us really excited.

The subject for the website, a panorama of us standing on a picturesque bridge in the heart of Amsterdam with our portfolio cases as paper flyers suspended in the air around us, came quite naturally and wasn't thought out at all. But somehow it perfectly suits what we want to tell about ourselves and our work. Barcinski & Jeanjean is us two, so you immediately see who you will be dealing with.

Do you have any promotional and/or collateral materials that drive traffic to your website?

The launch of the website was accompanied by a mailing of customized Barcinski & Jeanjean 3D glasses. We now also use the glasses as our business cards, which gets people instantly excited and wanting to get to a connected computer as fast as possible to have a look. However, the traffic generated by award sites such as FWA and Webby dwarfed the number of visitors driven to the site by the glasses. But it really went bananas once the website was picked up on StumbleUpon. The traffic literally brought the server to its knees. After these initial waves, the blogs that featured the site are still keeping the traffic on an average of 1000 visitors a day.

What do you think the main strengths of your website are (concept, ease of use, navigation, aspects of multimedia, brand identity, etc.)?

All in all it's a very tech-heavy website, but it doesn't feel like that to the average visitor. It's all about the experience and not the cutting-edge technology behind it. But at the same time it clearly shows our skills and qualities to those who care. We actually haven't considered any of the branding, identities, or other marketing buzzwords. We simply created the website we wanted to experience ourselves, and by doing that we created a website that's truly ours.

What was the most challenging part about creating this website? Did you develop the website yourself? If so, what programs and/or other development tools did you use?

The website is the result of a three-month process of experimenting, optimizing, and reworking. For this project we wanted to do everything by ourselves, from design to development to photography. We really learned a lot from that.

Along the way we've been confronted with numerous challenges, ranging from finding a five-minute window of no car traffic on a narrow bridge in a busy part of the city to shoot the footage to managing the fairly long preloading time.

By creating the panorama as a stop motion video rather than from multiple stills stitched together, the movement of people, boats, and bikes in the scene is also captured. This creates a rich background filled with little things to observe and discover. But it also makes the site a lot heavier. To keep the visitors entertained while the website loads we revamped the traditional pong waiting game into a solitary 3D version that's actually easier to play with 3D glasses.

What has been the response?

The response has been tremendously positive. Our visitor numbers went from a few hundred a month to over 100,000 in the first month after the launch. We've been featured in many prestigious magazines and countless blogs. Many of our all-time web heroes sent us congratulations mail for the awesomeness. The response couldn't have been any better than this!

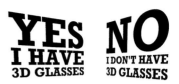

YES
I HAVE
3D GLASSES

NO
I DON'T HAVE
3D GLASSES

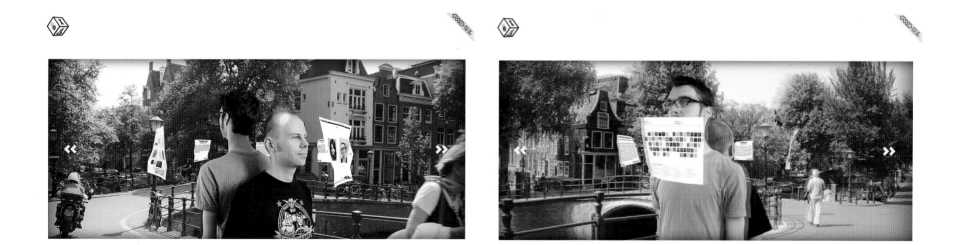

Keeping the Brand Voice Consistent

There are many visual properties that can and should remain consistent with the visual identity that you have already established. It's important to present a cohesive and visually unified portfolio package—one that looks and feels the same all around.

A consistently defined visual message will:

1. Make sure you stand out with a clear, recognizable brand message across multiple mediums.

2. Make sure your message is a memorable one because it will be consistently repeated.

3. Reflect on your ability to extend a concept and/or visual brand across multiple forms and mediums.

4. Demonstrate confidence in yourself and your message.

In advertising, a marketing campaign is often integrated across multiple mediums and formats. This "360-degree" advertising strategy means that from radio to billboards, magazine ads to television commercials, print to web, the concept, message, and visual approach all remain consistent.

Color, image stylization, and typographic treatment should remain consistent with your book design. While there is some color shifting from print to digital, the essential color palette can and should remain consistent. Keep in mind that colors tend to be darker in print than on the screen. Stylization of imagery should remain the same too. However, you can certainly create new imagery for your website—just make sure it matches the same style as the imagery in your book design. You should also consider how you can take advantage of the web's interactive and motion features to enhance the imagery and overall online experience. For example, it's quite easy to animate through a series of images—something that's not possible in the static medium of print.

Note:

Obviously the web isn't tactile like a book, so while it's possible to simulate texture and material references they certainly won't "feel" the same. Any HTML-type text included in your website needs to reference the standard typeface package installed on most computers. This is because the browser needs to reference these in order to format the type correctly. This limits the number of typefaces you can use and control on your website (especially with non-Flash-based websites). Special typographic treatments, such as for titles, navigation, or other typographic design elements, will need to be turned into a graphic in order to be included (non-Flash).

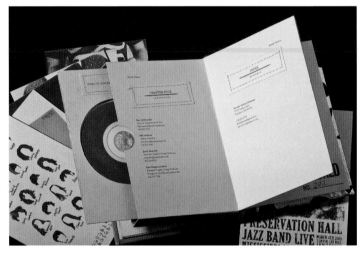

BEVERLY HAYMAN, STUDENT PORTFOLIO, Mississippi State University.

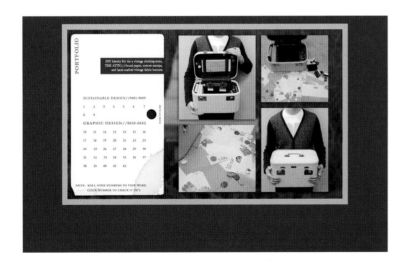

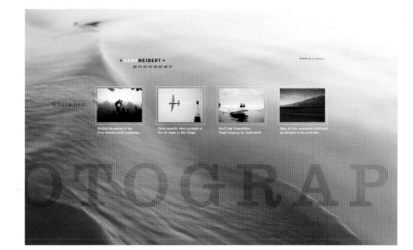

BEVERLY HAYMAN, STUDENT PORTFOLIO,
Mississippi State University, http://www.beverlyhayman.com/

DANA NEIBERT, CORONADO, CA, http://www.dananeibert.com/

I think it is very important that the print and online pieces look and feel connected. With so many photographers out there it is very easy for someone to forget your name. But if you keep all your communication design consistent, it helps develop you as a brand and hopefully gets your name to eventually stick

– DANA NEIBERT

Through interaction, the website on this page playfully moves around to various sections. The composition also "stretches" to the size of the browser.

The Uniqueness of a Web Composition

Consider how to modify your composition and layout design in order to better utilize the web's environment. The compositional space of a web page has some unique characteristics. While it's possible to keep the proportion and orientation of your website closely aligned to that of your book design, it may make more sense to go in a different direction. For although your web design will be seen through the fixed aspect ratio of a computer screen, there is actually a lot of flexibility regarding the overall composition's length, proportion, and orientation.

Through the use of a simple scrollbar a *website can be variably long*, extending the composition vertically almost indefinitely. The composition *can move and extend horizontally* too.

Consider the *z-axis* of the page (depth), incorporating interactivity that moves one forward and backward through space. Simple interactivity can also extend the composition past the confines of the browser, making a canvas that seems to "move" in any direction. The composition can even stretch with the browser's expanding or constricting size, creating a "liquid layout."

HTTP://WWW.BIO-BAK.NL/, Utrecht, The Netherlands.

HTTP://WWW.DANTESTYLE.SE/, STUDENT PORTFOLIO, Stockholm, Sweden.

HTTP://WWW.SERIALCUT.COM/, Madrid, Spain.

Keep in mind the *size* and *proportion* of the work you are showcasing in your online portfolio, as this may influence overall compositional decisions. Too often images of project work are small and crammed into a certain area of a website. Obviously this makes it difficult to get a good look at them, defeating the whole purpose of a portfolio website. Utilize the space you have in order to best showcase your work.

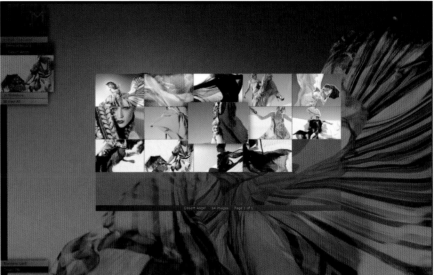

HTTP://WWW.JAMES-MEAKIN.COM/, London, UK.

This photography website, and the one on the opposite page, utilize a collection of smaller images to navigate to larger, almost full-screen views. This larger view allows the image to truly be seen – as it becomes the primary focus of the composition. Menu items and functionality can then be "layered" on top and placed to the side.

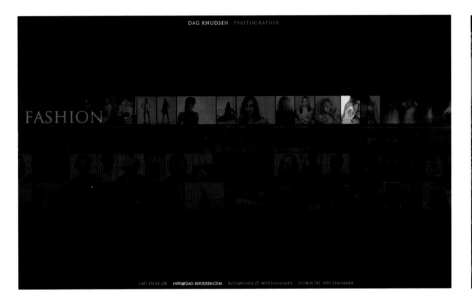

HTTP://WWW.DAG-KNUDSEN.COM/, Norway.

This website instantly highlights Kenjiro Harigai's range and depth at a glance, by featuring a background of slowly moving images. Upon rollover the image brightens, distinguishing it. Navigation at the top allows one to sort the works by category. A list which pops up from the bottom of the screen provides an additional means of navigating and viewing the portfolio.

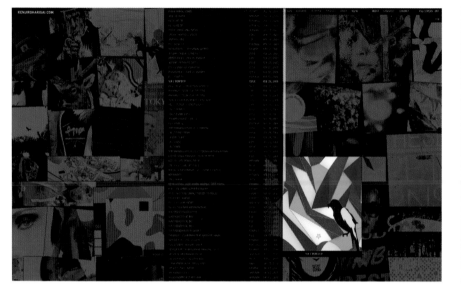

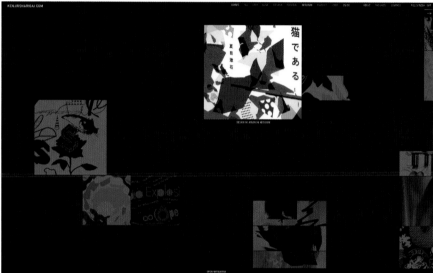

HTTP://WWW.KENJIROHARIGAI.COM, Japan.

Taking Advantage of the Web

There are unique aspects to the web experience. Consider how your design approach can take advantage of both *multimedia* and *interactivity*.

Multimedia includes a combination of different content forms, such as moving image sequences, video, animation, and sound. These different media types can be integrated together and/or linked to each other.

Interactivity is defined as the ability of the user to control the action and reaction of a media experience.

Both of these aspects can bring a new dimension to your design ideas. Moving from a static design to one that is interactive, moves, and animates can bring your online portfolio to life. **The challenge is to use these aspects to enhance the user's overall experience—to make your interface seamless, engaging and easy to use.**

Even if interactive design is not your forte, try not to be apprehensive about how you approach and utilize these qualities. If you decide to add elements of motion (video, animation) and/or sound, you should consider how they relate to your brand message. Keep in mind the conceptual framework you have already developed and explore ideas that relate. Integrating multimedia and interactive components should enhance the online experience in a meaningful way, without distracting from the original goals of your online portfolio.

Aspects to consider:

- Audio—background music, navigational cues, sound effects. Keep in mind that audio can get annoying—use sparingly and always include an on/off button.

- Animation/motion graphics.

- Video (and web codecs).

- Image sequences/slideshow.

- Transitions between sections and imagery.

- Movement through depth and space.

- Interconnectedness to content and media.

- Social networking.

Javier's portfolio website does a great job of integrating motion, sound, and interactivity, creating an engaging and memorable experience.

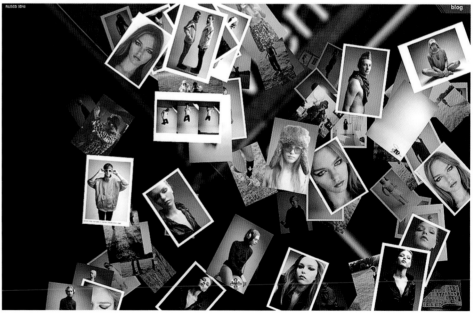

HTTP://WWW.JAVIERFERRERVIDAL.COM/, Spain.

Traditional Website Design

Traditionally, when designing a website one considers several different page layout designs; that of a homepage, and at least one or two secondary pages (depending on the variety of content to be presented). For more complex websites, additional page layout designs are also often necessary. A homepage has traditionally served a somewhat different purpose than that of the rest of the website. Much like a book cover or film title, its main purpose has been to attract, entice, and establish a particular mood, tone, or brand identity. This is often achieved through heavier graphics and/or animation, motion, and sound in order to "introduce" the website itself. On the other hand, secondary and lower-level pages have been traditionally designed more functionally to allow one to navigate to and view content, whether imagery, text, video, or animation.

Fluid Spaces

Many website designs nowadays don't differentiate as clearly between the look and functionality of a homepage versus the secondary pages. These websites layer visual elements and transition between content, navigation, and information more fluidly. Such a website doesn't jump from page to page so much as it moves, transitions, rearranges itself, and hides and reveals content, navigation, and other visual elements in response to the audience's interaction. In such cases, hierarchy becomes much more fluid; as shifts in the content change, so too do the relationships between the elements and the space around them. So while these elements exist in the same compositional space, they are simply layered onto multiple "levels"—shifting visual emphasis and focus as the priority of each section changes. A common technique used with these types of portfolio websites is to present project work in a "lightbox" of sorts, layered above a darkened or blurred-out background of content.

Simple and elegant animations bring life to Jonathan Yuen's captivating portfolio website.

HTTP://WWW.JONATHANYUEN.COM/, Singapore.

Layering and Separation

Many contemporary website designs take advantage of a design principle called *layering and separation.* If used strategically it can help one integrate and organize multiple levels of visual and functional information into the same space without clutter or confusion. To do so requires a careful balance of elements and hierarchy.

Integrated Media

One of the great things about the web is that it can bring together different types of media and content. It's important to consider how each separate element can work together as part of the larger whole. Each element should be considered and designed in order to achieve a cohesive overall composition, regardless of media type. The integration of content, navigation, imagery, video, and/or animation should be seamless.

Confusion and clutter are the failure of design, not the attributes of information.

– EDWARD TUFTE, Information Designer

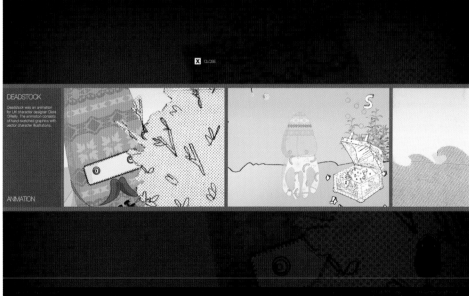

HTTP://ALLABOUTJAMES.CO.UK/, London, UK.

Video

To integrate video into your website you will need to compress the video and limit its file size. This can be done with a number of video codecs (compression schemes). Of course, you will trade video quality for file size. In addition, Adobe Flash has its own video format, which is quite popular— the FLV format.

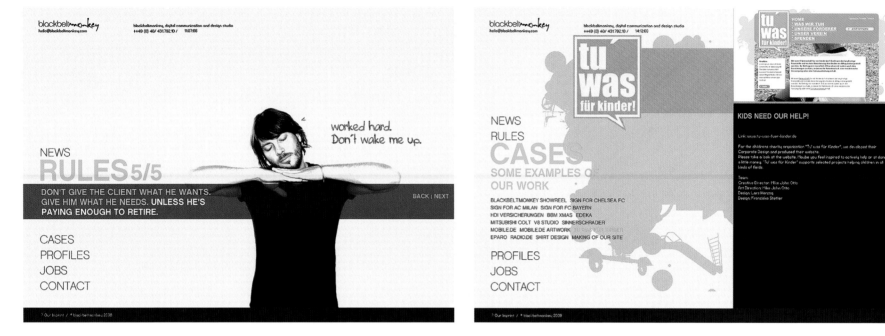

HTTP://WWW.BLACKBELTMONKEYCOM, Hamburg, Germany.

In Black Belt Monkey's website, video acts as an integral part of the composition, instead of being isolated and separated in its own little box.

HTTP://WWW.DIEGUTGESTALTEN.DE, Düsseldorf, Germany.

The creative studio Diegutgestalten utilizes full-screen video as part of a unique and captivating concept to present their works in public spaces or onscreen. They also use video to create a short introductory narrative about getting ready for work in the morning.

Movements and Transitions

It's important to consider the timing and manner in which visual elements move or appear on and off the screen, as well as transition between each other. Such movements in the interactive environment should be unobtrusive and smooth. Quick, simple motion effects and animations, such as fades, wipes, and dissolves, can work well to introduce individual elements and create smooth transitions between elements in an image sequence.

HTTP://WWW.GLENNBOWMAN.COM/, Orlando, FL.

In Glen Bowman's *Travel Japan* website, a simple crossfade between images helps make the sequence appear less abrupt and flow more naturally. Transitions such as these should happen quickly (often in less than a second) and be limited in type applied consistently and only when needed.

HTTP://WWW.PORLINIERS.COM/, Argentina.

Other types of motion effects can occur more broadly when transitioning from one section to another or adding and rearranging multiple elements onto the screen at one time. Often images, navigation, or text will slide into the viewable area of the screen in response to the user's interaction.

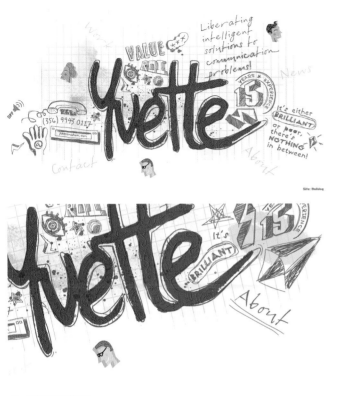

Site: Bulldog

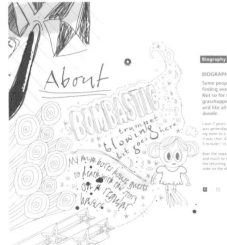

Another popular method for transitioning between website sections involves moving in and out of the compositional canvas. The main composition moves, zooms, and rotates around from one area to the next, each displaying a different section of content. Don't forget to apply an ease in/out to your motion effects so that they feel more natural.

Animation imitates the world that we live in, so it's important that movements within your animations feel as if they are based on real world movements, even if they are exaggerated. In our world, it is very rare that something will move at a constant rate.[1]

– CartoonSolutions.com

Time-Based Media

A basic familiarity with time-based media can be helpful when designing for fluid interactive spaces. If you don't have much experience in this area, you can learn a lot through trial and error. As you work, take the time to export your animation frequently. Watch it carefully. How's the timing? Is the motion fluid or jerky? Do transitions take too long? Does it feel rhythmic? Keep making adjustments until the playback feels right—then shorten it!

HTTP://WWW.YVETTEMAHON.COM, Sydney, Australia.

A Note about Blogs

With the increased popularity of blogs, one current trend for portfolio websites is to model themselves after its structure. In this way, the homepage acts less like a cohesive design and more like a portal or listing of text, images, video, etc., taking you directly to content and relational links. Traditionally, blogs are by nature more about social networking, linking content, and journaling than presenting a portfolio. This does not mean, however, that such a website can't still work for your purposes. But it will rely on the work speaking for itself, whereby the website structure functions more like a container. You'll have to decide if this approach works for you.

A blog structure is easy to use and gets you to content fast. It's also fairly easy to maintain and keep up to date. However, for a creative professional it may be important to design something that is more unique and can express an overarching vision and design concept. It may be a better idea to have a blog for more personal use and a separate portfolio website for professional use.

The Grid System (Again)

The use of a grid system can be useful in the design of a website. It can be helpful in planning the consistent placement of content and navigation from page to page, making for a well-organized sequence that is easy for website visitors to use. Remember that negative space is a good thing. You can use a grid to help group and separate content while not filling up the page. Traditionally, website designs have been organized and constructed based on a grid system, establishing some fairly predictable page layouts. Early on, the use of HTML tables supported this direction. Nowadays, website designs can take on a variety of forms—some still reference a grid, but others do not. Whether you use the grid, deconstruct the grid, or decide not to use it at all, make sure you at least consider your options.

Layout and Content Tips

- Don't let consistent areas of content shift placement or "jump around" from page to page.

- Include navigational cues, titles, and subtitles.

- Include brief explanations about project work.

- Think about the kinds of content that will be included "above the fold"—what can be seen in the browser without having to scroll.

Introductions

For those of you working with a heavier (k size) website design, you should consider the design and implementation of a preloader. A typical preloader includes a simple animation and/or progress bar, along with a dynamically updating percentage that indicates how much of the website is currently loaded. This will take a little coding, but it's really important to inform your audience how long they have to wait for your website to download. Of course, the longer someone waits, the greater his or her expectation will be!

HTTP://ALLABOUTJAMES.CO.UK/, London, UK.

HTTP://WWW.PORLINIERS.COM/, Argentina.

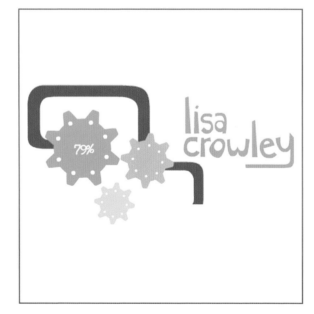

HTTP://WWW.YVETTEMAHON.COM,

Sydney, Australia.

LISA CROWLEY, STUDENT PORTFOLIO,

Endicott College.

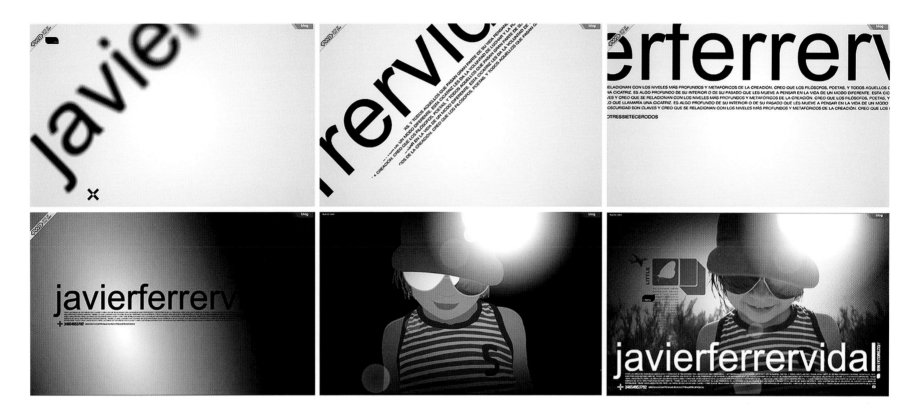

HTTP://WWW.JAVIERFERRERVIDAL.COM/, Spain.

Some websites also include an animated sequence, which acts as an introduction to the website. These can be fun, demonstrate your motion abilities, and set the tone of the portfolio experience. They are often designed with the website's concept in mind. Typically these animated sequences are created in Adobe Flash and can include animation, motion graphics, animated type, sound, and/or video. Often they include opening transitions that "build" up the website design, bringing visual and navigational elements onto the screen in a choreographed manner. It's important that such an introduction be quick. If it's more than a couple seconds long it's recommended that you provide a means to skip it. Keep in mind that someone may be going to your website more than once. If they are trying to get your contact information to offer you a job, you don't want them to be frustrated because they have to wait.

SITE ARCHITECTURE

One of the big reasons you can't just directly transform a print design into a web design is because of the inherent importance of navigation. The inclusion and integration of navigation into your interactive design is of course crucial and requires some thought. Navigational links and/or graphical "buttons" take you to additional content, such as web pages, images, video, or even other websites. Through navigation users are able to take control of the direction, sequence, and rate at which they move through, view, and sometimes even interact with content. Great navigation should be a perfect melding of both form and function.

When determining the navigation and functionality of your website you need to start by considering your website's overall architecture, which describes three things:

1. The kind of content you are including in the website and how much of it there will be.

2. How your content is organized and prioritized—subdivided and grouped into particular sections or web pages.

3. How these sections are linked together—that is, if you're in one area of the website, how do you get to another? Describe the path a user has to take in order to get around.

Grouping Content

It's important, especially for a portfolio website, to be clear about what content is included and how someone can get to it. To do this you should *organize* and *prioritize* content into main sections—"chunking" similar information into overarching logical groups. You should have already done something similar when organizing your portfolio book.

Think about not only the various similarities and differences between the information itself, but also the various kinds of content you have: There's a difference between a section that includes mainly text describing your talents and experiences in an "About Me" section versus a section that includes mainly images showing your talents and experiences in a "Portfolio" section. Keep in mind that the very act of organizing content affects the way the end user will interpret and understand the separate pieces of information in your portfolio. It creates context and also a way to find information.

Target Audience

Remember to always keep your target audience in mind: What is the purpose for the target audience's visit to your website? What do you think is most important for someone to look at first, second, third?

The manner in which you organize content will have a huge impact on the structure of your navigation. A good rule of thumb is to limit the number of main buckets of content to seven; this is the number a person can generally remember using short-term memory.

LATCH and Other Organizational Schemes

Richard Saul Wurman (famous information architect and designer) discusses information design principles at length in several of his books. He uses the acronym LATCH to identify five key ways to organize information:

Location: Great for geographic relationships such as with maps.

Alphabet: Like a dictionary or names in a phone book.

Time: Works well for things like train schedules.

Category: This organizational scheme is used quite frequently since it allows things to be grouped by some quality that they have in common. Defining that quality is crucial, as it will communicate a certain prejudice and understanding of the information more openly than any other organizational scheme.

Hierarchy: Organizes by magnitude such as small to large or least expensive to most expensive

One can also add:

Continuums: Qualitative comparisons such as ratings systems.

Numbers: Creating underlying mathematical relationships such as the Dewey Decimal system.

Randomness: Arbitrary organizations—the absence of a defined organizational system can be valuable at times.

Defining Categories and Labels

Determining how to name sections of your website and subsequent navigation will tell your target audience a lot about you right upfront. It will define the context with which someone will understand the depth and breadth of your talents and experience in one glance. However, it's not necessarily easy to capture the content of a website with only a handful of keywords.

For example, some people create a generalized grouping of their work under a "portfolio" section. In this case, a secondary level of navigation can be used to link to more specific kinds of work. Other people, however, are more specific in identifying the main section headers of their website. They use section names that distinguish among the various kinds of work in their portfolio, such as an "illustration" section or "logo design" section. Some people decide to merge both. They provide a main navigational link to a "portfolio" section, but break down each category as a more direct link from the homepage. Still, others find more offbeat and creative ways to describe each section of their website. Figuring out what's best for you means figuring out what works best with your overall concept and how you frame the context of your work.

On Trollback + Co's homepage, a user can filter a collection of thumbnails by different categories, some more conventional like "branding" and "titles," and some more fun like "shiny" and "yellow."

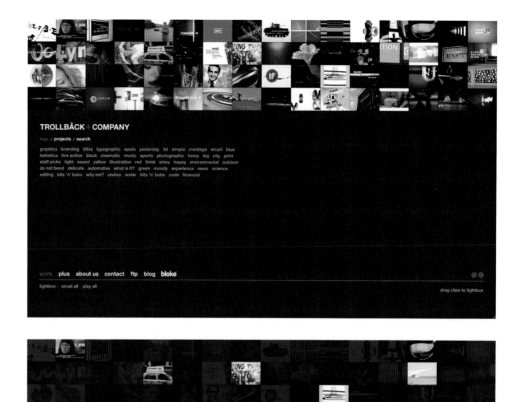

HTTP://WWW.TROLLBACK.COM/, New York, NY.

Make sure to include secondary navigation for major areas of your website, especially in the portfolio section. A user should be able to get to all the main areas of your website at anytime, no matter where they are. Within one main section, a user should be able to easily get to all the secondary subsections as well. So, if you break up your portfolio by category and someone clicks to go to the print section, he or she should be able to click and get to a photography section or video section from that same page. Don't make someone have to click back to the homepage in order to see more work. Your website should be easy to use and provide quick, efficient access to all your work.

Site Maps

It's best to draw out a site map so that you are clear about how you are going to organize your website and what navigational links or buttons you're going to need in order to allow someone to get to your content. There are two types of website architecture that are most widely used, separately and in combination.

The first is a *hierarchical structure*—starting with a homepage that links to a number of secondary pages, all of which typically identify main sections of the website. Additional pages are usually accessible from these secondary pages. In this way you prioritize the information and define not only the main sections, but secondary and tertiary levels too. (site example opposite page: top).

Another type is a *sequential structure*. This simply means that you set up your website map linearly, moving forwards or backwards in a sequence. Quite often this is used as a means to view a series of images, usually including "next" and "previous" buttons as well as links to individually numbered pieces. (site example opposite page: bottom).

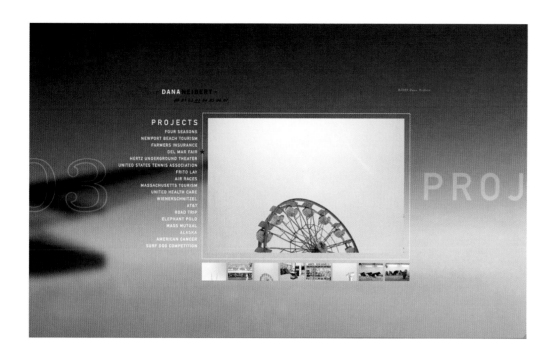

HTTP://WWW.DANANEIBERT.COM/,
Coronado, CA.

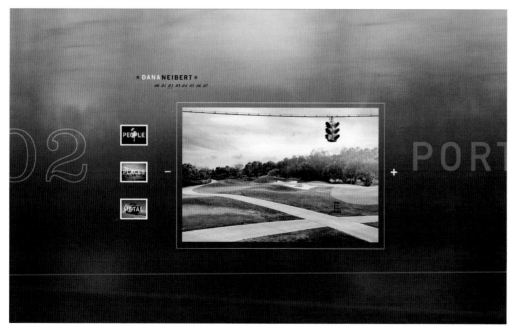

Regardless of the type of structure you choose, when it comes to your own website, try to keep it simple in terms of architecture and subsequent navigation.

User Interface Design

A user interface is the layer of interaction by which we are able to communicate with a computer, website, application, or other type of technology. The design of a user interface focuses on the expectation of a user's experience—attempting to facilitate interaction that is clearly understood and efficient in allowing the user to accomplish his or her goals. We often hear reference to a *graphical user interface* (GUI), which utilizes icons and other visual references in order to help one interact with and navigate a computer system, application, or website. The "desktop" metaphor used by almost all personal computers is a great example of a GUI—it allows people to more easily interact with the computer through familiar objects such as folders and task-specific icons. Obviously, the design and application of navigation within your website design is important; it will be the primary "interface" by which someone will use your website.

You can think of interface design as encompassing information design, interaction design, and some forms of sensorial design (mostly visual and auditory design, since most computers can only display sights and sounds). Typically interface designers have addressed the layout of screens, the design of screen elements like icons, and the flow among them.[2]

– NATHAN SHEDROFF, Author, *Experience Design*

Navigation

Well–thought out navigation is key to any good website design. In many cases it's even the focus of the design itself. Navigation can range from fun and playful to practical and efficient. The best navigational solutions reference the design concept and are intuitive to use.

It's important that navigation be visually distinguished from other elements on the page in terms of style and placement in the composition. It should be clear from the start how users can get to content that they are looking for. Rollovers and hover effects can also be quite useful, not only to indicate that something is "active," but also as a means to provide additional navigational information.

Navigation can take many forms: graphical buttons, hypertext links, CSS buttons, Flash animations, dropdown menus, icons, and so on. Whatever the style, navigation provides users with a sense of orientation within the website—where they are and where they can go. So it's important that at least the global navigation (main sections) of a website remain consistent. Make sure to design multiple "states" for your links and buttons. Once a user clicks on a link or button and goes to a new web page, that link or button should look different. This helps provide a visual cue to the user that he or she is now at a corresponding page within the website.

Keep in mind that you don't have to make your navigation too big—big, huge "buttons" on a web page look clumsy and unattractive. In addition, think about issues of growth and scalability. If you intend for your work to expand into other directions at some point, you may need to plan your design accordingly so that additional navigation can be added without much hassle.

HTTP:// WWW.THIBAUD.BE/, Belgium.

Thibaud's portfolio website focuses on a unique navigational system — "swatches" are draggable and fan out to reveal integrated content, such as imagery and video.

175 DIGITAL & ONLINE PORTFOLIOS

Hiding/Revealing

Another trend in website design is to collapse and reveal navigation, keeping menu items "hidden" or out of the way when not needed. In these cases, at least one word or icon typically remains visible in order to indicate where the menu is located. Upon rollover or click, the menu bar expands revealing navigation to the user. This is a great way to keep the compositional space clean and uncluttered, especially when presenting portfolio work. Collapsing menus, dropdown menus, hide and reveal layering, hovers, and pop-up menus all work for this purpose.

In this example, the navigational area of the portfolio section is "hidden" until it is rolled over. This creates a clean, clear presentation space for individual project images to be viewed. Upon rolling over that area, the focus of the composition changes—the project image is pulled out of focus and individual project links are listed. In addition, upon rolling over a "profile/contact" button, the compositional space opens up from the top to reveal profile and contact information. This collapses again upon rolling over a "close" button.

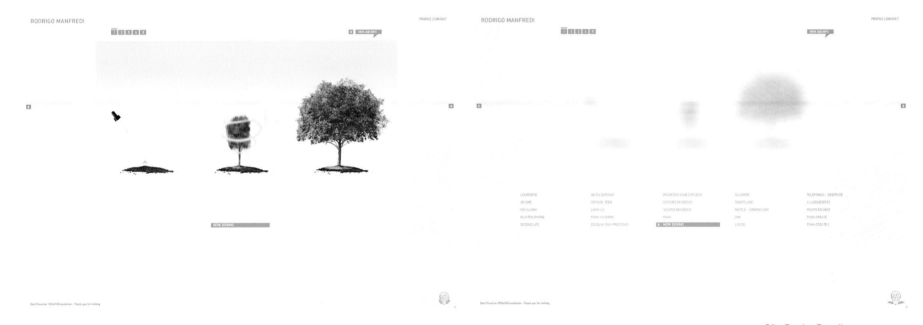

HTTP://WWW.RODRIGOMANFREDI.COM/08/, São Paulo, Brazil.

HTTP://WWW.SELFTITLED.CA/, Santa Monica, CA.

In this example, the color coding within the circle divides the content into sections. It also acts as the main navigational device. Additional menus reveal and collapse upon interaction.

Additional Tips: Don't Forget!

1. Include your contact information—make sure it's clear to the user how to get in touch with you.

2. Include a link to a resume or CV that will look good when it's printed out, like a downloadable PDF.

3. Keep your portfolio up to date. This is one of the inherent benefits to an online portfolio—keep it fresh!

Q&A: Interview with Chris Wooster, Group Creative Director, T3

Chris Wooster is the group creative director for T3 in Austin, TX. Chris' previous positions include vice president/associate creative director of interactive media at Mullen, senior copywriter at Baldwin & Stone, and copywriter at Zentropy Partners. He is a graduate of Boston University and his website is *http://chriswooster.net/*

How important do you feel an online and/or print portfolio is in securing a creative position in your industry?

Put simply, you don't have a chance without a digital book. I'm hiring for expertise in digital spaces, and if you have trouble getting a site up it suggests to me a wide array of things that concern me.

First, it suggests you don't have friends who work in this space and can help you out. If you don't have friends in this space, you likely haven't worked in it very long. And that's a huge, flapping-in-the-wind red flag. How about a school colleague? Kid neighbor? Somebody?

Second, putting digital work in print is kind of like putting a print portfolio on a 33 RPM record album. It simply disintegrates the ideas to take them out of the form they were meant to live. Plus, me asking for your printed portfolio raises your expectations that I'm really interested in you. I'd prefer to browse your site and then contact you, in that order.

Third, if you can't figure out how to market yourself, how can I trust you with the brands we work on?

What do you look for in a portfolio? What contributes to an overall portfolio design or construction that stands out and grabs your attention?

Simplicity of idea and execution. There are no points off for a site that is a bit spare in its technical construction, but *huge* points off if you both overthink and underexecute the presentation. I'd much rather see a simple, straightforward slideshow of work than a highly conceptual monstrosity with some kind of clever-seeming navigation that's a mystery to navigate. We return to the idea: If you didn't see why your own site was a user-experience challenge, how can I expect you to do anything worthwhile for our clients?

Concept:

Do: Think twice before developing a gimmicky concept for the whole site.
Do: Remember all the sites you hate that let concept get in the way of content.
Don't: Have four pages of intro click-through before you get to real work.
Don't: Overreach. You're going for a job, not a Cannes award.

Flash or no Flash:

Remember, unless you really know what you're doing, 100 percent Flash sites are poorly optimized for search, don't show up on mobile devices well, and are a huge pain to update unless you're a Flash wizard. This means, consecutively, that recruiters can't find you, on-the-go-iPhone-enabled creative directors have to be at their desks to browse you, and you'll never, ever have an up-to-date site with your best work. You can have some Flash if necessary, but you can do wonders with simple Javascript these days. Really. In fact, I'm more impressed with that since it shows awareness and workaround problem solving. Good on you for that.

Sweat the details. Don't have any links that error out. Double check them all from time to time, especially links to live sites that clients can modify or take offline unexpectedly.

Note: See more Q&A with Chris Wooster in Step 8: Professional Materials.

Designing Interactive Sequences

Most people design their websites in a program like Adobe Photoshop or Adobe Illustrator. It's a good idea to create multiple designs and iterations in search of the best solution. Make sure to sketch and draw out storyboards so that you understand not only how your website will look, but also how it will function. A storyboard should illustrate the homepage design, key transitions, and functionality, as well as the major sections of the website (such as the portfolio section). Such design mock-ups typically try to describe all the functional and visual elements of a website that are important in communicating the concept. This includes the various states of navigation and functionality, such as rollovers.

Include textual notes and visual information that describe transitions, interactivity, media, motion, sound, and animation as they correspond to the individual storyboard frames. While designing, utilize layers in Photoshop or Illustrator in order to indicate the various states of navigation and functionality (like a "default," "rollover," or "clicked" button). These layers can then be turned on and off in order to illustrate how functionality will work across a storyboard.

1.

2.

3.

4.

Concept = Interactive CV

1. Each colored stripe equals a project or achievement. Organized by timeline, recent activities first. Length of stripe indicates overall significance.

2. Content Filters:
 - Professional Activites
 - Interactive Design
 - Studio Art
 - Print Design
 - Syllabi & Student Work

 Additional links:
 - Emal & Cv

3. Rollover individual stripes for information - stripe gets larger. Click to see project work and additional info.

4. Transition to project layout - stripes recede to background, lightbox opens from left, "Click and drag" project area to see more. To "close" click X at top right corner - returns to main interface.

DANIELLE CURRIER, STORYBOARD

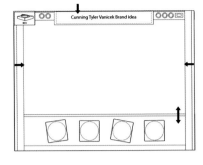
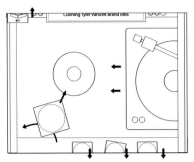

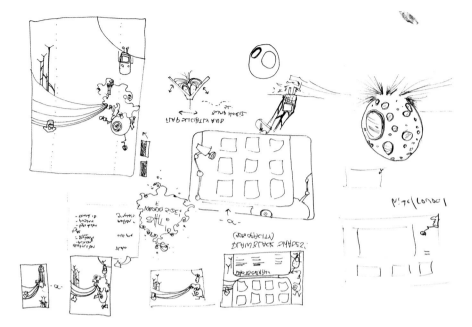

TYLER VANICEK, STUDENT STORYBOARD, Endicott College.

JESSICA HARTIGAN, STUDENT SKETCHES, Endicott College.

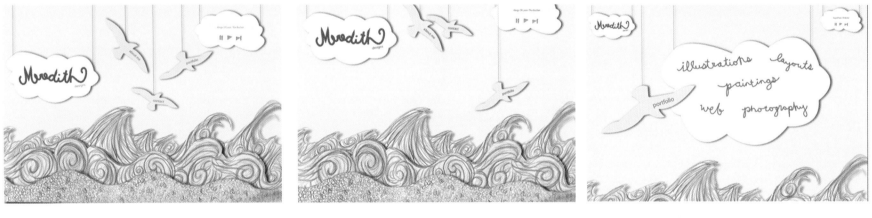

- Name, birds, music all drop down bounce, then stay in place
- Choose music
- Water rises from bottom slowly, waves continuously move, slightly

- Portfolio bird drops down, others pull up, waves go down
- portfolio bird moves to the right and off to another area
- starts zooming in.v

-- name, music comes back in but smaller
- options for portfolio cloud comes down bounces then settles.
- waves moving at the bottom slightly
- rolover options, just drop-shadow the word.

MEREDITH LINDSEY, STUDENT STORYBOARD, Endicott College.

For more information and resources about web development, check out Appendix A or visit us online at http://www.noplasticsleeves.com.

Note: *Screen size.* Recommended screen resolution: 1024 pixels × 768 pixels or 1280 pixels × 800 pixels.

Define the viewable area. Screen resolution — the browser = viewable area "above the fold."

Development Tools

For those with little to moderate experience, developing online content can be quite daunting. As the standard for website design and functionality has increased, so too has the level of knowledge one needs to know in order to develop a "successful" site. Thankfully, there are a broad range of tools and technologies that are available to help. Depending on your project goals, a variety of solutions may do the job. These range from out of the box solutions to software applications that do a lot of the heavy coding for you. The challenge is to make sure that you don't allow the technology to undermine your concept or vision, but understand how to take advantage of, work with (and sometimes even around) the technology in order to develop a successful portfolio solution. An understanding of current trends, schools of thought, and available technologies is a key part of figuring out how to do just that. Most of you will probably end up building your website through the use of web development software such as Adobe Flash or Adobe Dreamweaver. You might also decide to integrate video using such formats as Flash Video or Quicktime. As you develop your ideas for your website it should become clearer which applications to use. Your decisions may also be based on what you feel most comfortable using.

Adobe Flash is the industry standard for developing rich media web content. That means it's great for integrating 2D animation, video, sound, and interactivity. It's also used to develop more sophisticated online RIAs (rich Internet applications). Flash contains it own scripting language called Actionscript.

Adobe Dreamweaver is the industry standard for developing non-Flash-based websites. It enables users to build fully functional websites in two distinct ways: to write and edit code directly through the "code" view; or, allow users to visually see and edit the layout of the page through the "design" view.

Sites designed in either Photoshop or Illustrator are typically broken down and then reconstructed for the web. For websites built in Dreamweaver, a healthy knowledge of XHTML, CSS, and Javascript behaviors is a plus. Flash users will need to understand how to work within the Flash environment and how to code some basic Actionscript. Photoshop's built-in web tools can also be helpful for the less experienced – try slicing, animated gifs, and creating rollovers.

Developing a website demands a certain amount of skill. If you are unsure if your abilities will enable you to accomplish what you want, you may need to invest some time and money into getting up to speed. You may, for example, need to take a course or work through a set of tutorials in order to learn how to develop your website. You could also find someone who has the skill set you desire to work with. You may even be able to barter your professional services in exchange for theirs.

There are certain standards that have been developed within the web industry. These include standards regarding naming conventions and the setup of directory structures. If you are building your own website, you will need to be aware of these.

Optimization for the Web

When creating images of your portfolio work for a website, you will need to take screen resolution and file size into account—making sure that your images are 72 dpi and will physically fit within a standard web size format. The most common web file formats are JPEG, PNG, and SWF. When optimizing video for the web, use codecs that have been especially designed to balance file size, quality, and streaming.

The best way to approximate [overall screen dimensions] is to set a monitor at the appropriate screen size, expand the browser, and take a screen grab. You can then get an idea of how much space is actually available for displaying information.[3]

– JOSHUA DAVID MCCLURG-GENEVESE, Designer

How to Get Your Website Live

It's pretty inexpensive to purchase your own domain name and hosting space. Keeping your URL the same as your name or book title is also a great way to reinforce continuity and keep things professional. That goes for your email address too!

1. Purchase a domain name.

2. Purchase server space (site hosting).

3. Use FTP software to upload your website and push it "live."

It's recommended that you purchase your domain name through the same provider that will be hosting your website—it makes the set up a lot less painful. While the whole process can seem difficult, don't let that stop you—it's really advantageous to have your own website. If your grandmother can do it, so can you.

Online Portfolio Directories

There are a whole host of online directories that serve as a means for people to post and share their work. Many of these are searchable by geographic location and expertise. They provide a key way for potential employers and clients to search for someone who they'd like to hire, whether full time or for a specific job. Some of these websites require a fee in order to be listed and some don't. Examples: Photo Serv, Site Welder, *Communication Arts*, AIGA, ASMP.

Q&A: Interview with Andrew King, Partner, and Mike Wislocki, Partner, SquareWave Interactive

Founded in 1998, SquareWave Interactive, in Watertown, MA, has built a solid reputation for delivering exciting, engaging media solutions. Their services span the range of media made possible by their combination of technology and award-winning experience. Leveraging a specialty in Flash, they create websites, product demos, games, rich media ads, videos, and identities that turn heads—and get results. Each production involves the carefully orchestrated efforts of programmers, motion designers, 3D modelers, compositors, music composers, and audio engineers. Their skills are complimented by their state-of-the-art tools and software, and amplified by their dedication, vision, and expertise.

How important do you feel an online and print portfolio is in securing a creative position in the interactive industry?

Between a potential candidate's resume and portfolio, we feel that the portfolio is by far the most important criteria—hands down. To us, a resume shows your ability to type, spell (hopefully), and regurgitate a handful of technologies and buzzwords common to 95 percent of the applicants who come down the pipeline. We want to see what you can accomplish in practice; not in theory.

As an (interactive studio), what do you look for in an online portfolio? What contributes to an overall portfolio design that stands out and grabs your attention?

A solid portfolio really allows you to differentiate yourself—you can give a clear, practical demonstration of your skill set, and many things that are less tangible—your attention to detail, sense of aesthetics, ability to follow through, and most importantly, your range. Does everything you produce look, act, and feel the same, or are you flexible enough that you can adapt your skills to accommodate the needs of a specific project, without sacrificing your artistic vision?

What do you think makes for an effective reel?

Focus mostly on the content. Draw our attention to the design detail, motion design, transitional elements, and give us impressive examples of clever user interaction. Don't reduce the impact of your work by distracting us with gratuitous video effects.

In general, how many pieces of work do you think a student should include in his or her portfolio?

It's hard to nail down an exact figure—we'd like to see enough pieces so that we can be confident that the candidate has a solid level of experience and has been exposed to a diverse array of brands and project requirements. That said, we'd prefer to see a small handful of tight, complete, and polished pieces than an avalanche of interesting but incomplete work.

Do you have any advice for someone currently working on his or her portfolio and/or other promotional materials?

Be precise, concise, and if you're doing anything remotely interactive, test, test, test. Be positive that there aren't any bugs or breaks in the projects, because if we find them, it's going to count against you.

Animation/Broadcast Design Reels

For animators and broadcast designers, a demo/show reel is essential. It can be the portfolio in and of itself or part of a broader portfolio package included with a portfolio book or as part of a portfolio website.

To put together a show reel, compose your best motion work into a short montage feature (three to five minutes). Most show reels are also edited to a musical beat and are set to a fairly quick rhythm and pace. Try a royalty-free source so you don't run into copyright issues. Also pick something you really like because you'll listen to it many, many times! After the initial montage, select your best work to include—either edited down for length, or if short enough, in their entirety. Be sure to avoid cheesy transitions.

Nowadays DVD and online video is the standard reel format. Be sure to include your name and contact information clearly on the DVD jacket.

During an interview with Jeremie Dunning, a senior web designer with Burton Creative Services in Burlington, VT, he was asked: *What makes for a successful promo reel?*

The most important thing is to know your audience. What I mean by that is, if it's going in front of a director, their time is very short and they are very familiar with technology. In which case, choose a DVD and categorize your work—documentaries, commercial, motion graphics, animation, etc. This will help them get right to the work they are interested in.

Have your portfolio online—these are technically savvy people. They will want the ability to quickly get into the work they are interested in. These are people that sit in front of a computer all day—they are more apt to be responsive to a portfolio that is online and efficient in getting them the message.

Make it short—keep them asking for more. That will get you in the door.

The world of editing has expanded—make sure your audience knows what tools you have used in order to create what they are looking at. Different places expect you to know different tools. Communicate the craftsmanship behind your work.

Essentially, a showreel is a short video clip (around three minutes and rarely more than five) which showcases your best work.[4]

— Christian Darkin, *Filmmaker, Illustrator, and Animator*

CREATE
your own visual style... let it be unique *for yourself and yet*
identifiable *for others.*

ORSON WELLES
Actor/Director

PROMOTIONAL MATERIALS

Introduction

Aside from, and in addition to a portfolio, many people create promotional materials in order to market their talents and abilities. Unlike a portfolio, promotional pieces do not typically represent an artist's range or depth within an industry, but are instead focused around one central idea, providing a "snapshot" of one's capabilities. Promotionals are a great way to grab someone's attention and pique his or her interest—enough so that a potential client or employer would hopefully want to know more. That's difficult to do though, as most creatives in the industry have just about seen it all.

For that reason, the most successful promotional pieces are often developed around a specific and entertaining concept, form, or central theme, making them stand out and be more memorable. They should also accurately reflect the kind of work you want to do. Such a project can be developed as a single work or as a series of interrelated pieces. Often promotionals are developed in such a way that they can be made quick and cheap, easy to recreate and distribute. However, promotional pieces should still be a reflection of exquisite craftsmanship and attention to detail, reflecting the care and pride you take in your work.

Promotional pieces can be made to:

1. Function on their own, in absence of, or in addition to a portfolio.

2. Created in order to specifically drive someone to a portfolio, particularly an online one. Such promotionals are often designed in a similar style or conceptual framework as the portfolio itself, establishing a visual link and brand connection.

Promotional materials can take many forms, such as books, postcards, stickers, 3D objects, buttons, videos, animations, and more.

JESSICA HISCHE, STUDENT PROMOTIONAL, Tyler School of Art.

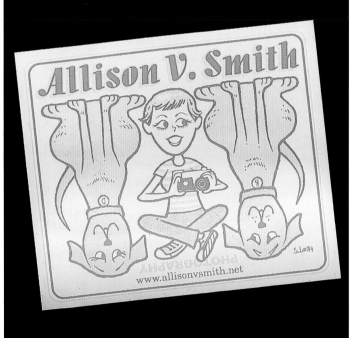

ALLISON SMITH, PROMOTIONAL MATERIALS, Dallas, TX.

Professional Organizations and Networks

While it goes without saying that relationships in your professional community are essential, they can also be extremely useful in extending yourself, your services, and your product, and for some, your brand. ASMP (American Society of Media Photographers), PPA (Professional Photographers of America), and AIGA (the professional organization for designers) are three examples of large organizations that provide resources both nationally and regionally. In addition to keeping up on emerging issues such as copyright and pricing, meeting individuals in the working community eventually can pay off in terms of marketing. While they are often your peers who are competing for similar clients, general networking can provide leads and ideas for self-promotion. At minimum, feedback and sharing experiences with other creatives is always of value. Finally, your membership to a professional association can add to your credibility as an invested professional who is established, or working toward establishing a long-term career.

Organizations and publications of your particular client's industry can also be useful for tracking trends, and identifying potential clients. It is also possible to access industry or association databases (if you are a member) to identify potential clients to target.

Mailings: Electronic versus Hard Copy

While electronic postcards or image samples are cost effective and easy to employ, they are not necessarily a replacement for printed mailers for the very same reason's that printed mailers are not an end themselves either. Your email, while effective, has less chance of standing out if viewed via a subject line that looks like every other email subject line and is part of hundreds of emails an individual might receive in a day. Essentially, you have no control over the delivery.

Further, if a potential client does open your email to view it, if it doesn't get printed out, it becomes one of dozens that are in their inbox at the end of the day. A busy editor or art buyer may not have the time or inclination to sort through emails to find you again. Electronic forms can be supplements to initial contacts, particularly when you are known to the individuals to whom you are sending materials.

A hardcopy printed postcard or mailer can be easily filed and saved for reference at a later date. While it is true that dozens may come into the office of a potential client, if you have done your homework, you have a better chance of being seen.

If your goal is to be hung on the wall the image should be something I'd be proud to display in front of all my colleagues. If your goal is a website visit it should be something intriguing that makes me want to see what the hell you're all about. If your goal is for me to show it to someone else it should be impressive, outrageous or hilarious. If your goal is a phone call then you need a bit of perfect timing so that the card lands on my desk when I'm looking for someone like you.[1]

–ROB HAGGART, *A Photo Editor*

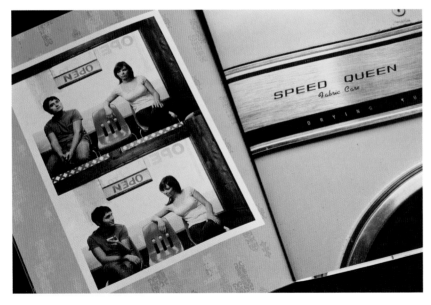

HAROLD LEE MILLER, PROMOTIONAL MATERIALS, Indianapolis, IN.

ALLISON SMITH, PROMOTIONAL MATERIALS, Dallas, TX.

Check out these personal promotional booklets from New York designer Nicholas Felton. He takes facts about his own life and turns them into a veritable feast of information design. He has published three such "annual reports" to date, aptly named the *Felton Reports*. His website, http://www.daytum.com, allows users to create their own personalized reports.

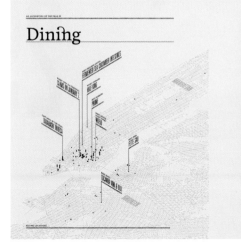

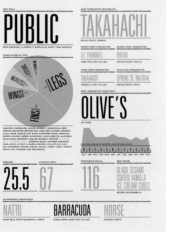

NICHOLAS FELTON, PROMOTIONAL MATERIALS, New York, NY.

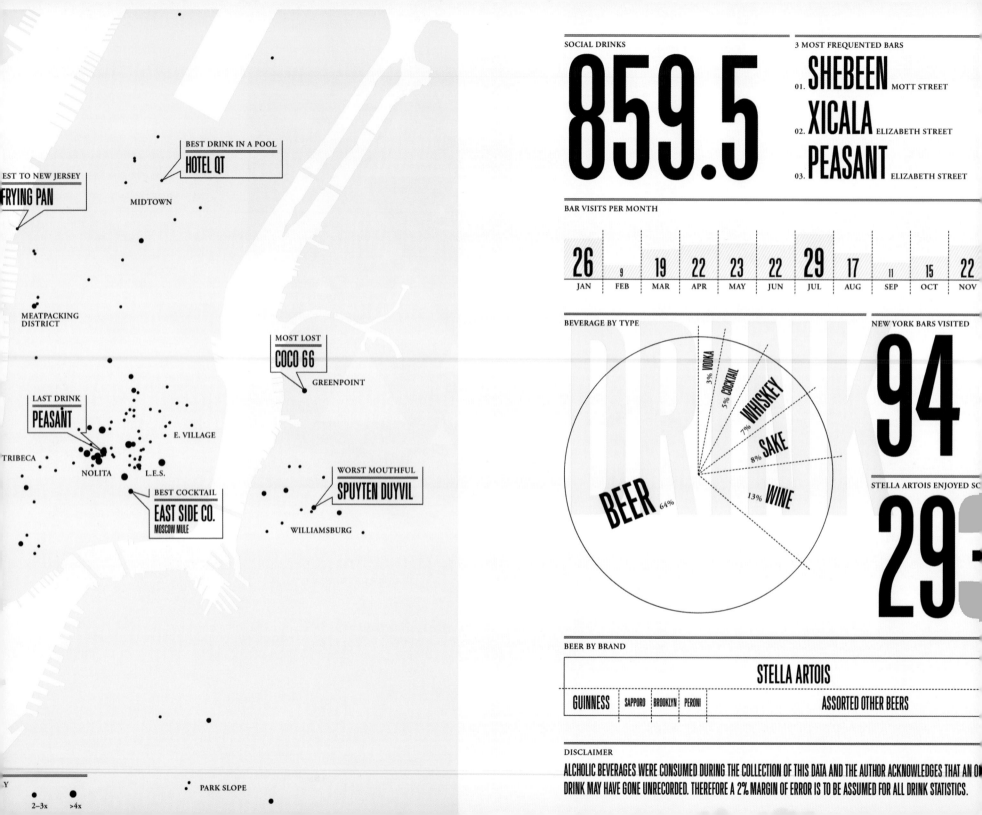

BEST DRINK IN A POOL
HOTEL QT

EST TO NEW JERSEY
FRYING PAN

MIDTOWN

MEATPACKING
DISTRICT

MOST LOST
COCO 66

GREENPOINT

LAST DRINK
PEASANT

E. VILLAGE

TRIBECA

NOLITA L.E.S.

BEST COCKTAIL
EAST SIDE CO.
MOSCOW MULE

WORST MOUTHFUL
SPUYTEN DUYVIL

WILLIAMSBURG

PARK SLOPE

2–3x >4x

SOCIAL DRINKS

859.5

3 MOST FREQUENTED BARS

01. **SHEBEEN** MOTT STREET
02. **XICALA** ELIZABETH STREET
03. **PEASANT** ELIZABETH STREET

BAR VISITS PER MONTH

26	9	19	22	23	22	29	17	11	15	22
JAN	FEB	MAR	APR	MAY	JUN	JUL	AUG	SEP	OCT	NOV

BEVERAGE BY TYPE

VODKA 3%
COCKTAIL 5%
WHISKEY 7%
SAKE 8%
WINE 13%
BEER 64%

NEW YORK BARS VISITED

94

STELLA ARTOIS ENJOYED SC

29

BEER BY BRAND

STELLA ARTOIS				
GUINNESS	SAPPORO	BROOKLYN	PERONI	ASSORTED OTHER BEERS

DISCLAIMER
ALCHOLIC BEVERAGES WERE CONSUMED DURING THE COLLECTION OF THIS DATA AND THE AUTHOR ACKNOWLEDGES THAT AN O
DRINK MAY HAVE GONE UNRECORDED. THEREFORE A 2% MARGIN OF ERROR IS TO BE ASSUMED FOR ALL DRINK STATISTICS.

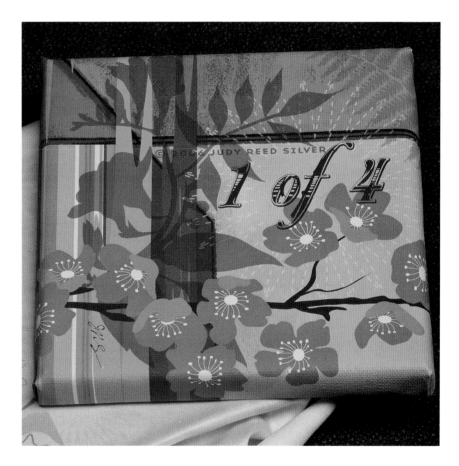

ALISON MURPHY, STUDENT PROMOTIONAL,
Massachusetts College of Art & Design.

JUDY REED-SILVER, PROMOTIONAL MATERIALS,
Calabasas, CA.

Marketing Tactics for Photographers

What is the best way to use mailers/portfolios and websites, and how do you send out something that isn't going to get instantly tossed in the trash? There are always more photographers available in any given week than there are jobs to be photographed. This doesn't mean that a creative director or buyer isn't interested in hiring you for your particular talent. He or she just might not have the job that fits your vision. Often your mailers, if they get the attention of someone, will be held or filed for future reference. You should think toward the longer term. Frequently, it may take a while for a client to find an appropriate job for someone they have not worked with. You may end up on file for more than a year. During that time, you need to show that you are out there and still working and still in the mix. You should be sending materials on a regular basis.

Have a Plan

To effectively reach your target audience or market you must have all of your materials ready and in good order. This means your website is live and accessible and your portfolio up to date and ready to ship. Once you start your initial marketing you want to be prepared to continue to make contact and send out materials. *Never contact anyone if you aren't ready to send out your portfolio.* It is often best to think three steps ahead. In addition, you would be well served by having your calendar worked out and determine how many pieces you are going to send during the year. Often the most difficult thing to maintain when work and contracts come in is self-promotion. If you need to have mailers printed, or you are putting together a particular promo for a specific group of clients, it is easier to get them produced and printed at the same time to be sent out at a later date.

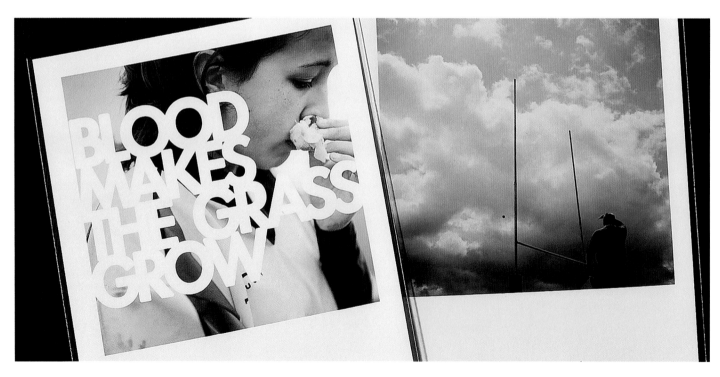

ANTHONY GEORGIS, BLOOD MAKES THE GRASS GROW, PROMOTIONAL BOOK.

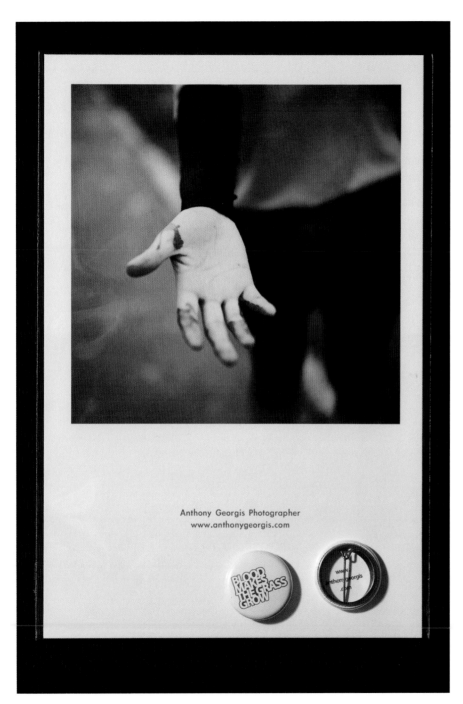

Anthony Georgis Photographer
www.anthonygeorgis.com

Competitions as Marketing Tools

Your portfolio and related promotional materials are the basis for this book, but the bottom line is that you must create visibility for yourself in a number of different ways. While contests in some sense can be validating and are good resume builders, more significantly they offer great bang for the buck as targeted marketing tools. These contests are resources for professionals seeking new talent. Inclusion in a contest or annual is an extremely valuable way for you to distinguish yourself in an oversaturated market. There are numerous industry-specific contests and annuals that are from publications and organizations such as *Graphis*, *How Magazine*, *Communication Arts*, PDN, SPD, Adobe Achievement Awards, The Type Directors Club, AIGA, AAF-ADDY Awards, London International Awards, etc. (see Appendix A for more).

Contests and juries create visibility, and further, they create credibility by having your work vetted by jurors who frequently are known industry professionals. Having your work selected can raise your profile in the eyes of potential clients, and they are extremely valuable in extending your work and your visual identity.

Marketing Tactics for Designers

Since most designers are looking to secure a full-time salary position and not a contract or freelance job, the designer's approach to marketing may be a little different than that of most photographers. A salary position often represents a significant commitment on the part of an agency or creative shop, more so than just a single job. It's a fairly serious investment on their part, especially considering benefits and the dedication of space and computer resources. Because of this, your promotional materials need to communicate a sense of who you—your attitudes and personality and what it would be like to work with you on a day-to-day basis. They also need to entice someone into wanting to know more and driving them toward your portfolio.

For designers, target specific companies or areas of the design discipline with promotional pieces that will resonate with a particular kind of company or client. Make pieces that are about more than just the "wow factor." Make work that is thoughtful, relevant, and will engage someone on an intellectual and emotional level—big ideas that are well executed will win people over. Highlight your amazing expertise or talent in a particular area. Think about unique approaches, forms, and concepts that will entertain and make a memorable impact.

Marketing and Self-Promotion: What to Do, and Connecting to Your Targeted Audience

Photographers and designers have more options for marketing that go far beyond the traditional practice of direct mail and cold calling. Online portfolios in combination with various materials can enable you to contact and update your targeted audience creatively and with great variety.

For Jeanie Chong's senior project she created her own unique typeface, inspired by five African tribal pictographs. She designed and developed a number of promotional materials featuring it, including a multipage newspaper.

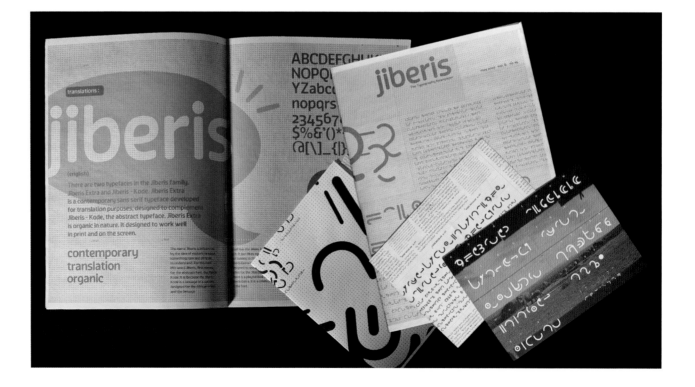

JEANIE CHONG, STUDENT PROMOTIONAL, Otis College of Art and Design.

While it is now considered *essential* for any photographer creative to have an online portfolio, the very fact that it is live and accessible does not guarantee you will be seen. The key is to take full advantage of the resources available to you and to think broadly regarding the approaches to reaching your target audience and breaking through. While electronic methods are convenient and cost effective, they do not eliminate the need to be innovative in what you send. Do not simply rely on the convenience of mass mailings, electronic, or otherwise.

Tip: Common sense—do your homework. While it may seem obvious, indiscriminate marketing, particularly email blasts, are not the most efficient or effective way to get on someone's radar. Sure, electronic systems make it easy and inexpensive to send out hundreds of emails, but you would do better to research to whom you are sending promotional pieces and what you should be sending them. Beyond the type of image you are sending out, you should consider the quality, level of production, and content. That doesn't mean you should rule out showing some range, but if you are so far off the mark, you may be wasting your time and might close out further opportunities with a particular individual, because they will have ruled out your work in relation to their needs.

Resources for Finding Your Audience

When working on direct mailings, electronic mailings, or sending out packages to targeted clients, it is important to have up-to-date information regarding art buyers, editors, creative directors, and designers. There are numerous services available that provide access to information regarding the individuals who you wish to target. Most of these services have subscription-based fee structures. For someone just entering the market, these costs can seem prohibitive, but in the long run they can save a great deal of time and energy when looking to build a client base. These databases are updated regularly and provide specific information and contacts. Two of the largest are Adbase and Agency Access.

An additional advantage of services such as Adbase is that one is able to download contacts and addresses that have been formatted for labels or email, which saves labor and time putting together mailings.

What Happens When It Works?

Self-promotion is an ongoing process or, better put, a never-ending process. Once you get someone's attention, submitted a portfolio, or even been hired, the communication has just begun. In fact, it is even more important to continue to stay in contact and keep past and potential clients aware of your presence and your work. You need to stay on their radar. What do you do once you have established contact, perhaps even had your portfolio requested by a buyer or editor? Follow-up and continued contacts are very important.

If an art buyer, potential employer, or editor makes an initial contact with you and requests and views your portfolio, common courtesy is a good starting point. Follow up with a visual thank you or leave-behind. Then in the weeks and, more likely, months that follow, it is necessary to send mailers and updates on your work, commissions, and new ideas, to keep you in their sites. If you make significant updates to your website, information should be sent out. If you update your portfolio, request to send it out again to give the client a fresh view.

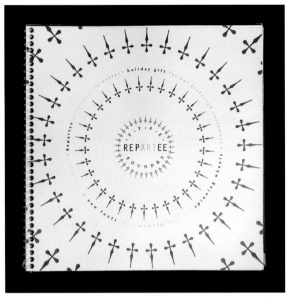

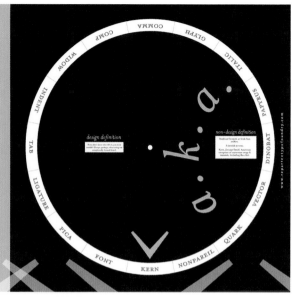

as the world
kerns

abcdefghijklmnopqrstuvwxyz
ABCDEFGHIJKLMNOPQRSTUVWXYZ
0123456789()(){}[].,:;"'?!<>/|
@#$%^&*-+=©®¢€

triumfont

abcdefghijklmnopqrstuvwxyz
ABCDEFGHIJKLMNOPQRSTUVWXYZ
0123456789(){}[],.:;"'?!<>/|
@#$%^&*-+=©®¢Đ

HOLLY BOBULU, STUDENT PROMOTIONAL BOOK,
Madison Area Technical College.

Your Other Work?

Think broadly about what you use for self-promotion. It isn't necessary or advantageous to simply send materials that only reflect the particular kind of work your clients might hire you for. In fact, personal projects and work that show diversity of interests and some range as a creative can be much more effective in gaining the interest of a potential client or employer. If you are exhibiting, or are involved in collaborative works, you can consider using these for self-promotion. This kind of work demonstrates breadth in thinking and concept development, and presents your clients with other aspects of your abilities to consider when hiring you. While you don't necessarily want to appear *as all things to all people,* as this can give an unclear message as to what you are as a creative, you can show depth and range and use it to your advantage.

JEFF ROSS, PROMOTIONAL, Chicago, IL.

AISLING MULLEN, STUDENT PROMOTIONAL, Endicott College.

Get Listed

While the fact is that direct contact and showing your work is ultimately going to connect you to potential clients, you still can benefit from professional listings. PDN's *Photoserve* is a searchable listing for photographers. While it isn't likely that a busy photo editor or art buyer will have time to search for a photographer, these listings can be useful by demonstrating you are active and working and engaged in the profession. Professional associations such as ASMP have membership listings and periodically these can result in referrals. There are still paid listings and publications such as the *The Black Book,* but they represent a significant investment.

Some great websites for designers to get listed include *Communication Arts* (*http://www.creativehotlist.com*) and AIGA's "jobs and community" at *http://www.aiga.org*. Both allow you to post examples of your work and are searchable by field and location.

Showings and Exhibitions

While exhibitions of noncommissioned work, personal projects, or inclusion in juries may not appear to be relevant to your client's needs, they can be sent in addition to your other mailings and promos. They are another way to show your range and commitment to your work, as well as how active you are as a creative. These are better suited for clients with whom you have had prior contact or for whom you have worked. Your client may even have another kind of job for you as a result of seeing another aspect of your creative production.

Note about Photographer Representatives (Reps)

These individuals function essentially as agents, taking your work out for you and connecting you to potential clients. There is a range of representation for photographers, in terms of fee structures, yet the fundamental basis for this is that the photographer has to have established himself or herself in the market prior to an association with a representative. While representatives or agents vary in how they work with photographers, most often it is a collaborative process. With this in mind, the photographer will continue to be responsible for marketing, portfolios, personal work, contests, and the like. Generally, a representative will help you move into a better market and push your work and portfolio in the direction of art directors and buyers who you might not have regular access to. They also can take on the challenging aspects of bidding and pricing larger-scale projects.

I LOVE SEEING

PERSONAL WORK.

It shows me that the photographer has some excitement about story-telling and image making in general.

HEATHER MORTON
Independent Art Buyer

Q&A: Interview with Heather Morton, Independent Art Buyer

Heather Morton is a freelance art buyer working in Canada. She has been given the opportunity to introduce this role to some of the most interesting agencies in the country, including John St., Leo Burnett, and Zig. In addition to art buying, she offers portfolio review and consultation, rebranding services, and quoting assistance.

How important is a printed portfolio? Is a portfolio still a necessity in addition to online portfolios, and is it the case when looking at photographers that you will always request a printed portfolio at some point in the process?

Although I don't call in portfolios as much in the reviewing process as I used to (but rather look at the work online), I still think having a printed portfolio is important. Although art buyers are looking at work initially online, the portfolio shows a different side of the photographer. More than a photographer's website, it shows us how the photographer markets him/herself, what their branding is, how he edits his own work, his design sense—but I do think the portfolio functions best as a calling card. Getting your portfolio in the door is basically getting your brand in the door.

What makes for a good portfolio? Should it have an overall vision, concept, or a visual identity beyond an edit or series of strong images? How much work do you like to see?

I think less is more when it comes to number of images. For some photographers it is completely appropriate to their work that their book has a strong concept. I definitely like to see an overall vision—whether the book is subdivided into different sections which flow well into each other or it tells a cohesive story, I like to see a lot of thought put into the edit. Working with image juxtaposition, cropping, white space, the gutter, overall flow—have all of these things been taken into consideration?

My pet peeves:

- No Plastic sleeves: Enough said.

- Too many images: I think it's important to ask what the fifth portrait of a dower-looking 20-something in studio is telling me about your abilities—it's redundant at that point.

- One-off shots: Sometimes I see an interesting creative idea, but it's a one-off and relates to nothing else in the book. Normally, this just ends up looking out of place. In most cases, the idea could be developed into a larger series or a bigger story, even by grabbing detail shots to use as a juxtaposition to the hero shot.

- Ads in the main part of the book: Unless the ad is something fantastic (and there are some), I want to see the photography alone. I do, however, like to see a spread of thumbnail ads or tearsheets at the back of the book. This can be really useful to communicate the breadth of jobs the photographer has done.

To what extent is seeing work beyond commercial commissions or jobs (such as personal work) effective when you have looked at the portfolios of photographers?

I love seeing personal work. It shows me that the photographer has some excitement about storytelling and image making in general. It is a great way for me to get a sense for the photographer's style and passions. Personal work can also be inspiring for art directors to see—it might open up some avenues as they conceptualize ideas for their clients.

There is a mantra that I espouse which pertains to this question: Show what you want to shoot, not what you can shoot. This is the type of work that will get the creatives excited about working with you and finding a project for your unique vision.

Having said this, it is sometimes necessary to show the client, or even the art director, that the photographer has shot for this type of client before, or has shot this type of job before.

Creative Placement Agencies and Reps for Designers

If you're having a difficult time getting connected and finding employment, hooking up with a creative placement agency, creative rep, or creative recruiter can be beneficial. They work to match creative talent with companies in their network. This can be true for short-term freelance work and full-time salary positions. Often, placement agencies are even aware of positions that are not being advertised publicly and can open up a number of possibilities for you. Occasionally, placement agencies organize events, such as resume workshops, "meet and greets," or interview fairs. They work with a person to secure a position and often offer advice about your portfolio, resume, interviewing style, etc. If you do find employment through a placement agency, they will work with you and the client to negotiate salary, benefits, and contract concerns. Make sure you are aware upfront how the agency or rep is being paid—typically the client pays for the service. Check out local agencies and reps first—they are often better connected with the local creative shops and talent.

Q&A: Interview with Kim Wachter, Senior Staffing Consultant, Hollister, Inc.

Kim Wachter is a senior staffing consultant for Hollister, Inc. in Boston. After 28 years in advertising and marketing working for companies like American Express, Scudder Stevens, and Clark, Rapp Collins, and Jack Morton, Ms. Wachter decided that a career change was in order. Currently, she handles any creative service or marketing position.

How important do you feel a print and/or online portfolio is in securing a job in the industry?

Both an online portfolio and a print portfolio are extremely important for both writers as well as designers (or ADs). We are inundated with resume submittals. Frequently I skip the resume and go right to the work. If a resume is not accompanied by a URL or at least PDF samples it gets moved down to the bottom of the email pile. Additionally, a print portfolio is important. We interview every candidate before I send them to clients, and I want to see how they present. Will they be an asset to the client when presenting creative ideas/campaigns? Is their presentation well organized and thought out? Do they have a story to tell? All too often, a candidate comes in with a hip portfolio case only to start pulling out old dog-eared samples in no particular order. My feeling is, if they don't take pride in their work, why should anyone else?

What do you think makes for an outstanding portfolio?

This is tough because each one is different and obviously writers need something different than designers and art directors. Regardless, the portfolio should grab me right away. I want to be enticed to continue to look through the samples. I want to forget that there's a pile of work on my desk and clients need to be called back. Also, the portfolio should reflect what the candidate does. So if the candidate is a UI designer, I want to see a clean elegant user interface on their own web page and also what technology they employed when designing their samples.

What qualities to you think a potential employer looks for in an applicant?

Obviously skill is important. However, in this market there are many skilled people. More and more employers are looking for the right chemistry. People are working harder now so they have to enjoy what they do. Also, employers are looking for candidates who can wear many hats. For example, we are getting more orders that call for hybrid design/development skills. Now, not only do they have to have a beautiful book, they have to be able to write code as well—front end as well as some back end.

What do you think makes for a successful interview?

A candidate should really do their research prior to going on an interview. LinkedIn is a great way to get to know the people you are interviewing with. Obviously, your recruiter should be able to prep you prior to an interview. A good recruiter gets to know their clients and will try to only send people who they think will click. A candidate shouldn't be afraid to ask things like "How do you think I'd fit in at company xyz?" or "How does my background fit your needs?" And of course don't be afraid to say "I'm really interested in this position. What are the next steps?"

Do you have any advice for a student currently working on his or her portfolio and/or promotional materials?

It's very hard for students because most companies are looking for some experience. Try to make sure you have as many real-world samples as possible. If all you have is school work, that's okay, but you should use things that look like they're real world. Fine art is great, but you probably won't be hired based on your lithographs. Also, many students have done internships with established companies and they put work in their portfolios that they have helped on. Please be aware that the art director or senior designer may also have that work in their portfolio and you don't want to misrepresent your work. It's perfectly permissible to annotate the work with something like "I did the Photoshop work on all photography."

Q&A: Interview with Bryn Mooth, Editor, *HOW* Magazine

Bryn isn't a graphic designer, and only occasionally pretends to be one. Nonetheless, she's keen on classical typography, and she's a sucker for letterpress printing. Bryn's involvement with HOW magazine spans nearly 20 years, both as a staff editor and contributing writer. During that time, she has written about design and the business of design, organized and judged countless design competitions and spoken at various professional events, including HOW's Design Conference, In-HOWse and Mind Your Own Business Conference, and AIGA chapter events.

As someone who has reviewed so many outstanding portfolios and self-promotional pieces, what distinguishes the very best?

Originality and personality are so important for self-promo pieces and portfolios. As a potential client or employer, I'd want to get a sense not only of the designer's talents, but also of what it would be like to work with her. And it's key to be able to show your thinking. For portfolios, that means including sketches that led to a finished project. For self-promo pieces, that means including case studies of how your work met a client's objective. And of course, the overall design of the piece or portfolio should reflect the designer's personality, originality and thinking.

How important do you feel a portfolio book and/or online portfolio is in securing a job in the creative industries?

Both are crucial. Prospective employers or clients need to see samples of your work online before they even consider bringing you in for a meeting. And then a portfolio that showcases your work during that meeting is essential.

In the last few years, have you noticed any trends or differences in the types of pieces submitted to HOW's Promotion Design competition?

We're seeing more and more work that has a handmade element: perhaps a promo piece that's hand-bound, or customized for the recipient. Digital printing is, for the most part, so good that designers can print small-run pieces in their own studios. Handmade touches convey personality and uniqueness.

Do you have any advice for a student or young professional currently working on their portfolio and/or promotional materials?

What you say about your portfolio is just as important as what you put in it. Be prepared to walk a client or employer through one or two projects from start to finish, detailing your thinking, your problem-solving, your creative process and your collaborative skills. A portfolio is only a jumping-off point for conversation.

MARK BURRIER, PROMOTIONAL BOOK, McLean, VA.

The book has a 2-color silkscreen cover and xeroxed insides. I used a printer for the cover and assembled it all myself. When doing small print runs, there's such a cost savings doing it that way.

–MARK BURRIER

ANY TOOL YOU USE IS LEGITIMATE. THE KEY TO THE TOOL IS WHETHER IT HAS
THE DIMENSIONS TO DEAL WITH WHAT HAVE BECOME YOUR QUESTIONS.

I consider art as a thought form
more than anything else.[1]

ROBERT IRWIN

Artist, ("The State of the Real, Part 1," conversation with Jan Butterfield, Arts 46, no. 10 (June 1972), p. 49)

PROFESSIONAL MATERIALS

Your resume (or CV-curriculum vitae) is a crucial part of your ability to market yourself. It should be approached with as much energy and effort as you would any other aspect of your comprehensive portfolio. A resume presents you with a fundamental and critical information design problem, and will require your best typographic and layout skills. It will be judged as a prime example of your design sensibilities and needs to communicate your educational and work experiences as clearly and concisely as possible. It should also, in a limited fashion, relate back to the look and feel established by your portfolio design. Keep in mind, however, that your resume is a unique visual problem. Don't force it to look exactly like your portfolio book or website, but instead reference your brand identity through color and typographic choices. You will need both a print and digital version of your resume.

Unless you have many years of experience in the industry, best practice is to keep your resume to one page (this is especially true for students and recent graduates). The following is a list, in order, of the standard categories of information that should be included in a resume. Some of the categories listed are optional.

- **Name and contact information**
 - Your name should be noticeable on the page and grouped with your contact information. List the best way to contact you first.

- **Objective** (other terms: mission statement, personal statement). *This is optional.* Some resumes include a brief statement or bullet points addressing the following:
 - The type of position one is seeking.
 - One's strategic skills and/or how one could benefit a potential employer.
 - A personal statement relevant to the industry or one's career.
 - Overall (and typically more generic) career goals or objectives.

It's not necessary to include an objectives category on your resume, and in fact, if it is too generalized, it may not serve you well. Think about whether this type of content could be included in a cover letter and relate more directly to the specific company and job you are applying for.

Nobody is hired because they have kick-ass solutions alone.

PEOPLE WANT TO WORK WITH PEOPLE THEY LIKE.

You are the most important factor.

SEAN ADAMS
Partner, ADAMSMORIOKA

- **Education.** Include:
 - Name of degree received and date of graduation.
 - Educational institution and its location.
 - You can additionally include any honors that you may have graduated with. For those of you who have not yet graduated, include your expected date of graduation. Note that it is the "expected date." If you have more than one degree, it is standard practice to list them in reverse chronological order.
- **Experience.** List your experience in reverse chronological order (start with the most recent). Include:
 - Company or client name
 - Job location (sometimes listed), with city and state
 - Position
 - Brief description of duties
 - Dates of employment

It's common practice to limit the jobs listed on your resume to those applicable to the industry and position that you are applying for. However, an exception could be made for a student with little to no industry experience who has worked a part-time or summer job over a number of years. In which case, try to include work experiences that demonstrate leadership skills and a positive work ethic. Additionally, it's completely acceptable for students and recent graduates to include internship and nonprofit work experiences, especially those related to the industry.

- **Awards** (other terms: accolades, acknowledgments). *This is optional.* If you have been recognized by the industry make sure to mention it. This includes:
 - Group or solo shows
 - Features about you or your work in a print or online publication
- **Software skills and capabilities.** *This is optional.* It's typically a good idea, especially for students and recent graduates, to list software and technical capabilities—print, web development, etc. Most entry-level positions require a significant amount of production work. Most employers will want to know that recent graduates can work with the software and processes the company uses right from the get go.
- **Organizations.** *This is optional.* Most potential employers or clients will like to see that you are involved in art, design, or photographic industry organizations. It shows you are engaged, informed, and passionate about your industry. However, don't just list clubs, sports teams, or other organizations that are not relevant to your profession.
- **References.** It's not necessary to list references on your resume, but it may be a good idea (again, especially for recent graduates). Include name, title, company, and contact information (email and phone number) for each person (usually three minimum). If you don't include references on your resume, you should at least include the line: *References available upon request.* Make sure your references know they are your references before they get a call from someone! Ask them ahead of time and give them a heads up if you have recently applied for a position. Additionally, they should be someone who can speak to your character and abilities related to the position you are applying for.

The type treatment for your resume should be clean, clear, and functional—without decorative flair or embellishment. Be careful that you don't overdesign the page. Don't get hung up on logos, decorative typefaces, or decorative shapes and symbols. It's best to avoid a mix and match of too many different typefaces. One practical strategy is to utilize a typographic family with a variety of weights and proportions. This will allow you to maintain visual consistency while still offering variability. Another common practice is to use a sans-serif typeface for titles and a serif typeface for the rest of the copy (serif typefaces are usually easier to read for text blocks). If applicable, use the same or similar typographic system as you used in your interior book design.

A well-designed resume utilizes a *strong typographic hierarchy*. To do so, you will need to create multiple groupings and levels of information. Not only does a resume include different categories of information (such as education, experience, awards, etc.), but there are also different types of information that belong in each category. The experience category alone includes several subcategories—company name and location, employment dates, job title, and job description—all belonging together, but each also representing a discrete kind of information. Some of this information belongs together on the same line, some on a different line, and some should be more visually prioritized over others. In addition, usually name and contact information stand apart from the other categories of information, either because an aspect of the grouping is more visually prominent (e.g., the name is larger than the rest of the text) and/or because of its placement on the page.

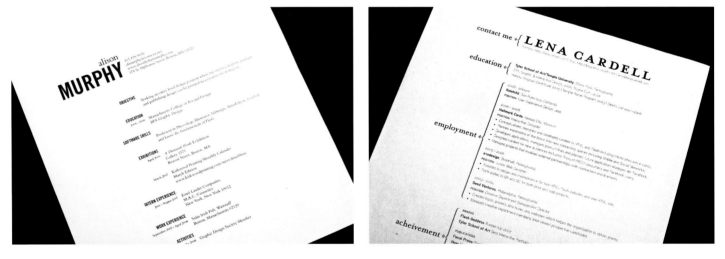

ALISON MURPHY, STUDENT PROFESSIONAL MATERIALS, **Massachusetts College of Art.**

LENA CARDELL, STUDENT PROFESSIONAL MATERIALS, **Tyler School of Art.**

You can emphasize and prioritize text through multiple techniques:

1. The amount of white or negative space surrounding the type—elements that are isolated on a page typically call more attention to themselves.

2. The simple order in which you compose the information—that is, the reading direction.

3. The use of typographic styles—there are a number of commonly used typographic styles that can be used to emphasize text (bold, italic, accent color, all caps, underline, and size). If you previously developed a color palette as part of your brand identity, the accent color can and should be used effectively to prioritize main categories of information.

4. Visual differentiation—a different typeface or shift in line orientation.

Use these techniques sparingly and strategically to structure information in the document—don't overdue it. Keep in mind that a simple typographic system usually proves to be the most effective. One or two typographic styles and/or compositional techniques should be applied as needed, and consistently in order to prioritize, group, and categorize information.

It's also possible to add variety to the organization and layout of your resume by utilizing vertical type for information like titles, subtitles, or dates. Since this makes the text a bit more difficult to read, use this technique sparingly and limit it to short lines of type. In addition, make sure the reading direction of vertical type starts in the lower left corner and faces up and out.

Keep the type size legible, but not too big (or too small); 9–12 point is usually a pretty safe bet. Make sure that you make adjustments to kerning, leading, and the typographic rag.

Bars, Rules, and Simple Graphical Elements

Bars, rules, or even simple graphical elements like brackets can be used to further emphasize the grouping and separating of information. Basic shapes, such as lines, circles, arrows, or rectangles, can be used at the starting point of a category or line of text in order to call attention to it. These elements can also be used as simple bullet points, however, make sure they are small enough so that they do not become distracting. Flow lines (lines that adhere to the grid itself, indicating its underlying structure) can also be quite helpful in activating or emphasizing subdivisions of space and separating content.

The standard orientation for a resume is vertical, however, horizontal layouts are becoming more popular (especially among designers). In general, it's recommended that you keep your paper to the standard size—8½ × 11 inches in the United States and 210 × 297 mm in Europe.

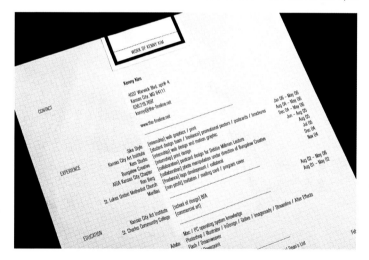

KENNY KIM, STUDENT PROFESSIONAL MATERIALS, Kansas City Art Institute.

Paper Stock

Material and paper selections are important parts of the print design and photographic process. Make sure you consider their importance when it comes to your resume. Your paper selection will communicate your attention to detail and concern for the total design. Don't just use a standard inkjet paper from an office supply store. Instead, check out a number of paper mills and compare paper selection, quality, and price. Almost all paper companies have samples that they are happy to share. You should avoid "fancy" papers with special linen or parchment finishes and tinted colors. Most will appear unsophisticated and look like they came from a craft store. If you're unsure of a direction, you can always play it safe with a paper that has a whitish or light cream hue, a plain smooth finish, and a slightly heavier weight.

See the following web links for more information:

http://www.neenahpaper.com/

http://www.mohawkpaper.com/

http://www.howdesign.com/papermillindex/

KRISTIE MILES, STUDENT PORTFOLIO,
Massachusetts College of Art.

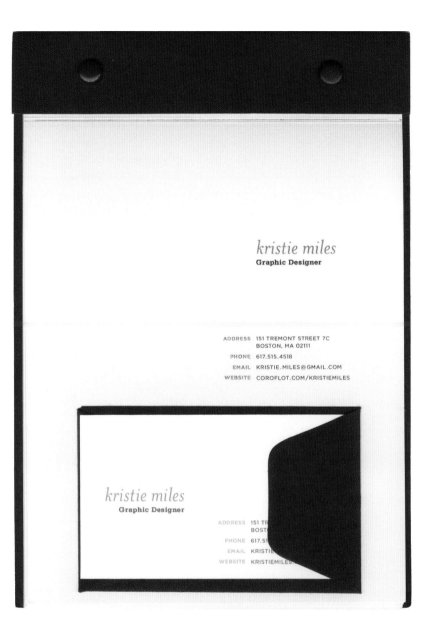

Jeanie Chong (Left)

2059 artesia blvd no.77
torrance, ca 90504

310. 569. 4552
nomorebadtype@yahoo.com

RECOGNITION

08 HOW Magazine's Promotion Design Competition
 Outstanding Achievement Award

08 OMAG Magazine 2008 Vol.4 and Vol.5
 Font in use—Jiberis

07 Otis College of Art and Design
 First place in senior show of Communication Arts.

EDUCATION

Otis College of Art and Design
BFA 2007 Graphic Design

EXPERIENCE

Intersection Studio
Currently Graphic Designer
 Design all kinds of publications, posters, promotion kits
 and identity. Also worked on few html and flash websites.
 Clients including Sundance Institute, Johnson and Johnson,
 United States Artists, Taku fish store, LA Philharmonic,
 The Getty Museum, The Colburn School, KCRW and more.

White Noise
May – Aug 07 Freelance Designer
 Worked on two identities. Design the logos and apply it on
 the actual object. Clients including Bossa Nova, Bebop Jeans,
 Voss Water, Voila Cigars, Studio Bauton and more.

ALT Design and Still Room
May – Jun 07 Freelance Designer
 Worked on Otis Viewbook with ALT Design and Still Room.
 Design typeface for the book and helped out some layouts
 in the book.

TwinArt Broadcast Design And Motion Graphics
Feb – May 07 Internship Graphic Designer
 Design all different kind of publications. Style frames design
 and web pages design. Clients including The Ellen DeGeneres
 Show, Fashion Rocks, CW network and more.

Orange County Museum of Art
Aug – Dec 06 Internship Graphic Designer
 Design all publications including monthly newspapers,
 flyers, postcards and posters.

SKILLS

Proficiencies
Adobe Photoshop, Illustrator, InDesign, Quark, Font Labs.
Flash and free hand drawing.

Working Knowledge
Final Cut Pro, After Effects.

OTHER

Fluent in Cantonese, Mandarin and Shanghainese.

KRISTEN BERNARD (Right)

KRISTEN BERNARD
WWW.KRISTENBERNARDDESIGNS.COM
KRISTEN.L.BERNARD@GMAIL.COM
603+494+3121

+ EDUCATION Endicott College | EXPECTED 2010
 B.F.A Visual Communication
 Concentration in Graphic Design
 Minor in Communications

+ EXPERIENCE WS Packaging | JAN 2007 - AUGUST 2007
 Prepress Intern

 Visual Communications | JAN 2008 - PRESENT
 Associate Designer

+ RELATED COURSEWORK & SKILLS Directed Study | FALL 2008
 Branding and Identity
 Case Study: Institute of Contemporary Art, Boston, MA

 Proficiency
 InDesign, Quark, Photoshop, Illustrator, Microsoft Word,
 MAC and PC Platforms

+ ACTIVITIES AIGA | SPRING 2007 - PRESENT
 ENsight Magazine Student Publication

 SVPA Logo Design Team | FALL 2008
 Developed logo for new School of Visual and Performing Arts
 at Endicott College

 Resident Assistant | SPRING 2007 - PRESENT
 RA of the Year, 2007-2008

 Student Peace Alliance | FALL 2007 - SPRING 2008

+ AWARDS Endicott Scholar | FALL 2006 - PRESENT
 Scholarship Recipient
 Honors-level coursework completed

 Steidel Scholarship | FALL 2008 - SPRING 2009
 Leadership Award

 Dean's List | FALL 2006 - PRESENT
 3.5 G.P.A or higher

(*LEFT*) *JEANIE CHONG,* STUDENT PROFESSIONAL MATERIALS, Otis College of Art and Design.

(*RIGHT*) *KRISTEN BERNARD,* STUDENT PROFESSIONAL MATERIALS, Endicott College.

LAYOUT

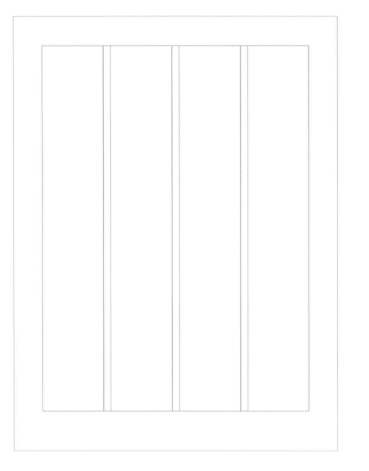

When designing your resume you should construct a clean, clear, well-organized layout. Utilize a simple grid system to help you do the following:

- Subdivide the page into equal or proportional columns (and rows if need be). Equal or proportionate units of positive and negative space create a visual rhythm throughout a composition. This pattern can help establish visual balance, harmony, and unity among groups of content and the negative space between and around them.

- Include a healthy margin of white space along the outside of the page.

- Organize and group information by utilizing:
 - *Alignment*—especially along the vertical axes of the grid. Zoom in to make sure that lines of type really are aligned to the same axis. You can utilize both left and right alignment. For multiple lines of text, be sure to pay attention to the typographic rag.
 - *Proximity*—the closer things are to each other the more they are perceived to connect and relate. When separating individual lines of text and groups of content, be sure to use an equal or proportionate increment of space to measure.

It goes without saying that the cover letter should be coordinated with your resume and even the leave-behinds. The paper, typeface, and design aesthetic should all tie together.

A cover letter should be direct and to the point, providing some context or rationale for your contact with the intended audience (e.g., your experience and interest in the available position). State:

- The reason for your writing.
- Who you are and where you are coming from—student, graduate, current employment.
- Your interest in the position/opportunity.
- Your (briefly) qualifications for this particular position.
- What you have attached/enclosed as support materials.
- Your desire to set up an interview/meeting.
- In some cases, how you will follow up (e.g., a phone call, more materials) and whatever might be relevant to the particular process.

Do not:

- Reprise every aspect of your resume.
- Provide a lengthy rationale of why you are the perfect person for the position. This will happen when they interview you.
- Make it any longer than one page—two to three paragraphs should suffice to get your point across.
- Forget to have someone else read it before you send it out.

Think about coordinating the visual look of:

- Business cards
- Envelope
- Thank-you notes

Love this.

Once, we salty and cynical ad people wanted nothing more than to do this for a living. You remind us of ourselves. If we see you love making this stuff, being creative, and never quitting on the pursuit of good ideas, we're more likely to go to the mat for you.

CHRIS WOOSTER
Group Creative Director, T3

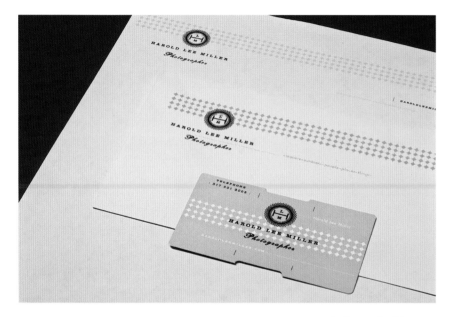

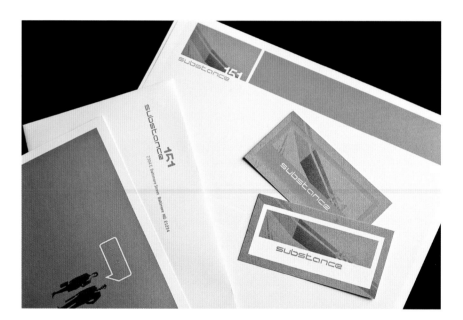

HAROLD LEE MILLER, P R O F E S S I O N A L M A T E R I A L S, Indianapolis, IN.

Designer: Funnel: The Fine Commercial Art Practice of Eric Kass.

SUBSTANCE 151, P R O F E S S I O N A L M A T E R I A L S, Baltimore, MD.

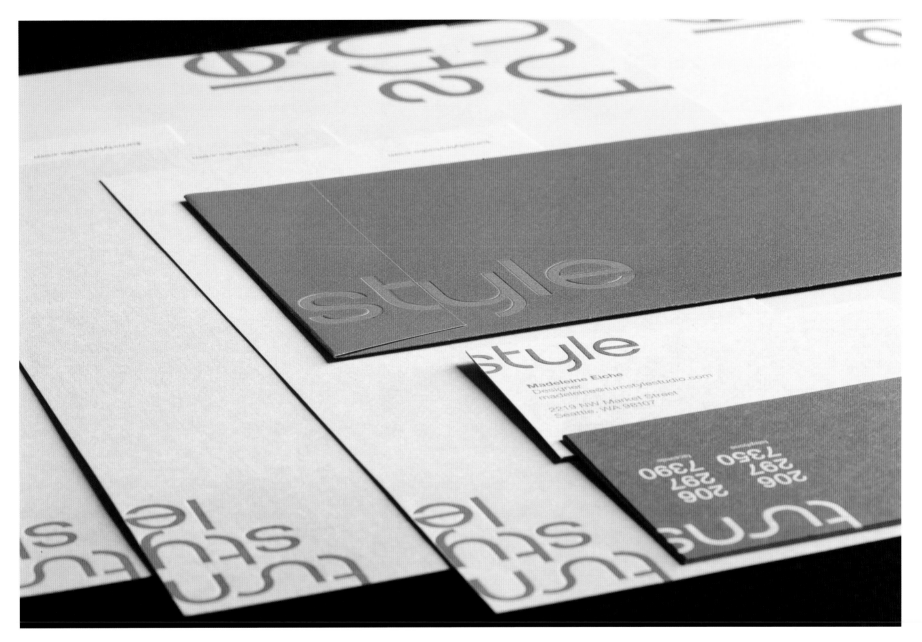

TURNSTYLE STUDIO, PROFESSIONAL MATERIALS, Seattle, WA.

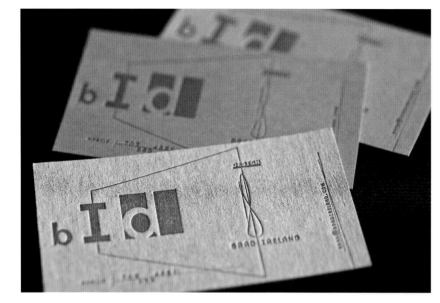

BRAD IRELAND, Washington, DC.

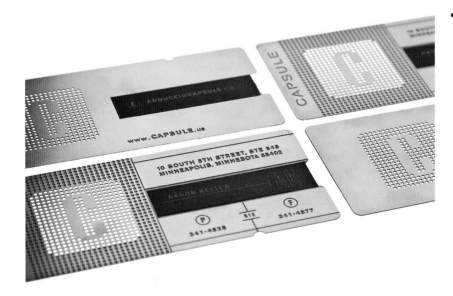

CAPSULE, Minneapolis, MN.

Some tips for business cards:

- Use the standard U.S. business card size (fits in holder) of 3½ × 2 inches.

- Design it in the same brand style as the rest of your comprehensive portfolio package.

- Make it easy to read—consider type size and contrast. Provide a margin around information.

- Make your name the top level of information on your card.

- Additionally, include email, phone number, and the URL to your portfolio website. Make sure your email address is a professional one.

- Keep the design simple (much like your resume). Use typeface and color effectively so the design is clean, clear, and stands out!

- Think about the ink, finish, card stock, and/or material of the card.

- For fast, inexpensive business cards, check out online companies like Moo Cards or http://www.psprint.com.

- A business card must be functional first and foremost—keep that in mind if you are pushing the envelope in terms of form, size, or materials.

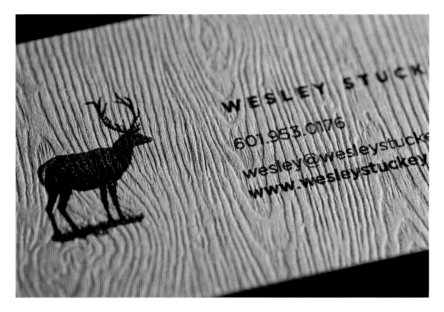

WESLEY STUCKEY, Mississippi State University.

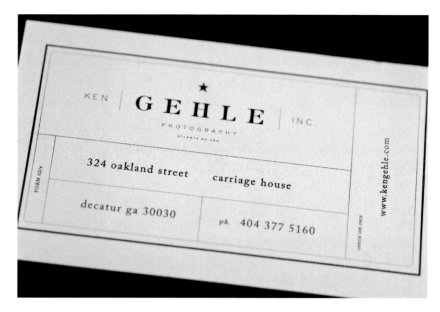

KEN GEHLE, Decator, GA.

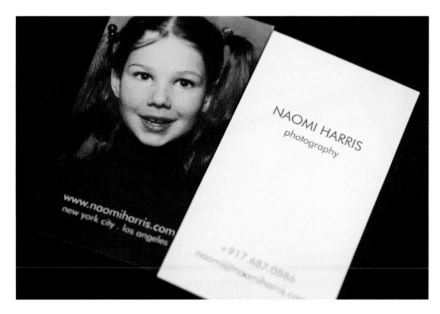

NAOMI HARRIS, New York, NY.

THEORETICAL UNIVERSE, Boston, MA.

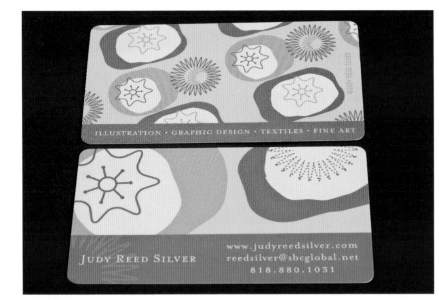

JUDY REED-SILVER, Calabasas, CA.

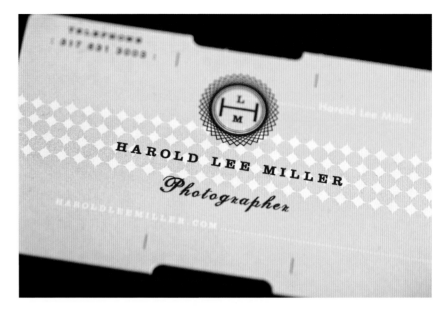

HAROLD LEE MILLER, Indianapolis, IN.

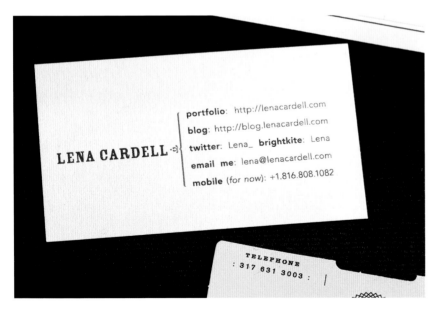

LENA CARDELL, Tyler School of Art.

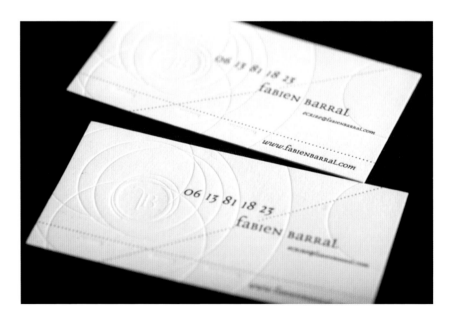

FABIEN BARRAL, Auvergne, France.

ANNI KUAN, BUSINESS CARD, Concept: Stefan Sagmeister;
Designer: Stefan Sagmeister and Hjalti Karlsson.

Interviewing

A portfolio is a requirement even to be considered for a position. After that, it's really all about the interview.
—JEREMIE DUNNING, Senior Web Designer, Burton Creative Services, Burlington, VT

Hopefully, after you've done all this work on your portfolio, you'll land that big interview. Sitting down with someone in person is a golden opportunity to engage someone in a discussion about who you are and what you can do, to essentially prove you are the right fit for the job both professionally and personally. The importance of making a great impression during your interview cannot be underestimated.

Consider that someone has already seen your work and liked it well enough to want to know more. So, bring your book to the interview, but be prepared to discuss more than just the work you've previously done. An interview is just as much about who you are and what you have to offer in the future as it is about what you've done in the past. During the interview, you'll be evaluated on what someone thinks it would be like to work with you—your personality, your enthusiasm for the industry, your passion for your work, your interest in the company your interviewing with, your knowledge about industry practice, your work ethic and attitude, and much more.

If you are a student, don't be afraid to present yourself as just that. An entry-level position or internship is a learning opportunity; you aren't supposed to know everything. Be confident and show them the energy, drive, and problem-solving skills you have, but don't try to show them something that you aren't. You are better off showing how hard you are willing to work and how capable you are of learning and developing as a creative.

Don't talk about work that you don't have available to show the interviewers. The last thing you want to do is get your interviewers interested in something that they can't see.

Do bring additional work to show. However, don't necessarily show it, as you can overwhelm the interview with too much work. Be prepared to show it if the interviewers ask about something in particular, want to see more work, or if you have a specific point you want to make and need an example.

Be prepared to talk about a work experience or project that you have worked on. Sometimes the best example is a job that didn't work out. What did you take away from that experience? What did you learn? This demonstrates self-awareness and humility.

Some interviewing tips are:

- Take some time to find out about the company or client you are interviewing with. Their website is a good place to start. You need to be able to answer the question "Well, tell me, why do you want to work here?" with specific knowledge about what makes this company or client unique and appealing to you. Find out what they are proud about and get excited about it too. Ask a couple of informed, intelligent questions about the position or company.

- Consider every interview as an opportunity to practice your interviewing skills. Don't be arrogant or pushy during the interview, but try not to lack confidence either. Remember that looking someone in the eyes and smiling can actually go a long way.

- Be prepared to discuss your work—the objective, your process, your solution. Be brief.

- If possible tailor your portfolio to the company or client you're interviewing with. Know what they are looking for and provide it.

- Take a moment to think before you respond to a question. If you don't understand the question, ask for clarification.

- Be polite and professional.

- Dress appropriately. Depending on the place, that may not mean wearing a suit. However, when in doubt, err on the side of dressing more formally than casually.

- It goes without saying: Be on time!

- Bring a few printed copies of your resume.

- Refrain from asking about salary or compensation on the first interview. That's something best reserved for a second interview. When you get to that point, know how much you're worth:

Photography: Contracts and Pricing

Photographers work as independent contractors 95 percent of the time, and as such your contact with potential clients will ultimately result in a bid or proposal for a specific job. The nature of pricing, bidding, and contracts is such that we could devote a whole book to this subject.

Image use and licensing constitute a big part of the bidding and fee structure for a photographer. The compensation for photographing and licensing of images has changed dramatically in the web era. This is in part to the proliferation of inexpensive stock photography, royalty-free compilations, and expanded uses for images. Businesses in turn are aware that the more uses they can get out of an image without incurring additional fees, the better. You should familiarize yourself with the fees for the particular market you are working in. If you are new to the industry, there are numerous resources for establishing rates and license terms. You can also talk with other professionals to get advice on bidding and fees.

When you talk to a potential client, you do not have to provide an estimate on the spot, and this is generally not the best practice. It is better to do your research than speak prematurely. Further, there is a judgment to be made on how you bid your job. If you are new and trying to break into the industry you might feel you need to underbid to get the work and build some client relationships and even portfolio material. This is generally not the best practice. Underselling yourself is a fast way to getting paid less further down the road. Your best gauge is the client. You may be making a photograph in the same manner, with the same use as an editorial publication. Your client may be a small business or nonprofit, with a smaller audience and ultimately much less budget. This may impact the scale of your license and fee, and again you have to make judgments about how to go about this.

Note: All work should be licensed.

With the exception of family portraits and other kinds of work for private individuals, all of your photographs made on commission should have licensing terms. Even pro bono work should reinforce the understanding to the client that you own the photographs and that the work has terms for its uses. You should define those terms in your contract and invoices.

Pro Bono Work

Should you work for free? You may find that you are approached by a nonprofit agency or a small business that can't afford to pay for the services of a designer or photographer. This is an opportunity to build your portfolio and extend yourself into the world with your work. While your goal is paying jobs, or a salaried position, occasionally doing a job for free can be very beneficial to you as well as the client. There are many professionals who do pro bono work as a regular part of their professional practice because they believe in offering services to support certain nonprofits. They often find that it has been work that they enjoyed and benefited from as well.

Pro bono work can offer you more creative freedom than you might have in a typical project, and for this reason alone it is worth taking on, particularly if you are starting out in the industry. It may lead to a paying job since the work you produce extends your visibility. It can be a portfolio builder and can help you gain some experience. There are no guarantees, but these are worth pursuing. The clients generally cover material costs.

Pricing, Licensing, and Salary Resources

Design

AIGA: http://www.aiga.org/content.cfm/salary-survey

How Magazine: http://www.howdesign.com/article/08SalaryReport/

Graphic Artists Guild Handbook: Pricing and Ethical Guidelines

Photography

The ASMP and resources like PDN can be invaluable in providing a basis for contracts and fees. Many individual photographers have also posted pricing guidelines in an effort to support industry standards:

Seth Resnick and D-65: http://www.d-65.com/photographers.html

Editorial Photographers: http://www.editorialphoto.com/resources/ (extremely helpful regarding contracts and license)

Software: Fotobiz and Fotoquote are quote-generation software

ASMP Licensing Guide: http://www.asmp.org/tutorials/licensing-guide.html

Salary surveys are also a great way to find out what (and where) positions are in demand in the marketplace.

Q&A: Interview with Chris Wooster, Group Creative Director, T3, Austin, TX (continued)

Do you have any advice for students or recent grads?

Junior people rarely have many questions in interviews, which is a mistake. I know you're anxious and a bit nervous, but consider as one of your questions: "Is there anything you recommend I take out of my portfolio?" Be prepared for some jerk to say "everything," but you'll mostly get some constructive advice from a real creative director, which early in your career is a rare opportunity.

Have a one-sentence pitch for every piece of work, summarizing the target audience, the ad's creative direction (what problem are you trying to solve with this ad), and why you thought it belongs in your book. If you don't have any of this, make it up. But have it. Without it, you've obviously just created something because you thought it was cool, and that's not how the industry works. We make cool stuff, but with a purpose and a mission behind it. Tell me that. If you don't, I'll probably just reconstruct the brief in my head backward from the work, and I may come to the conclusion you didn't solve the brief. You don't want that.

Credit your co-creators. This is a small industry, and word gets around if you're claiming full credit for work a group did. I always applaud people who clearly list their role in the creation of work. You don't need to name names; you can simply list your roles this like: Roles: concept, support copywriting; or Roles: execution, production support (if you weren't in on the concept).

Consider having different flavors of your portfolio. Especially for art directors, sometimes you're going for more "design-intensive" jobs, sometimes more "traditional/tactical" jobs, and sometimes more "conceptual" jobs. Having different collections of work ready helps you better answer the needs, and avoid showing irrelevant work. This is one way to help "cull" the number of pieces, especially with online portfolios.

Perfect your thank-you email/card. Thank me for a piece of relevant advice. Mention how you'll be thinking about something I said that resonated with you. Don't tell me how perfect a fit you think you'd be—you're biased and I already have my own opinion. But do take the time to make it personal without getting chummy.

Be human. If you're not ferociously curious about the world (and not just advertising), you're not a very interesting human being. Don't interview like a robot. Have questions, observations, opinions. Read things, stay up on current events and culture. More than anything, don't be dull. I promise to give you a chance to make an impression. Make the most of it by being interesting or engaging. Unless you're just batshit crazy, in which case you need to back it down a bit. Heh.

Love this. Once, we salty and cynical ad people wanted nothing more than to do this for a living. You remind us of ourselves. If we see you love making this stuff, being creative, and never quitting on the pursuit of good ideas, we're more likely to go to the mat for you. If you don't really, really love the process of making ads, or improving your book, you're probably chasing the wrong line of work. Even all these years later, I'm still that 13-year-old kid who loved TV ads and wanted to make them for a living. You're next; show me you've got the same nerdy love for this.

Q&A: Interview with Sean Adams, Partner, AdamsMorioka, Beverly Hills, CA

Sean Adams has been recognized by every major competition and publication, including *Step*, *Communication Arts*, Graphis AIGA, Type Directors Club, British Art Director's Club, and New York Art Director's Club. A solo exhibition on AdamsMorioka (Beverly Hills, CA) was held at The San Francisco Museum of Modern Art. Adams has been cited as one of the 40 most important people shaping design internationally in the ID40. Sean is the national president of AIGA, past AIGA national board member, and past president of AIGA Los Angeles. He is a Fellow of the Aspen Design Conference, and AIGA Fellow. He teaches at Art Center College of Design.

How important do you feel an online and print portfolio is in securing a creative position in your industry?

The portfolio is the point of entry. It is like wheels on a car; I expect them to work and be great quality, but I don't buy a car because of them. The baseline of a portfolio must present excellence in craft and concept. After that is proven, 80 percent of the decision to hire a designer is based on personality and presentation.

Do you have any advice for a student currently working on his or her portfolio and/or other promotional materials?

The portfolio is only a prop. It must be flawless, well made, and cared for. Time is short and precious. The interviewer does not care about every typeface choice, or how your first dog inspired a project. Give one simple explanation for each piece—what the assignment was, and what the best part of the solution is. Keep the explanations to a couple of sentences. If the interviewer wants more information, they'll ask. Nobody needs to go through every piece in detail. I can look at the work in a couple of minutes and understand if someone knows typography, or doesn't.

Most importantly, there are thousands of designers out there with beautiful, well-made work and wonderful portfolios. Nobody is hired because they have kick-ass solutions alone. People want to work with people they like. You are the most important factor. Learn about the company you're visiting. Compliment a recent piece or mention an article on the firm. Flattery always works. I once interviewed a young designer with incredible work, who started the interview with, "You know, you're work's not that bad. I thought you were just ripping off the old guys." Not good.

Job Listings and Professional Resources

http://www.creativehotlist.com/

http://www.coroflot.com/

http://www.aiga.org/content.cfm/careers

http://www.howdesign.com/career/

http://www.krop.com/

http://www.indeed.com/

http://www.behance.net/Job_List

Check out local chapters of professional organizations and clubs.

Contact local job placement agencies.

ENDNOTES

Step 2: Branding

1. Alina Wheeler. *Designing Brand Identity: A Complete Guide to Creating, Building, and Maintaining Strong Brands*, p. 1. New York: Wiley, 2006.

2. Scott Bedbury. *A New Brand World: Eight Principles for Achieving Brand Leadership in the Twenty-First Century*, p. 15. New York: Penguin Books, 2003.

3. David Ogilvy. *Ogilvy on Advertising*, 1st Vintage Books edition, p. 14. New York: Vintage, 1985.

4. Doug Menuez. "On Chaos, Fear, Survival and Luck: Longevity Is the Answer," *Editorial Photographers,* retrieved on October, 10, 2008; August 1, 2009, from *http://www.editorialphoto.com/articles/doug_menuez/.*

5. Alina Wheeler. *Designing Brand Identity: A Complete Guide to Creating, Building, and Maintaining Strong Brands*, p. 6. New York: Wiley, 2006.

Step 3A: Cover Design

1. Steven Heller and Seymour Chwast. *Graphic Style: From Victorian to Digital.* New York: Harry N. Abrams, 2001, p. 9.

2. Ibid., p. 12.

3. Fernando Lins. "Typography Tips and Advice for Graphic Design Students," *David Airey.com*, retrieved on August 1, 2009, from *http://www.davidairey.com/typography-tips-and-advice-for-graphic-design-students/.*

Step 4: Interior Page Design and Layout

1. Steven Snell. "Clear and Effective Communication in Web Design," *Smashing Magazine*, retrieved on August 1, 2009, from *http://www.smashingmagazine.com/2009/02/03/clear-and-effective-communication-in-web-design/.*

2. Ellen Lupton. *Thinking with Type: A Critical Guide for Designers, Writers, Editors, and Students*, p. 67. Princeton, NJ: Princeton Architectural Press, 2004.

3. Keith Smith. *The Structure of the Visual Book*, p. 16, 1st ed. Rochester, NY: Keith Smith Books, 1984.

4. Ibid., p. 46.

5. Ibid., p. 45.

Step 5: Book Construction

1. Keith Smith. *The Structure of the Visual Book*, p. 10, 1st ed. Rochester, NY: Keith Smith Books, 1984.

Step 6: Digital and Online Portfolios

1. "Timing: Easing In and Out," *Cartoon Solutions*, retrieved on August 1, 2009, from *http://www.cartoonsolutions.com/store/catalog/Timing-for-Animation-sp-7.html.*

2. Nathan Shedroff. *Experience Design*, p. 109. Indianapolis, IN: Waite Group Press, 2001.

3. Joshua David McClurg-Genevese. "Designing for the Web," *Digital Web Magazine*, retrieved on August 1, 2009, from *http://www.digitalweb.com/articles/designing_for_the_web/.*

4. Christian Darkin. "Stunning Showreels," *Computer Arts*, retrieved on August 1, 2009, from *http://www.computerarts.co.uk/tutorials/new_media/stunning_showreels.*

Step 7: Promotional Materials

1. Rob Haggart. "Photographer Promo Cards," *A Photo Editor Web*, retrieved on August 1, 2009, from *http://www.aphotoeditor.com/2008/01/09/photographer-promo-cards/.*

Step 8: Professional Materials

1. Robert Irwin (conversation with Jan Butterfield). "The State of the Real, Part 1," *Arts* 46(10) (June 1972): p. 49.

RESOURCES

Note: These resources can also be found online at **http://www. nomoreplasticsleeves.com**. Visit the website often for additional information, updates, and resources!

Step 2: Branding

Brand

Bedbury, Scott. *A New Brand World: Eight Principles for Achieving Brand Leadership in the Twenty-First Century*. New York: Penguin, 2003.

Ogilvy, David. *Ogilvy on Advertising*. New York: Vintage; 1st Vintage Books edition, 1985.

Wheeler, Alina. *Designing Brand Identity: A Complete Guide to Creating, Building, and Maintaining Strong Brands*. New York: Wiley, 2006.

Inspiration

Meggs, Phillip. B., and Alston, W. Purvis. *Meggs' History of Graphic Design*. New York: Wiley, 2005.

Brand Book

http://about.skype.com/brand/

Style Guides

http://www.behance.net/Search?main-search = Logo&realm = 44.

Step 3A: Cover Design

Visual Reference

Heller, Steven., and Seymour, Chwast. *Graphic Style: From Victorian to Digital*. New York: Harry N. Abrams, 2001.

http://www.frankchimero.com

Moodboards

http://www.imgspark.com

Color

http://kuler.adobe.com

http://www.colourlovers.com

Typography

http://www.myfonts.com/WhatTheFont/

http://www.davidairey.com/typography-tips-and-advice-for-graphic-design-students/

Iconography

Shepard Fairey: *http://obeygiant.com*

http://themoment.blogs.nytimes.com/2009/04/10/graphic-content-shepard-fairey-is-not-a-crook/

Copyright

Editorial Photographers (EP) Resources: *http://www.editorialphoto.com/copyright/*

U.S. Copyright Office: *http://www.copyright.gov*

AIGA Center for Practice Management: *http://cpm.aiga.org/legal_issues/copyright-basics-for-graphic-designers*

Fair Use: *http://en.wikipedia.org/wiki/Fair_use*

http://www.copyright.com

Andy Warhol

http://www.warhol.org

http://www.warholfoundation.org

Micah Wright

http://micahwright.com

Step 3B: Materials and Forms

(For book binding resources, see later under Step 5.)

Color Management

Andrew Rodney: *http://www.digitaldog.net*

Luminous Landscape tutorials and forums: *http://www.luminous-landscape.com*

NAPP (National Association of Photoshop Professionals): *http://www.photoshopuser.com*

http://photoshopnews.com

Book Printing and Binding

Apple Photo Books: *http://www.apple.com/ilife/iphoto/print-products.html*

Asukabook: *http://asukabook.com*

Blurb: *http://www.blurb.com*

Kodak Gallery: *http://www.kodakgallery.com*

LuLu: *http://www.lulu.com*

Paperchase: *http://www.paperchase.net*

Pitko Photobooks: *http://www.pikto.com*

Shared Ink: *http://www.sharedink.com*

Shutterfly: *http://www.shutterfly.com*

Snapfish: *http://www.snapfish.com*

VioVio: *http://www.viovio.com*

Step 4: Interior Page Design and Layout

Layout

http://www.smashingmagazine.com/2009/02/03/clear-and-effective-communication-in-web-design/

Cullen, Kristen. *Layout Workbook: A Real-World Guide to Building Pages in Graphic Design.* Beverly, MA: Rockport Publishers, 2007.

Elam, Kimberly. *Grid Systems: Principles of Organizing Type (Design Briefs).* Princeton, NJ: Princeton Architectural Press, 2004.

Type

http://www.writedesignonline.com/resources/design/rules/type.html

Elam, Kimberly. *Typographic Systems of Design.* Princeton, NJ: Princeton Architectural Press, 2007.

Hollis, Richard. *Swiss Graphic Design: The Origins and Growth of an International Style, 1920–1965.* New Haven, CT: Yale University Press, 2006.

Step 5: Book Construction

Book Binding Materials and Supplies

http://www.paper-source.com

http://www.hollanders.com

http://www.talasonline.com

http://www.lightimpressions.com (double-stick tape, ATG tape)

High-Quality Printing Paper Suppliers

http://www.inkjetart.com

http://www.lexjet.com

http://www.calumetphoto.com

Inkjet Printable Fabrics and Materials

Inkaid coatings: *http://www.inkaid1.com*

Jacquard Inkjet Fabric Systems: *http://www.inkjetfabrics.com*

Pabric: *http://www.pabric.com*

Papersource, inkjet linen book cloth: *http://www.paper-source.com/cgi-bin/paper/kits/bookcloth.html*

Online Resources

Book Arts Web: *http://www.philobiblon.com*

Step 6: Digital and Online Portfolios

Shedroff, Nathan. *Experience Design.* Indianapolis, IN: Waite Group Press, 2001.

Premade Web Templates

http://www.foliolink.com

http://www.livebooks.com

http://www.warmforestflash.com

http://www.coolhomepages.com

http://www.wix.com

http://wordpress.org

Development Resources

http://www.computerarts.co.uk

http://www.lynda.com

http://www.tutorialmagazine.com

http://www.computerarts.co.uk/tutorials/new_media/stunning_showreels

Optimization

http://www.cartoonsolutions.com/store/catalog/Timing-for-Animation-sp-7.html

http://www.digital-web.com/articles/designing_for_the_web

http://www.designerstoolbox.com/designresources/safearea/

Step 7: Promotional Materials

Design Competitions

http://www.adobe.com/education/adaa/

http://www.howdesign.com/competitions/

http://www.printmag.com

http://www.aaf.org

http://www.aiga.org/content.cfm/competitions

http://www.commarts.com/competitions

http://www.graphis.com

http://www.liaawards.com

http://www.adclub.org

http://www.webbyawards.com

http://www.computerarts.co.uk/competitions

http://www.oneclub.org/oc/press/?id=77

http://www.dandad.org

http://www.adcawards.org

http://tdc.org

Photography Competitions

http://www.pdnonline.com

http://www.comarts.com

http://www.dandad.org

http://www.adcawards.org

Step 8: Professional Materials

Paper Stock

http://www.neenahpaper.com

http://www.mohawkpaper.com

http://www.howdesign.com/papermillindex/

Design Resource

http://www.davidairey.com

http://www.designerstoolbox.com/designresources/

Postcard and/or Business Card Print Shops

http://www.moo.com

http://www.psprint.com

http://www.modernpostcard.com

Salary Surveys and Contracts

http://www.aiga.org/content.cfm/salary-survey

http://www.howdesign.com/article/08SalaryReport/

Graphic Artists Guild. *Graphic Artists Guild Handbook: Pricing and Ethical Guidelines*. Cincinnati, OH Graphic Artists Guild, 2007.

Job Listings and Professional Resources

http://www.creativehotlist.com

http://www.coroflot.com

http://www.aiga.org/content.cfm/careers

http://www.howdesign.com/career/

http://www.krop.com

http://www.indeed.com

http://www.behance.net/Job_List

http://us.firmlist.com

Resources for Photography Use License, Pricing, and Business Practices

ASMP: *http://www.asmp.org/tutorials/licensing-guide.html*

http://www.pdnonline.com/pdn/resources/index.jsp

EP Editorial Photographers: *http://www.editorialphoto.com/resources/*

Rob Haggart, A Photo Editor: *http://www.aphotoeditor.com*

Seth Resnick and D-65: *http://www.d-65.com/photographers.html*

Mailing List and Contact Services

Adbase: *http://www.adbase.com*

Agency Access: *http://www.agencyacess.com*

Creative Placement Agencies

Regional

Aquent: *http://aquent.us/*

Boston Area

Hollister: *http://www.hollisterstaff.com*

INTERVIEWS

Mary Virginia Swanson, Marketing Consultant and Educator, Tucson, AZ, *http://www.mvs.com*

Richard Grefé, Executive Director, AIGA, New York, *http://www.aiga.org/content.cfm/about-staff*

Joe Quackenbush, Associate Professor of Design at Massachusetts College of Art and Design, Boston, *http://www.jamdesign.com*

Kristen Bernard, Graphic Design Student, Endicott College, Beverly, MA, *http://www.kristenbernard.com*

Will Bryant, Recent B.F.A. Graduate, Mississippi State University, *http://will-bryant.com*

Christine Pillsbury, Creative Director, BEAM Interactive and Relationship Marketing, Boston, *http://www.sweettonic.com*

Jeremie Dunning, Senior Web Designer, Burton Creative Services, Burlington, VT, *http://www.burton.com*

Gail Swanlund, Codirector and Faculty, CalArts, Graphic Design Program, Valencia, CA, *http://calarts.edu/faculty_bios/art/faculty gailswanlund/gailswanlund*

Beverly Hayman, Recent B.F.A. Graduate, Mississippi State University, *http://beverlyhayman.com*

Jamie Burwell Mixon, Professor, Mississippi State University, *http://www.caad.msstate.edu/jmixon*

Naomi Harris, Photographer, New York, *http://www.naomiharris.com*

Hyun Sun Alex Cho, Associate Creative Director, Ogilvy and Mather, New York, *http://www.alexcho.com*

Mark Barcinski, Partner, and Adrien Jeanjean, Partner, Barcinski & Jeanjean, Interactive Studio, Amsterdam, The Netherlands, *http://www.barcinski-jeanjean.com*

Chris Wooster, Group Creative Director, T3, Austin, TX, *http://chriswooster.net*

Andrew King, Partner, and Mike Wislocki, Partner, SquareWave Interactive, Watertown, MA, *http://www.squarewave.com*

Heather Morton, Independent Art Buyer, Toronto, Canada, *http://www.heathermorton.ca*

Kim Wachter, Senior Staffing Consultant, Hollister, Inc., Boston, *http://www.hollisterstaff.com*

Bryn Mooth, Editor, HOW Magazine, *http://www.howdesign.com/howstaff/*

Sean Adams, Partner, AdamsMorioka, Beverly Hills, CA, and National President, AIGA, *http://www.adamsmorioka.com*

CONTRIBUTORS

Chapter Openers

Sketches provided by the following:

Step 1: Ashley Macleod, Student, Endicott College

Step 2: Danielle Currier, Beverly, MA

Step 3A: Kristina Mansour, Graduate, Endicott College

Step 3B: Jessica Hartigan, Student, Endicott College

Step 4: Ashley Macleod, Student, Endicott College

Step 5: Jessica Hartigan, Student, Endicott College

Step 6: Jessica Hartigan, Student, Endicott College

Step 7: Jessica Hartigan, Student, Endicott College

Step 8: Ashley Macleod, Student, Endicott College

Step 2: Branding

Kristen Bernard, Student Portfolio, Endicott College,
http://kristenbernard.com

Will Bryant, Student Portfolio, Mississippi State University,
http://will-bryant.com

Naomi Harris, Portfolio Website, New York,
http://www.naomiharris.com

Rachel Karaca, Student Portfolio, Kansas City, MO,
rachelkaraca@yahoo.com

Stephanie Kates, Student Portfolio, Endicott College

Kenny Kim, Student Portfolio and Promotional Materials,
Kansas City Art Institute, *http://www.the-fineline.net*

Solvita Marriott, Student Portfolio, Tyler School of Art,
solvita.home@gmail.com

Judy Reed-Silver, Promotional Materials, Calabasas, CA,
http://www.judyreedsilver.com

Turnstyle Studio, Collateral Materials, Seattle,
http://www.turnstylestudio.com

Noah Webb, Promotional Book, CA,
http://www.noahwebb.com

Step 3A: Cover Design

Laia Albaladejo, Senior Show Promotional, Suffolk University

Lena Cardell, Student Portfolio, Tyler School of Art,
http://lenacardell.com/

Nicholas Felton, Promotional Brochure, New York, *http://feltron.com*

Ken Gehle, Promotional Book, Decator, GA, *http://www.kengehle.com*

George Graves, Student Promotional, Endicott College

Naomi Harris, Website, New York, *http://www.naomiharris.com*
(Designer: Edgar Reyes)

Beverly Hayman, Student Portfolio, Mississippi State University,
http://beverlyhayman.com

Jessica Hische, Student Portfolio, Tyler School of Art,
http://www.jhische.com

Stephanie Kates, Promotional Materials and Logo, Endicott College

Kristina Mansour, Student Senior Thesis, Endicott College

Aisling Mullen, Student Portfolio, Endicott College

Dana Neibert, Portfolio and Promotional Materials, Coronado, CA,
http://www.dananeibert.com

Wesley Stuckey, Photographer, Portfolio and Support Materials,
Mount Olive, MI

Theoretical Universe, Logo, Boston,
http://www.theoreticaluniverse.com

Kylie M. Thorn, Student Promotional Book, Ohio State University,
http://www.kyliethorn.com

Larry Volk, from *A Story of Roses*, Beverly, MA, *http://www.larryvolk.com*

Noah Webb, Promotional Book, Los Angeles, *http://www.noahwebb.com*

Step 3B: Materials and Forms

Carrie Binette, galvinized steel cover, Student Portfolio,
Endicott College, *http://www.cbinettedesign.com*

Hilary Bovay, accordion fold book, Student Project, Endicott College

Rosie Fulton, back-to-back binding, Student Project, Endicott College

Nicole Gobiel, two sewn pamphlets, Student Book Project, Endicott College

Amy Grigg, coptic stitched binding with laminated photographs, Student Project, Endicott College

Beverly Hayman, Student Portfolio, Mississippi State University, *http://www.beverlyhayman.com*

Katherine King, Student Portfolio, Endicott College

Angela Klempner, blurb, softbound and hardbound versions, Student Thesis Project, Endicott College

David Le, panoramic image, accordion fold book, Student Project, Endicott College

Alison Murphy, Student Portfolio, Massachusetts College of Art and Design, alimurphy@comcast.net

Dana Neibert, commercially printed and folded promotional with embossed flap, Coronado, CA, *http://www.dananeibert.com*

Amanda Nelson, stab bindings, Somerville, MA, *http://www.amandanelsen.com*

Ann Pelikan, Artist's Book, Ipswich, MA, *annepelikan@mac.com*

Meghan Phillips, accordion fold book, Student Project, Endicott College

Kelly Saucier, post and screw, Student Portfolio, *saucier.ka@gmail.com*

Allison V. Smith, zine #2, Photography Portfolio/Promotional Materials, New York, *http://www.allisonvsmith.com*

Kylie Thorn, Student Promotional Book, Ohio State University, *http://www.kyliethorn.com*

Step 4: Layout Design: Interior Page Design

Kristen Bernard, Student Portfolio, Endicott College, *http://kristenbernard.com*

Will Bryant, Student Portfolio, Mississippi State University, *http://will-bryant.com*

Ron DiRito, compound image, Salem, MA, *rdirito@verizon.net*

Anthony Georgis, *http://www.anthonygeorgis.com*

Rachel Landis, Student Project, Endicott College

Meredith Lindsey, Student Project, Endicott College

Alison Murphy, Student Portfolio, Massachusetts College of Art and Design, *alimurphy@comcast.net*

Gretchen Nash, Student Promotional Book, California Institute of the Arts, *http://www.gretchenetc.com*

Emily Nathan, Website, New York, *http://www.emilynathan.com*

Dana Neibert, Promotional Book, Coronado, CA, *http://www.dananeibert.com*

Larry Volk, SX-70 Series, diptychs and triptychs, Beverly, MA, *http://www.larryvolk.com*

Step 6: Digital and Online Portfolios

http://allaboutjames.co.uk, London

http://www.barcinski-jeanjean.com, Amsterdam, The Netherlands

http://www.beverlyhayman.com, Student Portfolio, Mississippi State University

http://www.bio-bak.nl, Utrecht, The Netherlands

http://www.blackbeltmonkey.com, Hamburg, Germany

Danielle Currier, Storyboard, Beverly, MA

http://www.dag-knudsen.com, Norway

http://www.dananeibert.com, Coronado, CA

http://www.dantestyle.se, Student Portfolio, Stockholm, Sweden

http://www.diegutgestalten.de, Düsseldorf, Germany

http://www.glennbowman.com, Orlando

Jessica Hartigan, Student Sketches, Endicott College

http://www.james-meakin.com, United Kingdom and StrangeCorp.com

http://www.javierferrervidal.com, Spain

http://www.jonathanyuen.com, Singapore

http://www.kenjiroharigai.com, Japan

Meredith Lindsey, Student Storyboard, Endicott College

http://www.lisacrowleydesign.com, Student Portfolio, Endicott College

http://www.marcdahmen.de, Aachen, Germany

http://www.porliniers.com, Argentina

http://www.rodrigomanfredi.com/08/, São Paulo, Brazil

http://www.serialcut.com, Madrid, Spain

http://www.thibaud.be, Belgium

http://www.trollback.com, New York, NY

http://www.selftitled.ca, Santa Monica, CA

http://www.yvettemahon.com, Sydney, Australia

Tyler Vanicek, Student Storyboard, Endicott College

Step 7: Promotional Materials

Holly Bobulu, *Repartee*, Student Promotional, Madison Area Technical College, *http://www.hollybobula.com*

Mark Burrier, Promotional Book, McLean, VA, http://www.markburrier.com

Jeanie Chong, Student Promotional, Otis College of Art and Design, Los Angeles, *http://www.krop.com/nomorebadtype*

Anthony Georgis, Promotional Book, http://www.anthonygeorgis.com

Nicholas Felton, Promotional Materials, New York, *http://feltron.com*

Jessica Hische, Student Promotional, Tyler School of Art, *http://www.jhische.com*

Client: Harold Lee Miller, Promotional Materials, Indianapolis, *http://www.haroldleemiller.com*
Designer: Funnel: The Fine Commercial Art Practice of Eric Kass, *http://www.funnel.tv*

Alison Murphy, Student Promotional, Massachusetts College of Art and Design

Judy Reed-Silver, Promotional Materials, Calabasas, CA, *http://www.judyreedsilver.com*

Jeff Ross, Bowen Ross Photo, Promotional Materials, Chicago, *http://www.bowenrossphoto.com*

Step 8: Professional Materials

Fabien Barral, Business Card, Auvergne, France, *http://www.fabienbarral.com*

Kristen Bernard, Student Professional Materials, Endicott College, *http://kristenbernard.com*

Capsule, Business Card, Minneapolis, Creative Principal, Brian Adducci, *http://www.capsule.us*

Lena Cardell, Student Professional Materials, Tyler School of Art, *http://lenacardell.com*

Jeanie Chong, Student Professional Materials, Otis College of Art and Design, *http://www.krop.com/nomorebadtype*

Ken Gehle, Business Card, Decator, GA, *http://www.kengehle.com*

Naomi Harris, Business Card, New York, *http://www.naomiharris.com*

Brad Ireland, Business Card, Washington, DC, *http://www.bradireland.com*

Kenny Kim, Student Professional Materials, Kansas City Art Institute, *http://www.the-fineline.net*

Client: Anni Kuan, Professional Materials
Concept: Stefan Sagmeister
Design: Stefan Sagmeister and Hjalti Karlsson, *http://www.sagmeister.com*

Kristie Miles, Student Portfolio, Massachusetts College of Art, *http://kristiemiles.com*

Client: Harold Lee Miller, Business Card, Indianapolis, IN *http://www.haroldleemiller.com*
Designer: Funnel: The Fine Commercial Art Practice of Eric Kass, *http://www.funnel.tv*

Alison Murphy, Student Professional Materials, Massachusetts College of Art, *alimurphy@comcast.net*

Wesley Stuckey, Student Professional Materials, Mississippi State University, *http://www.wesleystuckey.com/*

Judy Reed-Silver, Business Card, Calabasas, CA, *http://www.judyreedsilver.com/*

Substance 151, Professional Materials, Baltimore, *http://substance151.com/*

Theoretical Universe, Business Card, Boston, *http://www.theoreticaluniverse.com*

Turnstyle Studio, Professional Materials, Seattle, *http://www.turnstylestudio.com*